THE BOOK OF
HOPS

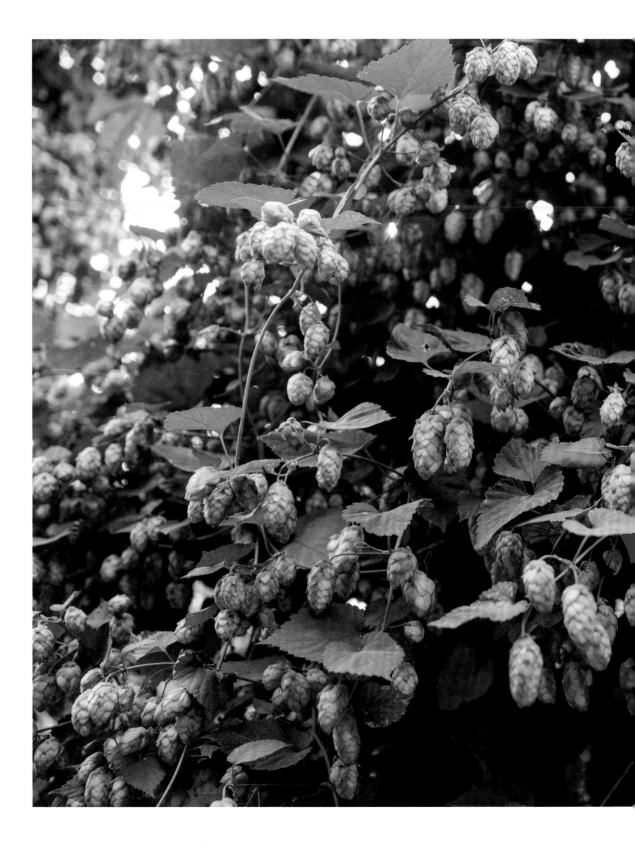

THE BOOK OF
HOPS

A Craft Beer Lover's
Guide to Hoppiness

By Dan DiSorbo
Photographs by Erik Christiansen

TEN SPEED PRESS
California | New York

CONTENTS

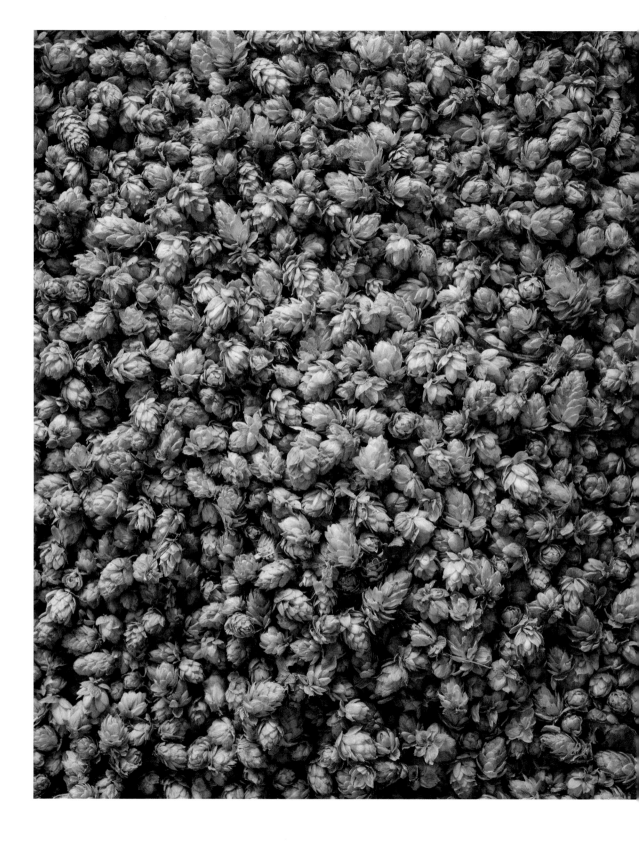

Introduction

All my friends are hopheads. For some, it's the spicy bitterness of a noble hop that has them fiending for more; others salivate with an uncontrollable Pavlovian response over the juicy fruit bouquet from new aroma hop varieties. For me, it's the sheer dankness of certain hops that entices my taste buds, bringing joy with each and every sip. As the most luscious ingredient in beer, hops offer a full spectrum of distinct aromas, delicious flavors, and soulful bitterness to the multitude of tasty beers we imbibe. Hop character is often *the* defining feature in some of the world's most celebrated beer styles.

Part science, part art, part magic, beer is one of the oldest and most consumed beverages on the planet. Since the days of our Neolithic ancestors, this strange brew has helped build civilizations and empires, revolutionized industries and cultures, and continues to transcend all borders to unite beer drinkers far and wide. The culture surrounding beer today grows increasingly complex with more breweries, ingredients, and styles seemingly introduced daily. The hundreds of styles available in the craft beer aisle can be a brave beer lover's dream or leave a curious newcomer overwhelmed and confused. How do we navigate the winding road to beer nirvana? Understand the difference between dry-hopped IPAs and barrel-aged Saisons? In short, how do we pick which beer to drink?

You've likely seen playful interpretations of the hop adorning many of these craft beer labels. Breweries are even using modern renditions of the hop cone as the main icon for the identity of their entire brand. It's time we look behind the lure of these labels to find real answers to all the questions we have about hops. What are they? Where do they come from? How do they impact all these different beer styles? Why do they taste so delicious? And, of course, which of these beautifully packaged beers is the best?

While no one can answer that last question, this book will tackle the rest of them by unlocking the secrets of the hop. It is time we honor and respect this virtuous flower with a book worthy of its importance to both contemporary beer culture and all

humankind. The scientific name of the plant is *Humulus lupulus,* and it's a native species to several continents, very hardy, and now grown the world over (at times referred to as the "wolf of the woods," for a more suitably badass translation of its Latin name). The cherished flowers of the female plants provide indispensable contributions to brewing; they inspire and shape beer craft culture and language; and they are what sets beer apart from all other beverages.

Simply put, without hops, nearly all of our best-loved craft beers and breweries would not exist. Every beer we drink today utilizes hops. As a natural preservative, hops allow a once fragile brew to survive. As a bittering agent, hops create a perfectly drinkable balance that allows beer to thrive. The essential oils concentrated inside the lupulin glands of the hop cones supply creative brewers with a cornucopia of aromatic and flavor profiles that allow the complex hoppy character of beer to evolve with consumer tastes.

New hop varieties being cultivated today continue to entice even the most discerning craft beer drinkers. For generations, some of the greatest minds in the world have employed technologically and scientifically advanced farming techniques and breeding programs to create a vast menu of options for brewers to select from. Patient hop breeders and farmers invest a decade of their lives to bring a new hop variety to market. Then complicated, massive logistical networks guarantee their quality and timely delivery to breweries, where only then can this vital ingredient contribute all its green and golden glory to beer.

The Book of Hops isn't a scientific dissertation on hops, an in-depth history of beer, or a step-by-step manual to brewing. Much more qualified people have written about those topics. Rather, this book offers an indispensable explanation of the symbiotic relationship between hops and craft beer, providing a clear window into an often-intimidating subject. We will capture how wonderful hops are with simple words, infographics, and ridiculously detailed photos, while we smell, sip, and savor all the tasty different styles of beer we love to put into our bellies. Drinking beer should be, above all else, fun—a liquid reminder to stop and smell the roses (or, in this case, hops). Think of this guide as a new drinking companion on your way to becoming an enlightened hophead.

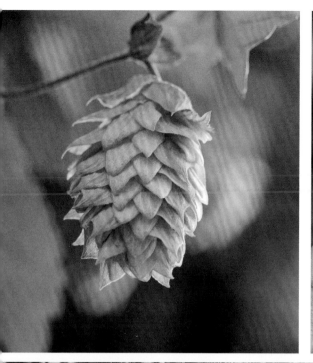

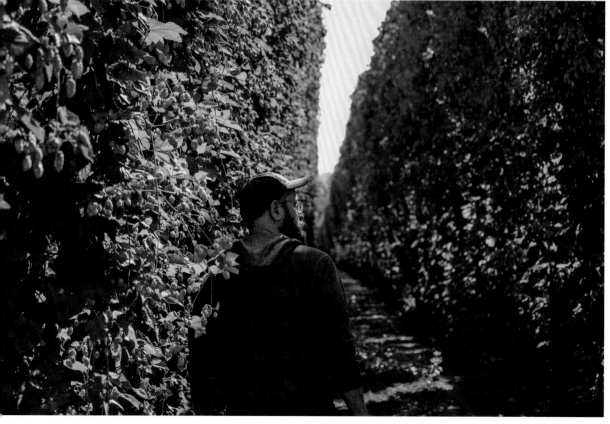

PART 1:
PRIMER

Beer and Hops Overview

Before we learn about different hop varieties and how they are used in different craft beer styles, we must first understand one of nature's perfect pairings—hops and beer. There is an integral relationship between the two. Hops are the primary catalyst that sparked the craft beer boom; ultimately hops are a divining rod for those seeking out the most innovative and delicious beer styles being brewed today. Alongside an overview of all things hops, we will cover essential craft beer basics, a crash course in the brewing process, and share other vital and hop-forward knowledge that will allow us to properly navigate the ever-expanding craft beer landscape.

What Is Beer?

Beer is among the most consumed liquids on the planet. Despite its ubiquity, many folks don't understand what beer is and how it's made. In its simplest form, beer is the physical manifestation of four primary ingredients: water, grain, hops, and yeast. It's the "liquid bread" that remains after grain sugars are consumed by yeast to create ethyl alcohol—with hops sprinkled in throughout the process. Brewers harness the power of hops to create harmonious balance and infuse the distinct aromas and flavors that set beer apart.

Early hominids may have invented beer *before* the wheel. Although scholars debate the specifics, there is evidence of fermented cereal grains dating back more than ten thousand years across many ancient civilizations, from the Persians to Sumerians. Beer was an instant success, perhaps because it was believed to be safer to drink than water, and then because it was tastier and intoxicating. The fuzzy story of beer continues into more recent European history, where brewers harnessed industrial, technological, and scientific innovations (and hops!) to mass produce shelf-stable beer and deliver it to thirsty people all over the planet.

Today, we no longer have to settle for any old swill. A proliferation of innovative craft breweries has spawned countless new variations of the beer styles our ancestors once concocted. Ale. Lager. Lambic. Saison. Sour. Stout. Witbier. The list goes on. Now more than ever, we have more choice, more creativity, and more community surrounding the craft of beer. We are drinking on the shoulders of giants.

FYI

All industries have their own specialized lingo, and beer is no different. Here are some key abbreviations you'll find used on beer labels and throughout this book.

ABV: Alcohol by volume, a measure of strength of a beer; the percentage of alcohol present in a given volume of water.

IBU: International Bittering Units, an ascending numeric scale of bitterness in a beer.

IPA: India Pale Ale, a popular hop-forward beer style that has led to other style variations and spin-offs such as APA (American Pale Ale), DIPA (Double IPA), IIPA (Imperial IPA), NEIPA (New England IPA), SIPA (Session IPA), IPL (India Pale Lager), and many more.

SRM: Standard Reference Model, a numeric (1–40+) and color scale used to specify the color intensity of a beer.

HOP-FORWARD

The term *hop-forward* is used to describe any beer whose initial smell and taste is dominated by hop alphas and oils—a first impression that's all about the hops and nothing else. There are infinite manifestations of hop character, combining varying levels of alpha acid–inspired hoppy bitterness with fruity, floral, herbal, and other vast hoppy not bitter flavors and aromas associated with hop oils (see "Hop Flavor Spectrum," page 18).

Beer by the Numbers

2100 BCE
First known fermented grain beverage that fits the modern definition of beer

822
Year of the first documented use of hops in beer

1663
Year first brewery opens in the United States

1933
Year the US federal government ended the prohibition on alcohol

1935
Year the beer can was introduced

157
Number of different beer styles commercially available today according to the Brewers Association

22,000+
Number of breweries in the world

388 Billion
Pints of beer consumed annually worldwide

98%
Percentage of operating breweries in the United States that fall under the craft category

186%
Percentage growth of the craft beer category globally over the past decade

What Are Hops?

The hop plant, or *Humulus lupulus* to be exact, is a flowering herbaceous perennial from the family *Cannabinaceae* (yes, the same as hemp and *Cannabis sativa*). It is a vascular plant with nonwoody stems that die and allow the plant to regrow annually from an underground root stem called a *rhizome*. It is the female cone-shaped flowers of the plant that are used in beer making. Much like the grapes that grow from a vine, these plump hop cones grow from a climbing shoot called a *bine*. Unlike a vine, the hop bine does not climb using tendrils or suckers but instead twists itself in a helix around a support as it rises up to the heavens.

Hops have been cultivated throughout the world for centuries and are utilized in every modern beer style. What is it about hops that makes them so desirable? All-natural preservatives, bitterness, aromas, and flavors are some of the features of the humble hop. We will explore each of these contributions in detail, but to truly appreciate the natural wonder of hops, we should begin with its natural anatomy. Here's the basic botany:

Hop Cone

These bud-like flowers (technically called *strobiles*) of the female hop plant are what are cherished, harvested, and used in making beer. These cones hold the keys to flavortown inside their lupulin glands. Just like potential bitterness, flavors, and aromas, the appearance (size, shape, and color) of hop cones can vary big time across different varieties.

Bract

This is a fancy term for the visible leaflike things that overlap and surround the outside of a hop cone.

Bracteoles

These soft structures inside the cone give the hop its structure and shape and the home where lupulin glands are formed and contained.

Lupulin glands

This yellow-gold powder-looking stuff contains resins, essential oils, and other chemical compounds that impart the characteristic bitterness (*alpha acids*) of the hops and most of their flavors and aromas (*oils*). Bittering potential and which aromas and flavors depend predominately on the specific variety and its growing conditions.

Strig

This is the small footstalk that connects the cone to the spray and possesses much of the hops' tannins.

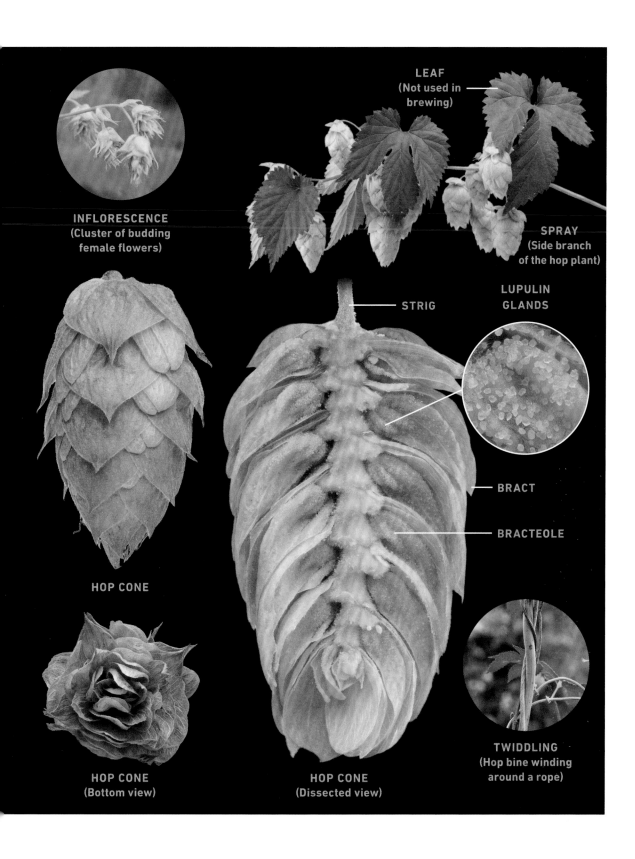

INFLORESCENCE
(Cluster of budding
female flowers)

LEAF
(Not used in
brewing)

SPRAY
(Side branch
of the hop plant)

STRIG

LUPULIN
GLANDS

BRACT

BRACTEOLE

HOP CONE

HOP CONE
(Bottom view)

HOP CONE
(Dissected view)

TWIDDLING
(Hop bine winding
around a rope)

Hop Cultivation 101

Hop cultivation is big business with over 200 million pounds produced annually in more than fifty countries. The first evidence of intentional hop growing dates back to 736 CE in Germany. Ever since, hop cultivation has spread like a weed—from small hop gardens, to bigger hop yards, to the commercial hop fields that now comprise hundreds of thousands of acres worldwide. Sunlight and day length are paramount to healthy and hearty hop production and overall yields, but during the dormant phase, the roots prefer a good freeze as they await the next growing season. This is why the majority of today's commercial hop cultivation occurs on farms located between thirty-five and fifty-five degrees latitude, either north or south of the equator (see "Hop-Growing Regions," page 25).

This hardy perennial plant can be cropped and regrown for more than twenty years, producing bines annually from a permanent underground stem, or rootstock, known as a rhizome. Hops are grown in rows of "hills" (often with two to four rhizomes per hill) with each hill set about 2 to 3 feet apart. In early spring, these rhizomes sprout numerous buds or shoots, which are fundamental to propagation. Young shoots are trained to grow clockwise around a wire support, and vigorous bines can reach over twenty feet in full bloom. Successful farming of hop bines requires a trellis system constructed of sturdy wire or twine connected to a series of poles.

As the bines grow and climb to reach the top trellis wire, lateral shoots called *sprays* begin to emerge and extend outward. This is where the hop cones form and finally begin to bloom. From this point forward, the flavors and aromas of the hop cones shift throughout the remainder of the growing and harvesting process—from flowering and maturing to the weeks and days before and after harvest. All this change is why picking windows (when) and lot selections (where) have become a fine art.

Once the cones are deemed ripe for harvest (usually late summer to early fall), the entire bine is cut at the base and top. Specially designed hop picking machines then remove and separate the hop cones from the sprays and leaves of the detached bines. After harvesting, the hops are washed, processed, and turned into a variety of finished products to suit any brewer's needs.

Opposite page: (top left) Hills begin to sprout. (top middle) A shoot twines a rope as it begins its ascent. (top right) Bines with established sprays and hop cones continue to grow toward the top wire of the trellis. (middle left) Ripe hop fields being harvested. (middle) Cut bines entering the picker, which will separate the cones. (middle right) Hops continuing through the cleaning process. (bottom left) Clean hop cones are spread in the kiln to dry. (bottom middle) Dried hops enter the cooling floor to rest. (bottom right) Cured hops are pressed into bales.

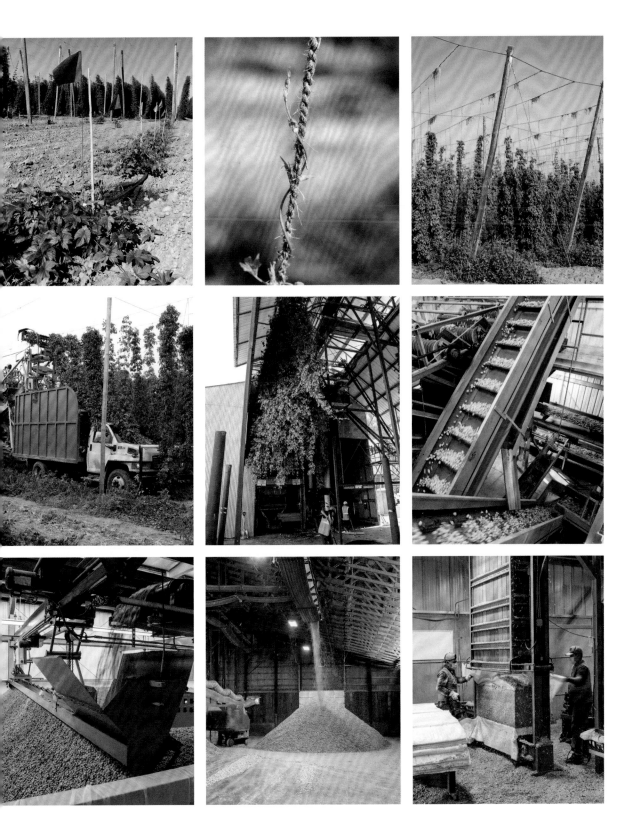

Hop Products

All beer is made using some form of the harvested hop cone. No matter which hop product(s) a brewer decides to use, it is always an all-natural derivative of the female flower. Following are several different "finished" forms hops can take.

Fresh Hops

Nature's purest gift, these whole *wet* cones are picked straight from the bine. Green hops have a very high moisture content that will rapidly begin to rot, so these flowers must be brewed within twenty-four to thirty-six hours. When used quickly, fresh hops provide vibrant flavor profiles that can only be found in fresh-hop beers.

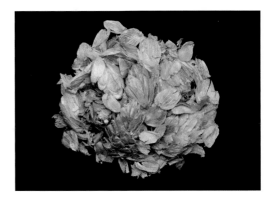

Dried Hops

To prevent spoilage, cones are dried, typically in a kiln within hours of harvesting to reduce the moisture content from around 80 percent to 8 to 10 percent. They are then pressed into bales for storage and distribution. This classic process dates back centuries, and the resulting dried flowers are often called *whole-leaf hops*. Whole-leaf hops take on the unique aspects of the field and season in which they are grown and are versatile enough to be utilized at all stages of the brewing process.

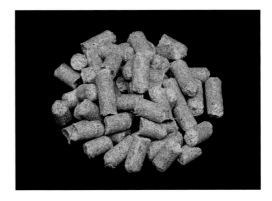

Hop Pellets

By far the most commonly used product, hop pellets are dried, whole-leaf hops milled into a powder before being compressed

into a concentrated pellet. These Type 90 (90 percent green matter and 10 percent lupulin) are commonly called T-90 pellets and offer a consistent density and retain all the natural lupulin and cone material. They are easily packaged in airtight, vacuum-sealed opaque bags that can be stored cold for up to three years.

Hop Extracts and Advanced Products

The future of hops is now. Innovative technologies have allowed hop processors to efficiently and precisely extract alpha acids, lupulin, resins, essential oils, or individual terpenes from hop cones to produce a variety of precise products that offer targeted bittering, aroma, or flavoring contributions without all the vegetal material. These hop-derived products are extremely stable and come in many forms, from supercritical CO_2-extracted concentrates and liquids for precise bittering to lupulin-enriched powders and T-45 pellets (45 percent green matter and 55 percent lupulin) for intense aroma and flavoring.

OAST HOUSES

From around the late sixteenth century up until the Industrial Revolution, hops were traditionally dried in cone-shaped buildings designed and built specifically for this task. In these oast houses, fresh hops were spread out on a batten floor and slowly dried by hot air rising from a wood or charcoal fire below. Some oasts can still be found in many European hop-growing regions, but nearly all of today's commercial hops are dried using industrial kilns.

OLD HOPS

Hop products are usually assigned a value on the Hops Storage Index (HSI), which, among other technical analyses, measures the aging rate and calculates alpha acid potential lost after six months when stored at 68°F. Time, temperature, oxygen, humidity, and light are the enemies of hop storage. When hops get old enough, they begin to smell cheesy and eventually lose their bittering components. Aged hops are only traditionally used in Lambics, a Belgian beer style focused on the antimicrobial properties of hops rather than its bittering characteristics.

Hop Variety Basics

The variety of hop chosen has a significant impact on the particular beer style. Hop plants began as a native species in temperate continents throughout the world. In some German cities you can still find wild hops growing in the streets, wrapping themselves around random lampposts. Another intriguing wild variety can be found climbing up willow trees in some of the canyon forests in New Mexico. These ancient bines have always grown naturally in the wild, perfected by Mother Nature for millennia, adapting, evolving, and improving their harmony with the natural environment.

A hop variety is simply the term used to describe a genetically unique version of the hop plant. Nearly all commercially cultivated hop varieties, or *cultivars,* have been carefully bred (see "Hop Breeding," page 20) to express specific trait combinations that are stored in its DNA. In essence, these hop varieties are a hybrid plant that results from the crossbreeding of two or more genetically different hop parents. This unique genetic makeup—referred to as the *genotype* of a variety—allows the same hop cultivar to be grown again and again.

While the genetics of a specific variety will always be the same, it's the *phenotypes*—or observable characteristics such as aromas and flavors—of the hops that make them so special. Although we can expect these unique characteristics to be consistent within each variety, they do fluctuate from year to year

or farm to farm. Different environmental factors (climate, soil, temperature) and growing conditions (precipitation, pests, diseases, harvest time) can all directly affect the desirable traits of each variety. Successful growers implement sensory analysis and chemistry testing at each step of the growing and harvesting process to yield the best result.

In terms of harvesting, more time on the bine results in more oils in the glands. For example, if the Mosaic hop (see page 160) is picked too late in the harvest window, the extra oil production may lead to less desirable onion and garlic flavors (often referred to as OG flavors) that overpower its trademark fruit and berry medley of aromas, which occur when the hops are harvested at the optimal time. Environmentally speaking, the versatile hop variety Cascade (see page 70) is grown throughout the world, and each region can impart its own nature vs. nurture influence. Originally developed and grown in the United States, Cascade famously offers a classic citrus fruit aroma, whereas Cascade grown in Australia, for example, can offer a more noticeable grapefruit distinction.

If that wasn't enough to think about, hop-drying methods and temperatures, processing techniques, and even hop product storage can all affect the final composition of the compounds and overall contributions of the hops to the beer itself. And some people think a hop is just a hop. . . .

HOP FAMILY TIES

There are five landrace botanical varieties that we can trace most hop variety's ancestry back to, and many track back to European and American hybrid lineage. Today there are more than 150 different hop varieties with countless more in development. Below is an example of the genealogy for the American hop variety Cascade and its popular "twins" (phenotypes grown in other regions), mapping its lineage back to Russian and English genetics.

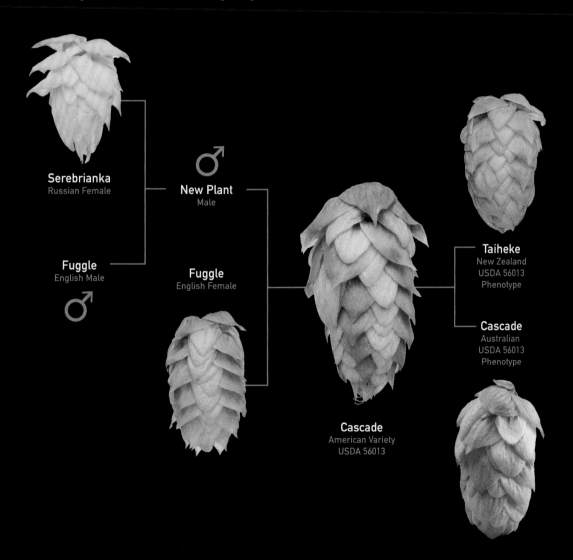

Serebrianka
Russian Female

New Plant
Male

Fuggle
English Male

Fuggle
English Female

Taiheke
New Zealand
USDA 56013
Phenotype

Cascade
Australian
USDA 56013
Phenotype

Cascade
American Variety
USDA 56013

Hop Compounds: Alphas, Oils, and Beyond

Hop varieties are carefully selected first and foremost for their overall sensory potential. Their acids, oils, and resins can be let loose in various ways as bittering agents and/or hoppy aroma and finishing flavors (see "Hop Flavor Spectrum," page 18), so it's imperative to know what each specific variety has to offer. Thankfully, as with any agricultural commodity, there are quantitative metrics associated with hop quality. Among the most important to both the brewer and consumer alike are alpha acid, cohumulone, and total oil content; these amounts vary hugely across all different hop varieties.

Acids

ALPHA ACIDS: Alpha acids represent the bittering potential of hops. They exist in the soft resin of the lupulin gland, and when *isomerized* (activated during boiling), alpha acids are responsible for most of the bitterness of the finished beer. Generally speaking, the more alpha acids that are isomerized, the more bitter the beer. Alpha acids typically comprise anywhere from 2 percent to over 20 percent of the total composition of a hop; the final number measured in a particular hop indicates its bittering potential.

COHUMULONE: This is a key alpha acid found in all hops. When present in high levels, it may present a harsher bitterness. Cohumulone is measured as a percentage of the total alpha acids with around 25 to 30 percent being the average. Some brewers seek higher levels of cohumulone, while others prefer lower levels—there's really no consensus.

BETA ACIDS: The other main component of the soft resin in hops, beta acids play an important antimicrobial role but have limited solubility in water (only trace amounts may end up in beer) and thus have little importance in other aspects of the brewing process. The ratio of alpha to beta acids present in the hop itself is important, as higher levels of beta acids aid in retaining a hop's bittering potential as it ages over time in storage—lower levels, not so much.

MEASURING BITTERNESS

IBU stands for International Bittering Units and is basically the final scientific measurement of the number of bittering compounds (alpha acids, and other select bittering chemicals) found in the beer. IBUs are often used by brewers as a quality-control measure when checking recipes. Most beer styles will fall somewhere on a low range of 4 to 5 IBUs up to very high levels of 100 to 120+ IBUs. It's important to note IBUs do not measure flavor, aroma, or *perceived* bitterness, which can sometimes be at odds with the final IBU calculation. A quick example of this perception deception would be a Pale Ale (see page 73) with 35 IBUs, which will have a more bitter taste to most drinkers than a Stout (see page 167) with 50 IBUs. The Stout does indeed have more bittering compounds, but the Pale Ale's bitterness is more apparent to your palate because the Stout has far more "sweet" ingredients to balance the bitterness. The lesson here is to use IBUs more generally and as part of the full description of a beer, an indicator of how bitter a beer *might* be.

Total Oil Content

This metric represents the potential of a hop to provide flavor and aroma. Aside from all their bittering compounds, the lupulin glands also contain all the essential oils and other organic compounds that provide the overall fragrances and flavors. These hydrocarbons and oxygenated compounds are volatile and susceptible to high temperatures. They can get lost during boiling, so they are better captured through late additions and dry-hopping (see "Hop Additions Explained," page 52). The total oil content of a beer can range from less than 0.5mL/100g to more than 3mL/100g in more saturated hop varieties. These essential oils are highly concentrated and are the magic behind aroma, so it doesn't take much to turn otherwise tiny glands into fully locked and loaded flavor bombs.

TERPENES: These volatile, unsaturated hydrocarbons or "terps" can be identified in all types of plant life and are responsible for universal smells and tastes like citrus, spicy, and floral. Different terps predominate in the essential oils of hops to create these familiar flavors, as well as many, many more to create a vast and diverse hoppy palate.

THIOLS: Well-known in wine making and detectible at miniscule thresholds, thiols are one of the many sulfur-containing organic compounds known as *mercaptans*. Thiols are highly aromatic, active compounds and their presence in hop essential oils is responsible for providing a wide range of complex tropical fruit flavors and aromas.

CONE COMPOSITION

A dried hop cone is commonly comprised of:

40–50% cellulose

10–25% proteins and minerals

8–10% water

3–5% tannins and polyphenols

2–20% alpha acids

2–10% beta acids

0.5–4% essential oils

5–10% other acids, fats, and simple sugars

TANNINS, POLYPHENOLS, AND HOP BURN

Tannins are very familiar to the wine world and are one of the many organic compounds called *polyphenols* that are found in a hop. Hop tannins are always present in beer and in high concentrations can cause a "dry" mouthfeel. Hop polyphenols in general promote the precipitation of proteins, meaning they may contribute to a permanent hazy appearance in beer or a temporary chill haze that disappears as the beer gets warmer. They also contribute to a more recent phenomenon called *hop burn*. With multiple, large dry-hopping additions often called for in many new IPA styles, all that extra hop matter can transfer excessive polyphenols to produce an unpleasant physical reaction that puckers your mouth and can even constrict your throat. This "green" hop burn sensation is annoying and unwelcome in any beer style.

Hop Flavor Spectrum

When, how, and for how long a brewer uses a selected variety of hops in the brewing process will directly influence all the final aromas, bitterness, and flavors a brewer can extract and infuse in the finished beer (see "Hop Additions Explained," page 52). Along with all its bittering resins, the lupulin glands also contain all the essential oils and other organic compounds that combine to provide the overall fragrances and flavors of the hops. And while lupulin is unique to just hops, many of its terpene compounds can be found in other types of plant life. The potential aroma and flavor of any given hop varietal depends a lot on which of the hundreds of these potential compounds dominate. While the exact blend will vary from hop to hop, there are many common bouquets you will experience from beer to beer. Here are the most frequently occurring and significant terps.

DANK COUSINS

Hops and cannabis (marijuana) are both members of the same *Cannabaceae* plant family. As such, they both contain many of the same terpenes but sadly, hops don't contain CBD, THC, or any of the other psychoactive cannabinoids of cannabis.

The Big Three:

Caryophyllene (ß-*caryophyllene*)
Also found in rosemary
FLAVORS:
Earthy, spicy, woody

Humulene (α-*caryophyllene*)
Also found in cannabis
FLAVORS:
Herbal, dank, hoppy

Myrcene
Also found in mango
FLAVORS:
Citrusy, fruity, peppery

Others:

Farnesene
Also found in apple skins
FLAVORS:
Herbal, grassy, citrusy

Linalool
Also found in lavender
FLAVORS:
Candy spice, floral, orange

Limonene
Also found in lemons
FLAVORS:
Lemon, tart, tangerine

Pinene (α-*pinene* **and** β-*pinene*)
Also found in pine needles
FLAVORS:
Piney, resinous

FLAVOR PALETTE

Brewers sometimes showcase a single hop variety in their beer, but more often than not, a brewer will use a combination of several different hops to provide an entourage of complementary aromas and flavors. The acids, oils, and other compounds in the hops all work together to form the final combination of hoppy sensations in a beer. Since tasting actually uses the same olfactory senses as smelling, we can break down all the main flavors found in hop varieties into five simple categories—sweet, sour, spicy, bitter, and savory. Here's a few of the most common ones found in today's beer styles.

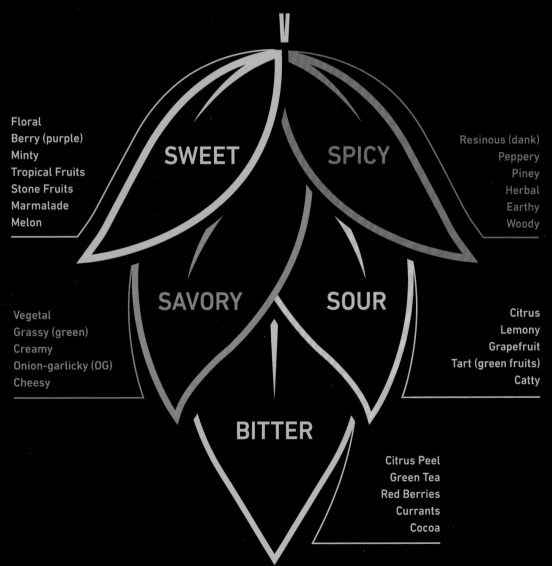

Floral
Berry (purple)
Minty
Tropical Fruits
Stone Fruits
Marmalade
Melon

SWEET

SPICY

Resinous (dank)
Peppery
Piney
Herbal
Earthy
Woody

SAVORY

SOUR

Vegetal
Grassy (green)
Creamy
Onion-garlicky (OG)
Cheesy

Citrus
Lemony
Grapefruit
Tart (green fruits)
Catty

BITTER

Citrus Peel
Green Tea
Red Berries
Currants
Cocoa

Hop Breeding

Much work goes into the development of a new hop variety. As one of the most crucial, expensive, and delicious ingredients in making beer, hops must perform as advertised in order to indulge farmers, brewers, beer drinkers, and everyone in between. Lucky for us, some of the world's greatest minds have dedicated their lives to breeding the highest quality hops. From the first breeding programs by E. S. Salmon in England in the early 1900s to Dr. Al Haunold's commercialization of game-changing hop varieties during his thirty-four-year tenure running the USDA hop-breeding program, the impact of hop breeders on craft-brewing history is phenomenal.

"It takes a big passionate team to successfully breed a hop variety. It might be one particular breeder who crosses some genetics initially, but credit must go to the whole slew of other people who take it through the long journey to commercialization. Cascade is a great example. The cross was made by Dr. Stan Brook in the 1950s; then a lot of the development work came later with Dr. Al Haunold and his entire team, and Cascade wouldn't be where it is today if it wasn't for Chuck Zimmerman, who literally brought the variety to Washington State where the Segal, Roy, Perrault, and other family farms began growing it."

—JASON PERRAULT,
lead hop breeder for Yakima Chief Ranches

Mixing genes is always a good thing for the evolution of any species. This is one of the basic rules of genetics, valid for all forms of complex life on this planet. With hops, there are three main variables hop breeders have focused on when developing new hop varieties—yield, disease and pest resistance, and to every brewer's and hophead's delight, total oil and resin composition. Today, a new generation of hop originators are responding to consumer demands by developing some of the best-known New World hop varieties, with flavor reigning supreme.

Along with being a fourth-generation hop farmer, Jason Perrault is also one of the most prolific hop breeders in the world and a key contributor to the creation of the all-pervasive Citra hop variety and other sought-after varieties, such as Mosaic and Simcoe. "The trend toward aroma has really taken place over the last decade or so," he says. "We are responding to the demand for a more meaningful beer-drinking experience at the consumer level. People want to drink something flavorful that was responsibly produced. I don't see this changing in the next decade. As hop breeders, we can respond to this by keeping the breadth of our genetic selection wide, continuing to identify novel attributes, and selecting plants that are efficient to produce with fewer inputs and focus on consistent quality."

THE ELEMENTS OF BREEDING

Below are some of the many important factors a hop breeder must consider when developing a new hop variety that will meet the increasingly specific demands of growers, brewers, and beer drinkers alike.

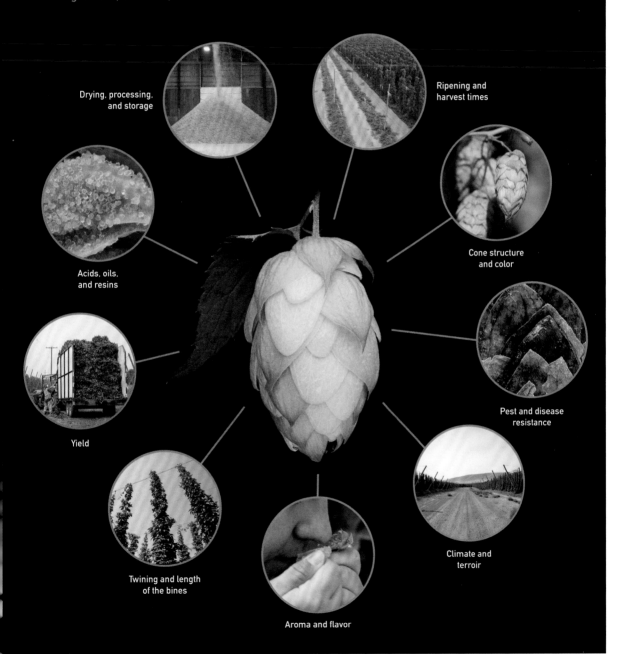

Drying, processing, and storage

Ripening and harvest times

Cone structure and color

Acids, oils, and resins

Pest and disease resistance

Yield

Climate and terroir

Twining and length of the bines

Aroma and flavor

From Seed to Sip

Hops are *dioecious*, meaning they produce both male and female plants. The flowers (cones) of the female plant are fertilized by the pollen of the male flowers with the result that the female flowers form seeds that will grow a new hop love child. To successfully crossbreed hops, identify a potential new hop variety, and then take it into commerce takes skill, a little luck, and more than ten years to complete!

All breeders apply their own scientific methods to the complicated breeding cycle, but this timeline from Indie Hops and Dr. Shaun Townsend of Oregon State University—the team that created the newly beloved hop variety, Strata (see page 208)—outlines the crucial steps involved in this very long vetting process.

TAX DOLLARS HARD AT WORK

Since 1931, the US Department of Agriculture's Agricultural Research Service (USDA-ARS) hop-breeding and genetics program has been heavily involved with genetic research. They are responsible for the development of advanced hop cultivars that feature superior pest and disease resistance, increased yield, and enhanced brewing characteristics, like Cascade, Willamette, and countless other varieties that have shaped the American hop industry.

RAW HOP SENSORY EVALUATION

STEP 1. Gently pick a hop cone off the bine and note its appearance—color(s), size, shape.

STEP 2. Squeeze the opposite sides of the cone and split it open to reveal the lupulin gland production.

STEP 3. Rub the insides and lupulin glands of the two halves together several times.

STEP 4. Bring the insides of the cone close to your nose and note all the different aromas.

YEAR 1:
CROSS-POLLINATION AND SELECTION

Select parent plants

FEMALE MALE

Cross-pollinate

Harvest seeds

Plant seeds in greenhouse

YEARS 2 TO 3:
EXPERIMENTAL TRIAL PHASE

Select for disease-resistant genotypes in the greenhouse

Plant in small plots to evaluate vigor, disease resistance, and identify female genotypes

Harvest

Conduct chemistry and sensory analysis

Select promising genotypes for the advanced trial phase

YEARS 3 TO 6:
ADVANCED TRIAL PHASE

Plant advanced genotypes in multi-hill plots at farms

Evaluate them throughout the year for pest and disease resistance, vigor, yield, cone quality, chemistry, and unique sensory characteristics

Work with brewers to produce pilot test batches of beer with genotypes

Advance a genotype into commercial trial phase after several years of consistent data results

YEARS 7 TO 9:
COMMERCIAL TRIAL PHASE

Plant additional acreage

Assess commercial attributes, including yield and suitability for machine harvesting

Prototype the creation of hop pellets; conduct more oil and resin analysis

Start broader commercial brewing trials for the ultimate final test

YEARS 9 TO 12:
VARIETY RELEASE!

The hop is named and registered as a new variety

Hop is made commercially available for brewers everywhere to use

Hop is found in a beer near you!

The Hop Hierarchy: How to Categorize Hops

There are three main ways to organize hop varieties: by *use* (the contribution of the hop to the brewing process), *ownership* (the genetics of the hops), and *origin* (the area in which the hops are grown).

1. Use

The simplest way to categorize hops is by their main purposes in brewing.

AROMA HOPS: These varieties are used to contribute flavor and aroma characteristics associated with their high oil content. Some of the newest hybrid varieties have even been dubbed "flavor hops" for their intense oils and distinct flavoring capabilities, but the industry has yet to separate flavor hops into their own category.

BITTERING HOPS: These varieties possess superior alpha acid content and are used to add various levels of bitterness to beer. They offer very little or mild aroma characteristics, and many high-alpha and super-alpha (over 15 percent alpha acid content) varieties are grown solely for their alpha acid content and then processed into an extract product.

DUAL-USE HOPS: These hop varieties offer the best of both worlds with desirable alpha and oil content. They exhibit the qualities of both aroma hops and bittering hops and can be used for either or both purposes.

2. Ownership

The hops grown and sold today are separated by ownership rights, depending on whether the genetics are public or proprietary, protected with exclusive legal rights and commercial licensing fees associated with growing them.

PUBLIC: There are public, government-funded research and breeding programs such as that of the USDA Agricultural Research Service, and public-private partnerships, like Germany's Hop Research Center Hüll, which develop promising varieties and release rhizomes or seedlings to hop farmers for commercial growing.

PROPRIETARY: Private companies such as the Hop Breeding Company in the United States or Hop Products Australia (HPA) crossbreed and develop their own proprietary varieties with patented genetics for which they control all the production and distribution rights through licensing fees and royalty agreements. These rock-star hops can be recognized by their variety names accompanied by the small ™ or ® symbols to designate their official trademark status.

3. Origin

Hops can be distinguished further by the ancestry or region in which they were derived or are grown.

OLD WORLD HOPS

Like Old World grapes, Old World hops (sometimes referred to as continental hops) are long-established "vintage" hops that hail from continental Europe and Britain. They include the traditional four noble hops, as well as many other classic old-school varieties. In either case, Old World hops tend to emit delicate herbal and earthy hoppy characteristics and are known for having less aggressive acid and oil profiles than their New World counterparts.

NOBLE HOPS: Also known as "Saazer-type" hops, these four landrace varieties have been dosing European beers since the Middle Ages. The three German varieties—Hallertauer Mittelfrüh, Tettnang, and Spalt—are from Bavaria, Baden-Wurttemberg, and Nuremberg, respectively. The Bohemian variety, Saaz, hails from what is currently Zatec, Czech Republic. These original aroma hops offer spicy, floral, and earthy characteristics, each nuanced by their own region's terroir.

NEW WORLD HOPS

New World hops are more contemporary varieties known for having higher acid levels and more pungent oil profiles than Old World hops. Many are dual-use, and many of the newest New World varieties boast huge and juicy citrus, tropical, and stone-fruit flavors and aromas. New World varieties have been bred and grown throughout the world, even in some predominantly Old World regions.

AMERICAN HOPS: This New World sub-category began with hops that evolved from Old World British varieties that arrived with settlers in the seventeenth and eighteenth centuries and have been hybridized, some with wild American hop plants. Their famous citrus, resin, and pine characteristics are revered and have been integral to the explosion in IPA popularity. These new-school hops are exemplified in what have become known as *American C hops*—Cascade, Centennial, Chinook, CTZ, and the new heavyweight champ, Citra.

Hop-Growing Regions

The United States has recently taken the crown as the top hop-producing country on the planet. The Pacific Northwest (Washington, Oregon, Idaho) accounts for 99 percent of the United States hop crop. Hops are also successfully grown around the globe in countries such as Argentina, China, France, Italy, Japan, and South Africa, but there are only a handful of major hop-cultivating regions. These top hop spots include Germany, Great Britain, New Zealand, Australia, and of course the United States. Our tour begins on the next page.

Hallertau, Germany

FROM THE FIELDS: Hallertau Blanc (see page 138) • Mandarina Bavaria (see page 154) • Perle (see page 186)

Hop cultivation in the Hallertau area of Bavaria, Germany, has spanned over two millennia and is the largest continuous hop-growing area in the world. This is where hops have come to be called "green gold" and are synonymous with the whole of Bavaria and Bavarian beer culture—then and now. Accounting for roughly 80 percent of all German hop production, the Hallertau is to Germany as the Yakima Valley (see page 41) is to the United States (with a much longer history).

The first hop gardens date back to the eighth century. In those early days, hops were not used just for brewing beer, but also used to make teas and to flavor food. They were also commonly used as medicinal plants thanks to their therapeutic and preservative qualities. A German Benedictine abbess nun named Hildegard of Bingen famously wrote about hops in her twelfth-century pharmacopeia *Physica,* and her beer recipe is often considered the first recorded reference of the use of hops in beer as a preservative.

Hundreds of years later, the best-known version of "Purity Laws," or *Reinheitsgebot,* from Bavaria were enacted in 1516, giving the recipe for beer its official seal—beer could only be brewed from water, barley, and hops. Although no longer an enforced law, this strict regulation is still proudly practiced today and has made Bavarian beer with its outstanding ingredients and quality famous throughout the world.

> "Hops are the jewel of Germany's liquid gold."
>
> —ELISABETH STIGLMAIER

What makes the Hallertau so special aside from its culture and community spirit is the remarkable terrain of this hop-growing district. The fertile land has small hills that protect the hops against storms and soil that is a natural mixture of loess and loam; the roots of hops grow very deep here. All this, along with a mild climate, has made for a hop-growing paradise.

Today, many historic farms are still in operation and continue to preserve this pristine landscape through their hop-growing traditions. One of these is the farm of Franz and Elisabeth Stiglmaier in the lower Bavarian village of Attenhofen.

Opposite page: Elisabeth Stiglmaier and views of her farm and facilities.

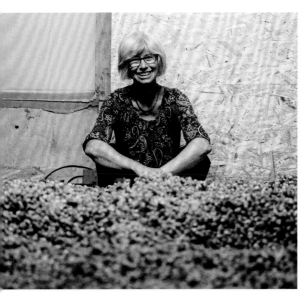
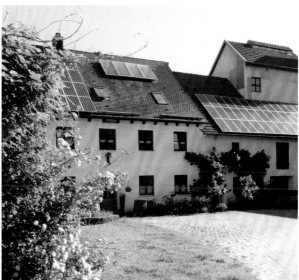
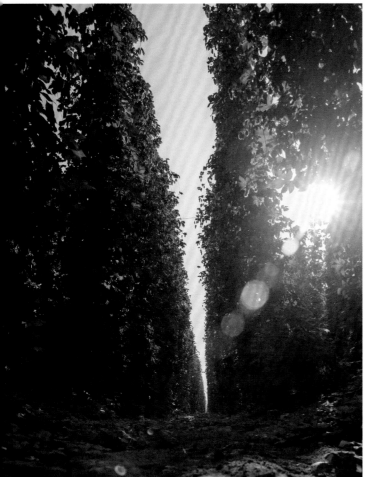
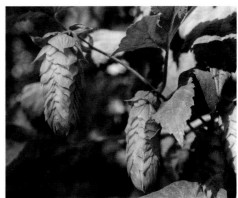

Hopfen-Pro-Bier-Stube

"Our farm has been growing hops for more than 180 years, now in the sixth generation and soon to be seventh generation, when our son Andreas takes over the family tradition," says Elisabeth. People here simply enjoy living with hop cultivation. From handpicking hops to making historical raw ales, the community prospers with something Elisabeth refers to as a "special hand feeling."

"We have no secrets. The work with hops is always the same—what to do in spring, what to do in summer. Our goal is always to grow the best hops without diseases and pests. Many want to hear a romantic story but this is the reality. Harvesting and drying hops is repetitive. Every farm nowadays has its own procedure with mechanized harvest but the results should always be the same: dried hops with green color, no damaged cones, with only 9 percent water content."

Elisabeth is also a designated hop ambassador in the Hallertau. With exciting journeys back in time, authentic stories, and an unconditional love of hops, she imparts her knowledge of the hop plant and the Hallertau's special cultural landscape to future generations. However, her indispensable role to all beer lovers involves far more than just boosting the image of the region; it is her passion for hop varieties, aromas, and tastes that keeps her immersed in the world of the hop.

"In the Hallertau, we sometimes say our hops smell 'noisy,' but they can also have very refined and mild flavors. All these traits are very unique—and only to hops."

HOP RESEARCH CENTER HÜLL

Since 1926, the Hop Research Center Hüll has been a central hub in the Hallertau for breeding, research, and counseling for German hop growing. These breeding lines and cultivators are currently planted on more than 80 percent of the German hop acreage.

Great Britain

FROM THE FIELDS: East Kent Goldings (see page 106) • Fuggle (see page 124) • Northern Brewer (see page 176)

The exact beginning of hop cultivation in Great Britain is very much like its climate, cloudy. Certain lore suggests that hops were being cultivated in the early Middle Ages but that the advantages of brewing with them had mysteriously disappeared until the sixteenth century. According to other sources, Flemish settlers brought the plant to the island in the early 1500s, but still there were reservations against using hops in brewing. Many bloody-minded Brits believed hops presented a health danger and would ruin the taste of their precious ales. In fact, hops were what distinguished "beer" (brewed with hops) from "ale" (brewed without hops) in those antiquated times. As perceptions changed, what has come to light is that since the nineteenth century, Great Britain has certainly become one of the most important countries in hop history.

Early English varieties, such as Fuggles and East Kent Goldings, have a fascinating history that dates back to the late 1790s and have formed the basis of British brewing for centuries. During the 1800s, these varieties became the inspiration and the main ingredients of the very first IPAs. By 1900 more than twenty unique hop varieties were known in England. Then came along a gentleman by the name of E. S. Salmon, who would change the course of hop-breeding history. In 1906 he began at Wye College what many believe to be the very first hop-breeding program. Because of its location in the center of Kent, the main growing region in England, Wye College is now virtually synonymous with all British hop research, breeding, and development. By the 1930s, novel varieties such as Brewer's Gold and Northern Brewer were bred, and these hop "godmothers" are now the genesis of *all* other higher-alpha varieties around the world. Great Britain is also the first region to have focused so strongly on disease resistance, making British hops both environmentally friendly and inevitably more appealing to growers and breeders.

"Breeding requirements have changed greatly over my career. In the 1980s it was all about alpha; in the 1990s it was more about environmental matters like disease resistance and pesticide reduction, and in this new century it's all down to flavor."

—DR. PETER DARBY

According to Dr. Peter Darby of Wye Hops, "British hops make the most drinkable beer in the world. There are no overwhelming flavor notes but there are many notes interacting with one another. None are discordant. They are soft, complex, and balanced

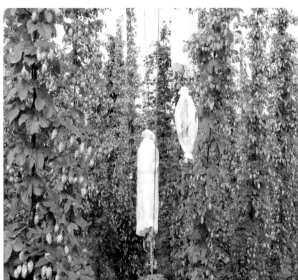

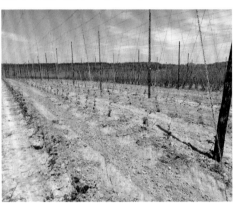

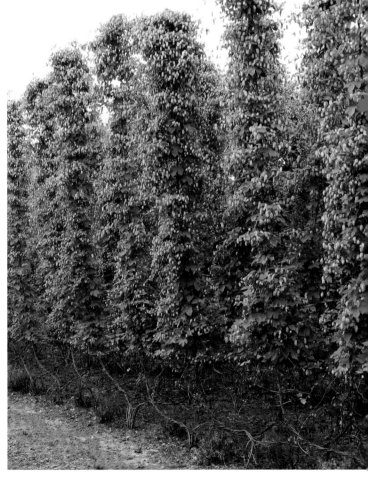

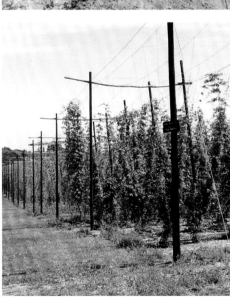

to very much give a brewer more scope to show their art." Today's notable British hop aromas include notes such as tangerine, citrus, grass, grapefruit, chocolate, black currant, spice, pepper, apricot, marmalade, mint, honey, floral, and molasses.

The British environment can take much of the credit for these nuanced characteristics. Hops here grow best where it is slightly dry, so Britian's main hop-growing fields are located in areas that are sheltered from rain and winds by the country's many hill ranges. These rain shadows along with the very cold months of February and March also directly affect the large number of glands that form in British-grown hops. A warm June helps the hops retain those glands; the hot temperatures of August fill those glands to their full potential.

The main factor affecting hop flavors is sunshine. UV radiation directly affects oil maturation with different oils maturing at different rates. Since England is quite cloudy, this leads to a much more even maturation of all the essential oils in the hops to create a refined balance with no single flavor predominating. In comparison, regions such as those in the United States, Australia, and New Zealand have high UV sunshine, which can lead to higher monoterpenes that result in a much stronger but singular flavor.

"British hop aromas and flavors are subtle and balanced. Although their hoppiness is distinct, there are also fruity and woody notes present but without any one singular note being predominant," continues Dr. Peter Darby. "Like a chamber orchestra, the hops give simultaneously the high notes and the bass notes. The effect is that you want to have another sip of the same beer. An enjoyable beer with consistency and individuality—this is the perfect home for British varieties."

Compared to other growing regions, the British hop industry is relatively small in terms of acreage but its impact on aroma, flavor, and genetics are indispensable. However, this region's influence on the evolution of hops and, in turn, beer itself is as vast as it comes.

WYE HOPS

The breeding program at Wye College began in 1906 and is now a subsidiary of the British Hop Association. Since its inception, there have been only four breeders: Professor Ernest Stanley Salmon (1906–53), Dr. Ray Neve (1953–81), Dr. Peter Darby (1981–2021), and Klara Hajdu (2021–present).

Opposite page: (top left) Dr. Peter Darby at Wye Hops. (top right) Pollination sleeves used for controlled cross-breeding. (middle left) New seedlings planted out. (bottom left) Wye Hops' permanent living collection site of more than 400 breeding varieties. (bottom right) A commercial plot at Wye Hops.

New Zealand

FROM THE FIELDS: Motueka (see page 168) · Nelson Sauvin (see page 174) · Riwaka (see page 188)

New Zealand accounts for only 1 percent of the world's total hop crop, but these exceptional varieties are some of the most highly sought after. Hops were originally introduced to New Zealand by immigrants from England and Germany in the mid-1800s. These early settlers brought hop seedlings with them to establish their first gardens, and hop growing commenced immediately. New Zealand's isolation presented the advantage of being free from the usual pests and diseases that typically challenge the plant's growth. Early farmers were able to quickly produce quality hops.

By the early 1900s, hops were grown in many areas across New Zealand, but the Nelson-Tasman area on the South Island eventually became the heart of the hop industry. With its high number of sunshine hours, even rainfall throughout the year, and shelter from strong prevailing winds, this region is a hop-growing paradise. As a result, other growing areas faded away as Nelson-Tasman became the center of the hop-export industry and ultimately the only hop-growing area in the country.

There are plenty of hop farmers meeting this demand. Founded in 2005 by passionate plant scientist Dr. Susan Wheeler and her husband, Kerry Skilton, Hop Revolution has its roots deep in the soil of the rebellion found in New Zealand's beer culture. "I come from the wine industry with a PhD in viticulture," says Dr. Susan Wheeler. "I found grape growing tedious, and my love of drinking craft beer made my decision to instead grow hops relatively easy. Hop cones are a result of their terroir and, like wine grapes, can show considerable variation from year to year, as well as from individual site to site. I am really intrigued by the picking windows of hops in the field and how those aromas transfer into the beer. For us this is a collaborative process. By studying industry data and through conversations and collaborations with brewers, we keep on top of trends."

"New Zealand hop gardens have a unique advantage due to their isolation from other hop-growing nations. We are naturally free of most pests and diseases and this, along with world-class research, allows us to produce quality, spray-free hops with flavors and aromas not replicated in any other part of the world."

—DR. SUSAN WHEELER

Opposite page: (top left) Dr. Susan Wheeler at Hop Revolution. (top right) Fields at Freestyle Hops in the Sunrise Valley. (middle right) Bruce Eggers examining his special blend at Freestyle Hops. (bottom left) Hop Revolution's Tapawera Hop Garden. (bottom right) Training young bines at Hop Revolution.

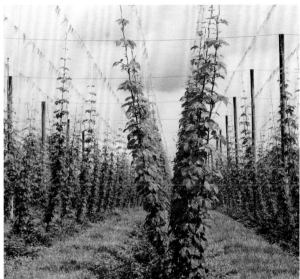

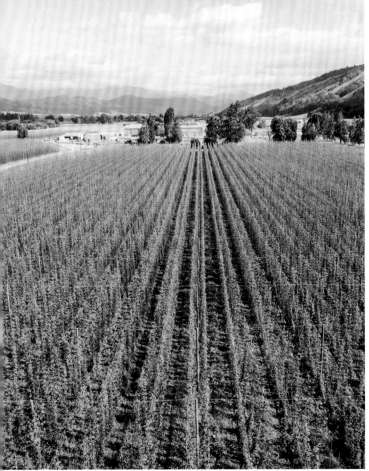

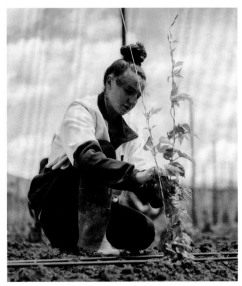

New Zealand has been fortunate to have produced hop varieties over the last nearly thirty years that still resonate with craft brewers of today. Dr. Susan Wheeler continues, "We work closely with brewers to help determine whether a new hop variety has potential. All brewers are looking for hops with distinct flavor profiles, be it more tropical or berry focused than the current varieties. However, experiments on the interaction of the hops with specific yeasts and when in the brewing process the hop is utilized are necessary to fully realize the potential of new flavor profiles of promising varieties."

Freestyle Hops is another independent hop grower whose collaborations with like-minded craft brewers around the world influence how they grow the most flavorful and aromatic hops their amazing terroir allows. "We seek unique and appealing flavors. Nothing more and nothing less," says Dave Dunbar of Freestyle Hops. "That said, our terroir seems to lend itself toward complex citrus, wine-like, and tropical fruit characters. As such, many of our selections have those attributes."

Located in the thriving artisan community of Upper Moutere just outside Nelson, Freestyle Hops is also home to Hāpi Research. Hāpi Research is a collaborative development program supporting the sustainable growth of craft beer and hop farming. Hāpi Research is driving benefits for New Zealand's premium hops and craft beer industries through an advanced cross-industry hop-breeding program, precision farming and processing techniques, and international market collaboration with leading craft breweries such as Garage Project, Hill Farmstead, and Sierra Nevada.

"The goal in everything we do is to deeply collaborate with great brewers to collectively push the art and science of hops to new heights," says Dave Dunbar. "We're a niche producer and the beauty of partnering with a craft brewery is that we can really chase exciting flavors and not be focused on a specific profile or characteristic. As a beer drinker, I love the emergence of highly hop-forward beers across varying styles. They often share a truly complex character, intense aromatics, and wonderful mouthfeel."

CROWN RESEARCH INSTITUTE

More than 95 percent of the proprietary hop varieties grown in New Zealand today have been developed by a government-owned Crown Research Institute called the New Zealand Institute for Plant and Food Research. Its dedicated hop-breeding program dates back to the late 1950s, and today they license all their varieties through a partnership with NZ Hops, Ltd.

Australia

FROM THE FIELDS: Eclipse (see page 110) • Galaxy (see page 128) • Vic Secret (see page 220)

Hops have been cultivated down under ever since William Shoobridge brought his hops over from England to Tasmania, Australia, in 1822. It was his son Ebenezer who then established Bushy Park Estates in 1865, and thus began the spread of distinctly Australian varieties throughout the beer world. Today, Hop Products Australia, or HPA, operates Bushy Park Estates and, together with their Rostrevor Hop Gardens and Buffalo River Valley farms in Victoria, now cultivate 90 percent of all Australian hops. Not only are they the largest hop grower in Australia, they are backed by a team of experts in plant breeding, farm operations, customer service, and brewing support and are an independently managed part of the world's largest hop broker, BarthHaas.

HPA handles all phases of breeding, cultivation, and processing, which makes them unique. "There are some structural differences between our hops and those produced in other growing regions around the world," says Simon Whittock, manager of agronomic services and head of the hop-breeding program at HPA. "We also have more concentrated farming operations that we control all aspects of—from the crossing of cultivars all the way through to the final package. This allows us to process our crop quickly. However, the primary point of difference is that our hops have been developed for and grown exclusively in the Australian environment.

> "Now that the fruity hop genie is out of the bottle, we are seeing multiple hops deliver these fruit-forward characteristics. Beer styles like NEIPAs would find it hard to succeed in the absence of these hop-derived characters."
>
> —SIMON WHITTOCK

The extreme weather events of Australia create a lot of variability in horticulture— severe frosts in early autumn and late spring, extreme temperatures in summer, and high winds and extreme rainfall during the growing season all impact cultivation. Having farming operations that are fully irrigated allows HPA to even out a lot of seasonal variability, and their ability to crossbreed specific varieties that can be grown sustainably and adapt to this environment is imperative.

Initially, hop breeding in Australia was all about bittering hops. This was during a period of time when processing and packaging was changing. Lucky for us all, a newfound ability to preserve high levels of alpha acids came along. By processing cones into hop pellets that could be easily stored between annual hop harvests, hop fields no longer

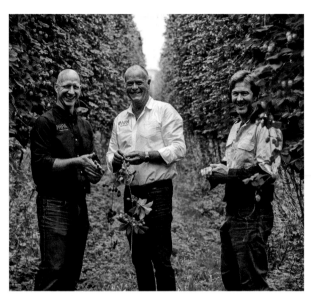
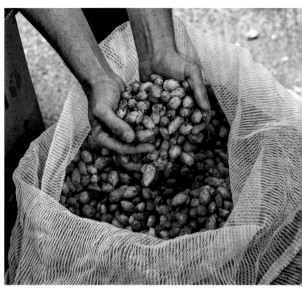
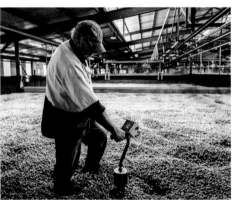

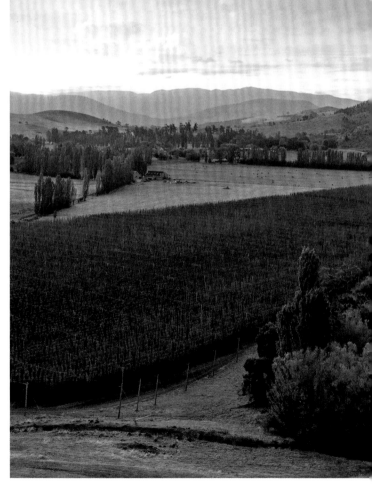

had to be dominated by various bittering hop varieties and could now be limited to a much smaller footprint of a high-quality, high-alpha variety. This led to the development and deployment of one of Australia's own first celebrated varieties, known as Topaz (see page 218). This revolutionary hop also marked the beginning of a pivot away from bittering hops toward fresh new flavor hops that could now be grown on the open fields.

Over the past ten years, the next generation of graduates from the HPA hop-breeding program have come to forever change the landscape of brewing. Proprietary hops such as Eclipse, Ella (see page 118), Enigma (see page 122), Vic Secret, and the breakthrough golden child, Galaxy, are now sought-after by brewers and beer drinkers the world over for their distinct, fruit-forward hoppiness.

These high-impact flavor hops do tend to exhibit a certain similarity in an analytical sensory profile that has become synonymous with Australian hops. Bright, bold, fruity flavors with delicate floral, evergreen, and spice notes are what set Aussie varieties apart and certainly set the standard for what's to come.

"Our outlook for new hops over the next ten years is still based around yield, adaptability, and impact in beer. The varieties to be released in the next ten years are already in our program now," says Simon Whittock. "We aim to maintain a genetically diverse pool of commercially interesting, experimental varieties that are well characterized in terms of their horticultural performance and a believable, reproducible flavor descriptor. We are focused on growing proprietary hops that offer the brewer and a beer drinker something that might not be available from any other hop in the global market."

Opposite page: (top left) Owen Johnston, Tim Lord, and Simon Whittock at HPA. (top right) Fresh Galaxy hops. (middle left) Taking measurements in the kiln with a moisture probe. (bottom left) Inspecting cross pollination sleeves. (bottom right) HPA hop fields in Victoria.

Oregon

FROM THE FIELDS: Nugget (see page 180) • Strata (see page 208) • Willamette (see page 232)

Hops have been grown in the United States ever since the days of the Pilgrims. Terrified of running out of beer at the end of their long journey to the New World, passengers began threatening mutiny and as a result got kicked off the *Mayflower* earlier than expected at Plymouth Rock; the rest is history. Hop cultivation quickly began soon after settlement in Massachusetts and, like the early settlers themselves, spread throughout New England, New York, and eventually west through the Ohio Valley, Wisconsin, California, and eventually finding one of its favorite resting spots in Oregon.

Thanks to massive ice age floods, rich volcanic and glacial soil from eastern Washington state was deposited across the valley floor of western Oregon. When the waters of these Missoula floods subsided, the Willamette Valley we know today came to be an extremely fertile area for all types of farming. A massively productive agricultural zone, the valley was widely publicized from the mid-1800s as a promised land of agricultural prosperity. The area often became the destination of choice for the oxen-drawn wagon trains of emigrants traveling west on the Oregon Trail. It was during this era that hop production began and quickly grew from the 1850s to become the largest hop-growing region in the United States in the 1900s, beating out and eventually shuttering the hop fields of California and New York.

It was in 1900 that first-generation hop farmer Albert Crosby planted the first hops in the rich soil outside the town of Woodburn—soil that is still producing what came to be known as Crosby Hops today. Blake Crosby, the current president and CEO, is the fifth-generation Crosby in hops to carry on the family's farming tradition. They now cultivate over six hundred acres of estate-grown Crosby hops. In 2012, Blake led the family to invest heavily in a new vision for the farm that left behind the days of a highly commoditized alpha-hop business and instead welcomed a sharp focus specialized on exceptional quality aroma hops, processed into pellets on site. This new business model grew rapidly with the craft beer industry over the last decade. Today, the family business has a global footprint and a robust hop merchant-processor, which complements the family estate-grown hops and legacy spirit of Crosby Hop Farm.

Opposite page: (top left) Field views at Crosby Hop Farm. (top right) Freshly kilned Strata hops. (middle right) The Willamette River running beside hop fields. (bottom left) Blake Crosby at Crosby Hops. (bottom right) Jim Soldberg evaluating a new experimental variety at Indie Hops.

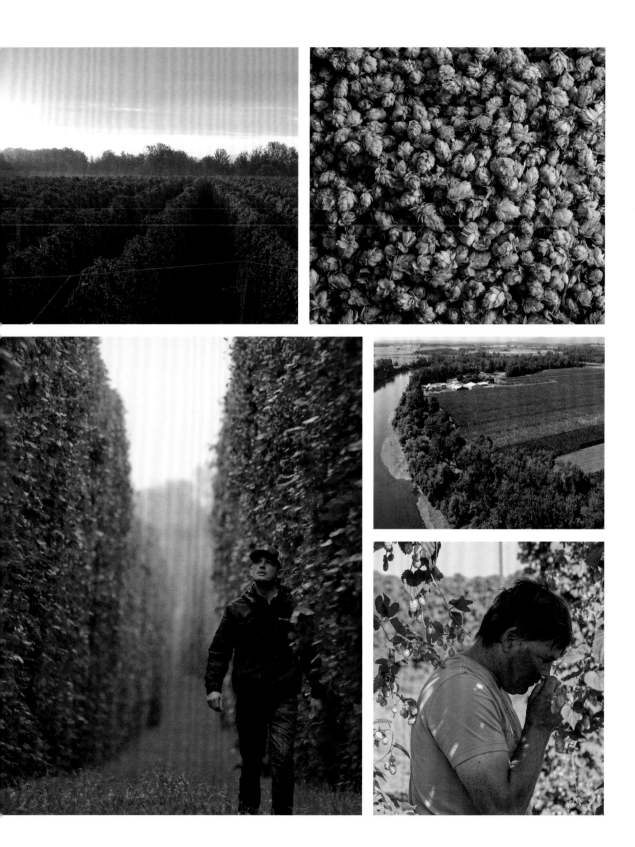

> "The craft beer industry and hop industry are innovating together at such a fast pace. I'm excited to see the 'new guard' of hop growers stepping up to the plate to meet the demand for modern and desirable hop profiles while critically thinking about their impact on the environment and how to be good stewards of the land."
>
> —BLAKE CROSBY

"We grow, process, and market hop varieties with a focus on overall hop aroma intensity," says Blake Crosby. "Brewers want intensity and impact with new and innovative hop varieties. It's no secret that New England IPAs have really put hop varieties front and center in both brewers' and consumers' eyes. Now we're seeing a resurgence in breweries putting a focus on West Coast IPAs again, but not the 1990s malt-forward IPA we all remember, but an evolved, tropical, and citrus-forward style that brings aspects from NEIPA incorporated in a West Coast format. With this trend making a comeback, we're seeing a spike in demand for varieties such as Centennial, Amarillo, Cascade, and Chinook being used alongside new-wave hops such as El Dorado, Idaho 7, and Strata."

Released in 2018, Strata in particular has set a new standard for the new wave of Oregon hops. This game-changing variety is the result of a partnership between the hop-breeding program at Oregon State University and Indie Hops. Cofounders Roger Worthington and Jim Solberg started the Indie Hops Flavor Project in 2009 to explore new opportunities for Oregon-grown hops and ensure Oregon-based breeding was focused on the craft beer marketplace.

"We're convinced the expansion of craft beer and breweries will continue into more communities around Oregon, the United States, and the world. The community-based nature of craft beer and breweries is simply something people want and enjoy," says Jim Solberg. "Flavorful beer will always be a big part of this community, so we became dedicated to all the efforts that go into developing new Oregon flavors of hops. This starts with our breeding program, then continues with propagators and farms to maximize flavor development in the fields, and finally through processing efforts to lock in the great hop flavor so that brewers have top-shelf ingredients to utilize year-round."

With a continued focus on USDA public varieties and a passion for new varieties and state-of-the art-processing, the future of Oregon hops is in good hands. This next chapter of hop development and sustainable farming will keep the legacy of Willamette Valley thriving for generations to come.

Yakima Valley

FROM THE FIELDS: Cascade (see page 70) • Citra (see page 86) • El Dorado (see page 116)

Welcome to hop heaven. The Yakima Valley is one of the most important hop-growing regions in the world and accounts for roughly 80 percent of all hop field acreage in the United States. The chance combination of perfect climate, ideal day length, fertile volcanic soil, and critical irrigation make this area of eastern Washington state a hotspot for hop agriculture and breeding.

The Yakima Valley is essentially a desert caused by the rain shadow effect of the Cascade Range. While the rain and snow does not reach the valley in large quantities, it is captured in the Cascades and in a series of reservoirs and irrigation canals that transport the stored water to the Yakima Valley for irrigation during the summertime. Eager farmers flocked to the area once this irrigation was firmly established in the 1860s, planted the first hop crops in the 1870s, and never looked back. This area has been the top hop-producing region in the United States ever since surpassing Oregon in the 1940s.

TOTAL UNITED STATES HOP ACREAGE

According to the USDA National Agriculture Statistics Service, total US hop acreage more than doubled over the past ten years and is now at an all-time high of more than sixty thousand acres that produce over 110 million pounds of hops annually.

Today, many of these original family farms are still in operation. "Most hop growers in the Yakima Valley are multigenerational, and we are no different," says Claire Desmarais of CLS Farms. "I am a fifth-generation hop farmer. My great-great-grandparents came from Quebec, Canada, along with many other families here, which is why many of us have French last names."

CLS Farms is one of many in a long line of family farms cultivating some of today's finest hops in Yakima Valley. They are also the creators of some of the newest and most interesting varieties being grown there, including El Dorado, Medusa (see page 158), and Zappa (see page 234). "Zappa and Medusa are 100 percent *Neomexicanus* hop varieties that are native to the Southwestern United States," says Eric Desmarais, hop breeder and fourth-generation farmer at CLS Farms. "*Neomexicanus* is a wild-growing and completely different hop subspecies. It is considered a true American hop, and we are proud to grow them commercially."

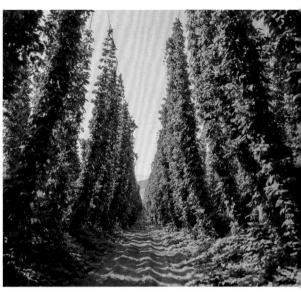

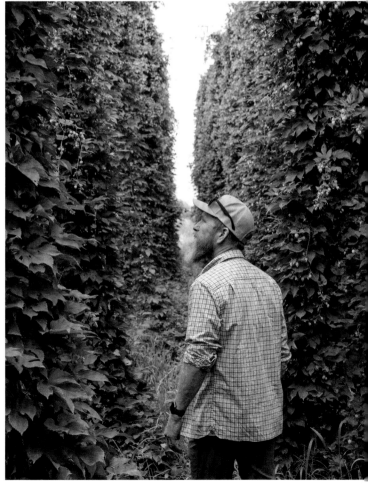
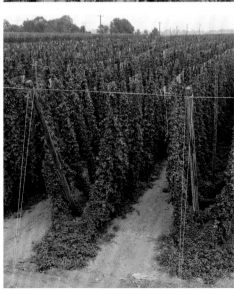

The Yakima Valley is not only home to true American hops, it's also home to true American trailblazers known as Yakima Chief Ranches (YCR). YCR has emerged from the valley to become a top global supplier of premium hop products. They curate and manage a 100 percent grower-owned network of more than forty-five family farms across the Pacific Northwest.

Founded by the Carpenter, Smith, and Perrault families a little over thirty years ago, all from multigenerational hop-growing families, the founders shared a vision of revamping the hop supply chain by selling their hops directly to brewers rather than through the conventional dealer/broker channels. Part of this new model was the start of a hop-breeding project under the direction of Chuck Zimmerman to develop new hop varieties with improved agricultural and economic efficiency. This breeding program has evolved, and today YCR and the Hops Breeding Program (a joint venture between Yakima Chief Ranches and John I. Haas) are responsible for creating some of the world's most prolific new hop varieties, including Simcoe (see page 200), Mosaic (see page 160), and Citra. They continue to change hop history with their ground-breaking genetics and breeding prowess.

"The consumers demand for a flavorful drinking experience and the brewers technical and artistic ability to satisfy this demand is what we as growers are all responding to."

—JASON PERRAULT

"As a breeder, one of my goals is to find that new flavor or function that even the brewer or drinker didn't know they wanted or was possible," says Jason Perrault, lead hop breeder for Yakima Chief Ranches. "Any new hop variety must add an equal level of value across its function, flavor, aroma, and farming efficiency. I can appreciate the drive for fruity character in beer and love that we are finding ways to derive that from hops."

As acreage continues to increase, new hops continue to be bred, and new technologies advance the industry, the Yakima Valley is at the forefront of innovation, quality, and the pioneering spirit that drives not only American hop cultivation, but ultimately craft beer—an industry that would not be where it is today if not for the hops that arise from this valley.

Opposite page: (top left) Claire Desmarais at CLS Farms. (top right) El Dorado hops growing at CLS Farms. (middle left and bottom left) Arial field views at Perrault Family Farms. (bottom right) Jason Perrault assessing his organic Citra hop bines.

The Other Ingredients

Hops alone can't make a beer. Beer is the result of a wonderful alchemy of natural raw materials. And like master chefs in the kitchen, brewers must intimately understand all the components of their recipes in order to create the best finished products. To that end, hop farmers and brokers along with grain farmers, maltsters, yeast suppliers, and even public water-treatment facilities have all developed meticulous standards in order to provide the best ingredients for concocting the finest liquid gold. Here's the rundown on the hops supporting cast.

Water

WHAT IT IS: Two parts hydrogen, one part oxygen, water is the primary medium in which beer is brewed.

THE BIG PICTURE: The unsung hero of the brewing process, water accounts for upward of 95 percent of the finished product. Although water is often overlooked by the average consumer, brewers are seldom as indifferent to the water profile of their beers as the individuals who drink it. Before the invention of complex water-treatment technologies, there weren't many options when it came to altering water. Many of the most celebrated beer styles evolved simply due to the local water profile. Czech Pilsners (see page 197) famously use soft water, while Irish Stouts (see page 167) benefit from the drying sensation of the high sulfate content in the water of Dublin. Just think, if it wasn't for their locally sourced water, many major breweries wouldn't even exist!

Today's brewers don't have to rely on local water because they can engineer the water they want through technology. A host of unwanted contaminants such as bacteria, metals, and pesticides are removed through water-treatment methods, including activated carbon and reverse osmosis filtering. Brewers also regularly monitor and adjust pH, alkalinity, mineral profiles, and temperature of the water that goes directly into making a beer, otherwise known as product water.

A basic product water mineral profile includes calcium, magnesium, sodium, chloride, sulfate, and bicarbonate. Each of these minerals impacts the brewing and fermentation process differently and is precisely adjusted using one or several brewing salts.

WHY IT MATTERS: Left untreated, water can lead to a variety of negative results. From harmless things, like disgusting off-flavors, to more serious concerns such as toxicity, water treatment is a vital component to ensuring a safe and consistent beer brewed to style.

Grain

WHAT IT IS: Although most beer is made from cereal grains such as barley, wheat, rice, and corn, the list of grains that creative fermenters are utilizing is vast, including millet, spelt, buckwheat, rye, oats, sorghum, farro, quinoa, and spelt—and the list goes on.

THE BIG PICTURE: When referring to grain in beer brewing, you have likely heard the term *malt* used. Malt is cereal grain that has been steeped in water to promote the germination that activates its enzymes. After germinating, the sprouted grain is then kilned with hot air to dry it and halt the growth. The length of time and temperature at which the grain is kilned determines the malt color, as well as the degree to which it is toasted as measured by the Maillard reaction (think of bread in a toaster). Some grain is even roasted like coffee and is generally found in Porters and Stouts. A brewer's choice of malt is truly only limited by their imagination.

Despite the seemingly infinite options, barley is by far the most popular grain for brewing beer. Not only does it have ample starch reserves, but the outer husks of the barley kernals also make an ideal filtration bed. Malted barley is generally divided into two types: "2-row" and "6-row" and named for the arrangement of kernels on the barley plant's head when viewed from above. Most craft brewers choose 2-row as the "base malt" for its versatility in all styles of beer. A base malt represents the majority of fermentable sugars for a brew and is usually lightly kilned to only approximately 2 degrees Lovibond, which is a color measuring scale. Brewers may also add a specialty malt in smaller quantities in order to augment the base malt and add complexity to the beer. By contrast, these other malts may be hundreds of degrees Lovibond.

WHY IT MATTERS: During the brewing process, grain starch reserves provide the sugars that drive the production of alcohol by yeast during fermentation. Regardless of the grain that is selected for fermentation, it is the starch brewers are after; enzymes will convert it into fermentable sugars during the mashing process. These enzymes are activated during the malting process.

SRM

Malt selection is the largest determinant to the final color of the beer. Short for Standard Reference Method, SRM is a widely used reference scale originally adopted by the American Society of Brewing Chemists in 1951 as "Beer-10" and defined by "10 times the absorbance at 430nm of a clear (turbidity-free) sample of beer with a light path length of 0.5 inches or 12.7 times the absorbance in a sample with a path of 10mm." In much less technical terms, SRM is a scale used to specify the color intensity of a beer, as shown below.

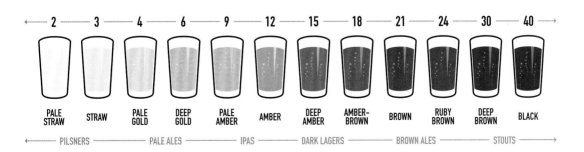

2	3	4	6	9	12	15	18	21	24	30	40
PALE STRAW	STRAW	PALE GOLD	DEEP GOLD	PALE AMBER	AMBER	DEEP AMBER	AMBER-BROWN	BROWN	RUBY BROWN	DEEP BROWN	BLACK

PILSNERS ——— PALE ALES ——— IPAS ——— DARK LAGERS ——— BROWN ALES ——— STOUTS

Yeast

WHAT IT IS: Yeast is a single-celled fungi that is responsible for fermentation, a biological process that brewers harness to produce alcohol.

THE BIG PICTURE: It's important to understand yeast is a living organism. Although there are many strains of yeast that exist, both wild and lab-cultured, we are largely interested in brewer's yeast. *Saccharomyces cerevisiae* (top-fermenting ale yeast) and *Saccharomyces pastorianus* (bottom-fermenting Lager yeast) are the two primary strains of yeast used by brewers. *Brettanomyces* is a genus of wild yeast and the principal yeast used in wild beer styles.

In most cases, yeast is purchased commercially or grown from an existing live culture. Different yeast strains possess specific characteristics that brewers account for when calculating recipes, and brewers select their yeast strain depending on the particular beer style they're brewing. *Pitching*, or adding, yeast is a complicated process that requires many considerations, such as the amount, temperature, oxygenation level, and other variable characteristics. Different yeasts emit different compounds during fermentation. For example, German Hefeweizen yeast is famous for contributing notes of banana, bubblegum, and clove, while French Saison yeast (see page 121) is known for its spicy, peppery aromas. In the case of "spontaneous" beer styles such as Lambic (see page 133), brewers actually allow wild yeasts from the air and other naturally occurring fauna and flora to naturally enter the wort and spontaneously cause fermentation.

WHY IT MATTERS: Ask the craft beer professionals, and they will tell you, brewers don't make beer, yeast does. In the wrong conditions, an otherwise perfect yeast pitch can get stressed and emit unpredictable off-flavors that ultimately compromise the performance of the yeast, leading to inappropriate flavor and aroma characteristics. In some cases, a poor yeast pitch may fail to fully ferment, or worse, may never begin fermentation at all.

ABV

ABV, or alcohol by volume, is the proportion of alcohol to the total volume of liquid—it's the strength of a beer. The more malt (and adjuncts) used in making a beer, the more sugars the yeast can eat, and the more alcohol the yeast puts out. A higher ABV beer is typically sweeter, more full-bodied, and carries more "heat" in its finish.

Adjuncts

WHAT IT IS: Technically, adjuncts refer to any nonmalted source of fermentable sugars. This can include fruits, vegetables, and sugars such as honey and maple syrup, as well as unmalted grains, such as wheat, oats, barley, and rye.

THE BIG PICTURE: Like it or not, the world's bestselling beers (Budweiser, Miller, and Coors) are American adjunct Lagers. They all use a significant amount of adjuncts, primarily rice or corn syrups. Today, however, as craft brewers continue to experiment with new recipes, adjunct has come to refer to almost anything added to beer—fermentable or not. Lactose (milk sugars), vanilla, coffee, and chocolate are now used to create desserts in liquid form called Pastry Stouts (see page 167) and Milkshake IPAs (see page 115). The list of ingredients finding their way into beer recipes grows daily, from breakfast cereal and donuts, to pizza and ice cream, to even oysters.

WHY IT MATTERS: To some, adjuncts are an abomination to the sanctity of brewing, to others they may pose health risks (think lactose intolerance), but to a new era of rabble-rousers, adjuncts open up a world of creative opportunities and freedom in brewing to expand the independent spirit of craft brewers.

THE BEER PURITY LAW

Historic regulations used to govern all aspects of the Bavarian beer industry. In 1516, the most famous of its laws—*Reinheitsgebot*—stipulated the only ingredients permitted in beer production were water, hops, and barley. It wasn't until 1906 that yeast was added as the fourth approved ingredient, perhaps because there was less understanding of microorganisms in medieval times, although yeast was known to brewers and sometimes deliberately used.

The Brewing Process Demystified

Brewing takes preparation and skill, time and patience, precision and artistry, and, above all, craft. Perhaps this is why the earliest brewers were women—high priestesses thought to be divinely inspired to brew by the goddesses of their cultures, be that Ninkasi (Sumerian), Ceres (Roman), or Mbaba Mwana Waresa (Zulu). Brewers are equal parts scientist, artisan, and guardian as they concoct and check recipes, source and prepare ingredients, and ensure their equipment is clean and safe before they brew. Pressurized vessels, boiling liquids, corrosive chemicals, electrical hazards, and sharp moving parts are just some of the dangers brewers negotiate throughout the delicate brewing process.

Easier to replicate but harder to master, the steps outlined here break down and simplify the fundamentals of this intricate process. The first three steps are known as *hot-side*, and the last three are *cold-side*.

Hot-Side

1. MILLING/MASHING

Grain is milled prior to mashing, crushing the kernels to access starch reserves contained inside. Then, much like preparing tea, the grain is steeped in warm water (152°F is a common mashing temperature) for a period of time (thirty to sixty minutes is common). This process triggers enzymes to convert the complex carbohydrates (starch) of the grains into simple, fermentable sugars. The resulting "tea" is a concentrated sugar solution known as *wort*. It is during this step that the finished body, color, and ABV of the beer are largely determined.

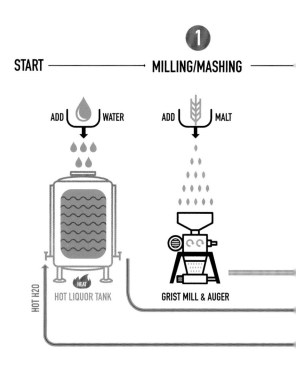

START ——————————→ MILLING/MASHING ——

ADD WATER ADD MALT

HOT H2O HEAT HOT LIQUOR TANK GRIST MILL & AUGER

2. LAUTERING

Lautering is the process of separating sweet liquid wort from solid spent grains. Liquid wort filters down through the bed of grain husks and a false bottom grate and is pumped into the boil kettle. As the liquid fill level drops, the submerged grain husks are revealed, allowing brewers to begin the *sparge*. Sparging is simply the sprinkling of hot water (169°F is common) over the exposed grain bed to rinse residual sugars into the run-off of wort—maximizing the sugar content necessary for yeast to consume later.

3. BOILING

Once transferred to the kettle, the wort is brought to a boil (212°F). Boiling accomplishes several things: It sterilizes the wort to kill unwanted microorganisms; it ends the starch conversion to fix the sugar content; and it coagulates the proteins so they can be separated out post-boil. Finally, boiling wort provides an ideal environment to add hops for bitterness. After the boil is finished (usually after forty-five to ninety minutes of boiling), the wort is circulated in a whirlpool motion to collect residual solid matter, such as hop debris and coagulated solids. This *whirlpooling* separates and settles this residue in the center of the vessel as a shallow cone-shaped pile called *trub*.

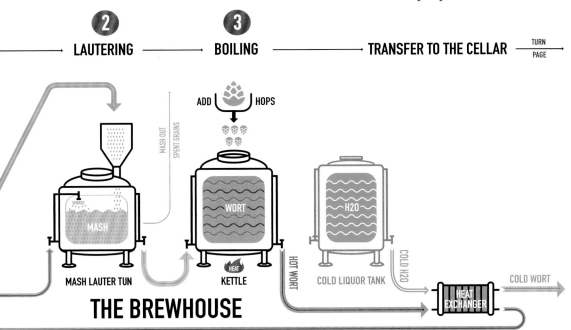

2 LAUTERING — **3 BOILING** — **TRANSFER TO THE CELLAR** TURN PAGE

ADD HOPS

MASH OUT
SPENT GRAINS

SPARGE

MASH

WORT

H2O

HOT WORT

COLD H2O

COLD WORT

MASH LAUTER TUN

KETTLE
HEAT

COLD LIQUOR TANK

HEAT EXCHANGER

THE BREWHOUSE

Cold-Side

4. FERMENTATION

After boiling and whirlpooling, the wort is cooled and aerated with oxygen en route to the fermentation vessel. Here, yeast is pitched, and over the course of several days, this living organism replicates itself and consumes all the sugar—transforming it into CO_2 and alcohol. Brewers must monitor a host of indicators, including temperature, pressure, gravity, and pH during fermentation, which can take anywhere from about three to five days for ales and about five to twelve days for Lagers. Once the yeast finishes its feeding frenzy, the wort becomes beer.

5. CONDITIONING/AGING

After the primary fermentation is complete, there is still much to do. Fresh green beer is often *racked*, or transferred, to conditioning tanks—Lager is transferred to horizontal tanks, ales to vertical tanks. During this stage, cellar workers may use various fining and filtration methods to remove any residual particulate matter from the beer. Decisions are also made regarding additional dry-hopping, adjuncts, secondary fermentation, barrel treatments, and other aging techniques. Finally, the beer is accurately carbonated to specific levels just before packaging.

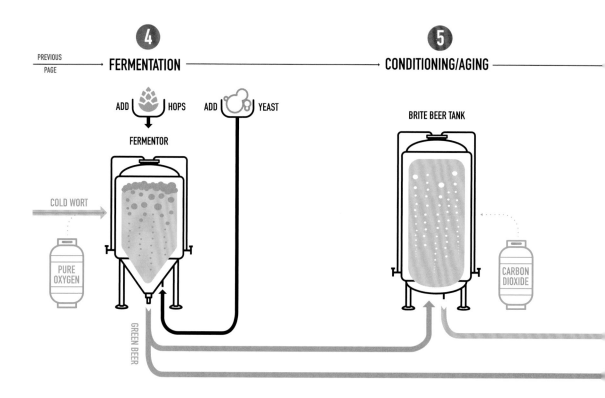

6. PACKAGING

Unless serving directly from brite, or serving, tanks, finished beer is generally sealed in kegs, bottles, or cans. Bottling and canning lines are highly engineered, assembly-line operations meticulously calibrated to prevent microbial infection, maintain proper carbonation, and minimize the pick-up of additional oxygen, which increases the rate of aging and decreases shelf-time. This is a critical last step; all the hard work of brewers and cellar workers means nothing if packaging technicians infect or oxygenate the beer during packaging.

Now the beer is ready to be shipped, sold, sipped, and savored by all. Cheers!

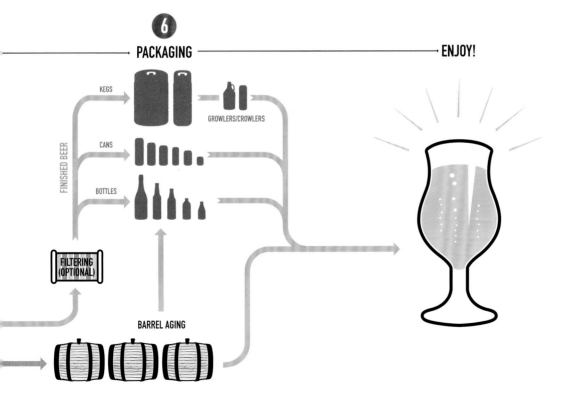

Hop Additions Explained: First Wort to Dry-Hopping

When, how much, at what temperature, and for how long a brewer incorporates hops into their brewing process will determine the final bitterness, balance, saturation, and complexity of all the nuanced hoppy aromas and flavors that are sought after in today's craft beers. Brewers can choose to showcase the unique traits of an individual hop, or they can combine different varieties to develop a complex kaleidoscope of tastes and aromas. Here are the most common ways hops may or may not be added in chronological brewing order.

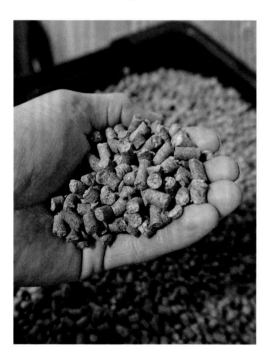

FIRST WORT ADDITION: When bittering hops are added to the kettle prior to boil, this hop addition steeps in the wort while lautering. The hops remain in the kettle throughout the boil, resulting in what many perceive as a smoother, more pleasant bitterness.

BOIL ADDITIONS: Bittering hops are added to boiling wort in the kettle and boiled on average for sixty minutes to create bitterness. Heat activates or isomerizes the alpha acids in them, altering their chemical composition to make the alpha acids soluble in water. The longer hops are boiled, the more of their potential perceived bitterness is expressed, albeit with less flavor and aroma. On the other hand, finishing hops, generally aroma or dual-use varieties, may be added later in the boil so more of the oil content will remain, thus providing additional flavor and aroma characteristics.

IBU WARS

In the late 1990s and early 2000s, a fierce but friendly competition emerged among brewers who began to push the boundaries of boil additions, sparking an IBU eruption that spewed mouth-puckering IPAs surpassing 100 IBUs throughout the American craft beer landscape—devastating countless palates in its path.

WHIRLPOOL ADDITION: Brewers may choose to add hops post-boil while whirlpooling the wort. Whirlpool additions prioritize hop oils over alphas. Since the wort has ceased boiling, considerably lower temperatures will isomerize less alpha acids, allowing more of the essential oil content of the hops to be preserved.

DRY-HOPPING: To intensify flavor, hops are often added to fermenting and/or conditioning beer. Because no heat is present, more of the essential oils of the hops are imparted into the beer—maximizing hoppy resins, flavors, and aromas. How long the hops are in contact with the beer depends largely on the various techniques and equipment used, with seemingly no limits to the actual dry-hopping rates (pounds of hops added per barrel of beer). Once all the hoppy oils have infused into the beer (over the course of one to several days), the hops are then removed. Dry-hopping can take place at one or multiple stages (fermenting and/or conditioning), once or at several different times (think double or triple dry-hopped beer) for even more assertive flavors. When hops are added during active fermentation, they trigger a complex and mysterious process known as *hop biotransformation,* where new and otherwise unattainable flavor and aromatic compounds are achieved through the symbiotic interaction between the actively fermenting yeast and the hop oils.

GAME-CHANGING GADGETRY

Innovative engineers are hacking the dry-hopping process with new inventions that pack in even more hop character. From custom dry-hopping ports for manually dumping hops to hop cannons that use pressurized, external vessels to efficiently extract every last bit of hop oil, brewers now have plenty of options to quench consumers' insatiable demand for extra hoppiness.

WET-HOPPING: Though dried and pelletized hops are the most commonly used products, brewers can instead add copious amounts of freshly picked whole-cone hops. When done correctly and ideally within twenty-four hours of the hop harvest, wet-hopped beers tend to offer more fresh and vibrant flavors from the unadulterated natural oils.

HOP CREEP

Dry-hopping in the presence of active yeast can trigger an unwanted secondary fermentation that can be harmful to beer. This unexpected and still-unsolved mystery has been attributed to the excess release of certain enzymes found in the green flower matter of the hops during the dry-hopping process. Hop creep can be monitored and controlled with extended conditioning times but can significantly delay production, increase alcohol content, and/or create undesirable off-flavors. If hop creep goes unnoticed and beer is packaged, hop creep can even lead to a serious hazard—creating explosive levels of CO_2 pressure inside bottles and cans.

Craft Beer Appreciation 101

Now that we know how much time and energy goes into getting that hoppy beer in front of us, we wouldn't want to disrespect all the people responsible for its creation by carelessly chugging it. We want to savor and understand the endless palette of flavors and aromas emanating from its frothy crest. To truly appreciate a beer, we must consider several key elements: proper glassware, correct pouring technique, and sensory analysis. We've done the learning, now let's get to the fun part—drinking!

Good Glassware

Believe it or not, one's selection of glassware is critical to properly experiencing this liquid that so many hop and beer-industry professionals gave their blood, sweat, and tears for. The beer glass size and shape matter a lot. Thankfully, the design of craft beer drinkware has become a big part of the culture, and there are now countless unique glassware types and designs used to serve beer.

For starters, the stronger a beer, the smaller the serving size. A Double IPA with an 8.5 percent ABV should be served in a smaller glass than a Pale Ale with a 5 percent ABV to account for their disparity in strength. Furthermore, the shape of a specific type of glassware is functional, its geometry impacting how we evaluate appearance, aroma, and flavor. Knowing a few design archetypes will prove instrumental for your glassware selection.

BASIC: TUMBLERS AND PINTS

These universal, cylindrical, and typically sixteen-ounce glasses line the majority of bars and are the default choice for many styles (though the large serving sizes are not appropriate for stronger beers).

CONICAL OR SHAKER: Down and dirty but gets the job done. Don't hate on these for being simple.

NONIC: Small bump for added strength and comfort makes these pub pints a fine choice for any sessionable beer.

TULIP PINT: Curved taper and squatter stature is a practical all-around choice and commonly used for serving Porters and Stouts.

WILLI BECHER: A narrow streamlined appearance with some flare that has become a go-to glass for session ales and modern Lagers.

BOUJEE: TULIPS AND STEMWARE

The elegant design and often smaller serving sizes of this group of stemmed glassware make them the ideal choice for an array of ales, IPAs, and many imperial styles.

STEMMED TULIP: These glasses possess an inward taper at its midsection that perfectly captures different aromas, while its outward taper at the rim supports a frothy head.

TEKU: A proprietary Rastal design take on the classic tulip shape. The modern look with stemmed and unstemmed versions has given rise to the popularity of this glass for NEIPA and other modern IPA styles.

GOBLET OR CHALICE: Famous in Belgium with a bowl design that promotes great head and aroma.

SNIFTER: The tapered rims not only concentrate aromas, they also force the head on itself, thickening the head to make it creamier and ideal for Imperial Stouts, and Barleywine particularly.

BOLD: TALL AND SLIM

Having a slender design to a glass allows for better release of carbonation and also supports head foam—making it ideal for all types of light-bodied beer styles.

POKAL: This sleek design may be tapered or more bulbous but this vessel is defined by the short stem and broad base it rests upon to present a classic choice for German and Belgian styles and a fresh choice for versatility and swagger.

PILSNER OR WEIZEN VASE: Similarly tall and curvaceous with narrow bases, these wide mouth glasses (extra wide for Weizens) capture big head aromas and makes for easy drinking of any light Lager and wheat beer.

FOOTED PILSNER: The long, narrow shape of this glass highlights pale colors, its outward straight taper supports beautiful foam, and its footed base design adds a touch of class.

STANGE: Slender and straight-up "stick" design is ideal for more delicate styles (famous for serving Kölsch) to help intensify carbonation, aromas, and flavors.

BADASS: MUGS AND SEIDELS

Having a nice handle to grip onto not only feels great but these classic designs are thick, sturdy, and typically hold a lot more volume than the rest of the pack.

DIMPLE JUG: A classic British design originally intended for bitters and cask ales, this glass is making a comeback with Pale Ales and hoppy Lagers.

TANKARD: These glass beasts are based on historical ornamental steins (steins are earthenware, not glass), synonymous with beer halls and Oktoberfest, and perfect for session ales or Lagers.

Proper Pouring

You've procured the finest IPA in all the land, meticulously selected the perfect glass from which to consume it, and are ready to transfer the liquid. Pouring beer, a highly respected and coveted profession these days, isn't quite as simple as it looks. Beer style, carbonation, temperature, pressure, equipment hygiene, and glassware type and cleanliness are just a few of the many considerations a beer-tender must negotiate in real-time in order to pour the perfect pint. Lucky for all you new hop-kids on the block, here's the basic step by step:

BEER CLEAN

Everything begins with a *beer clean* glass, which means it has been thoroughly washed, sanitized (by chemicals or heat), and cold-water rinsed prior to filling. This can be checked in one of several ways. Prior to filling, one can assume a glass is clean if water evenly coats and sheets off the inside after dipping it in water. After filling, undeniable evidence a glass was not properly cleaned is the clinging of CO_2 bubbles to the inside of the glass. A beer-clean glass supports proper foam retention and is evidenced by well-defined foam rings, or lacing, (see page 61) as you drink.

Step 1. We're gonna have so much fun.

Grab your freshly popped can (or tap handle) in one hand and put a beer clean, freshly rinsed, room-temperature glass an inch or two away from it in your other hand at a 45-degree angle.

Step 2. There's still so much to do.

Aim for the middle portion of the side of the glass and begin to pour at a moderate pace hitting the same exact spot as the beer flows. If the beer is poured too slowly, it can become flat and bland. When poured too quickly, it can turn into a foamy mess.

Step 3. Let the foam go free.

Continue to pour until the glass is slightly more than half full, then gradually begin leveling out the glass and bringing it to an upright position. Be sure to tilt the glass back at a pace to match the flow of beer and continue to pour in the middle of the liquid to create the proper amount of foam as the glass becomes full.

HOP HEAD

Creating proper foam when pouring is paramount to releasing carbonation and especially hop aroma. Because our sense of smell highly influences our sense of taste, beer head is a vital component to flavor and should not be an afterthought. The style of a beer and personal preference will determine how much is proper, but a few inches of creamy froth will always present nicely. Hops play an added role in head retention, with recent studies attributing hop acids to improving overall hold, structure, and even lacing.

Step 4. Time to finish the pour.

Timing is key to perfectly synchronizing the glass getting back to its upright, 90-degree position just as the last drop of beer hits the top of the fresh foam. Always ensure proper foam because it not only helps release volatile hop aromatics for our olfactory pleasure but it looks great. And never touch the can to the glass or submerge the tap in the beer.

Step 5. The time has arrived . . . to drink.

Tasting Tips

The beer has been poured and we're ready to drink. Before we can knock one back with the gravitas of a true hophead, we must use our senses to evaluate all the deliciousness that's about to go down. While we obviously employ our gustatory system (taste), we must also use our sense of sight, smell, and a special touch called mouthfeel in order to fully enjoy all aspects of this glowing masterpiece. This is all very personal and very subjective, so don't feel ashamed of what you might prefer over others. It's all good!

To enjoy any beer, we must first relax. Set and setting play a huge role in our overall experience of just about everything. Get comfortable, grab some good friends, and maybe even throw on some good music so your sense of hearing doesn't feel left out. Now, we are finally ready to mindfully appreciate the drink.

 APPEARANCE: First, note the color, perhaps compare to an SRM color spectrum to hone in. Is the color appealing? Is it hazy or clear? Also note the carbonation and foam retention character and clarity. *Does it all look appealing?*

 AROMA: Now take a few short sniffs of the beer and don't be afraid to get your nose right up to (but not in) the head. Take note of any familiar smells. Far more sensitive than the human sense of taste, olfactory signals can trigger memories and emotions. Pay attention to both traditional orthonasal olfaction, where aromas are experienced through the nostrils, and retronasal olfaction, which refers to experiencing aromas in the back of the throat, where the brain processes them more like flavor. *Does it all smell tasty?*

 FLAVOR: Now it's time for a sip. Start small, allowing the liquid to remain in your mouth. Correlate the flavors, if possible, to the aromas you experienced, noting sweetness, bitterness, and acidity. The five flavor categories most often described as established are sour, sweet, salty, bitter, and umami (savory). Start with the hops and think about each of these categories when distinguishing their complex flavors. Then remember the other ingredients of yeast, grains, and adjuncts and try to pick any flavors they may provide. *Does it all taste delicious?*

 MOUTHFEEL: Most aptly defined as the physical sensation of beer in one's mouth, mouthfeel seeks to describe body, carbonation, creaminess, level of alcoholic warming, and astringency. Is it thin or full? Flat or effervescent? Do you feel the alcohol warming your mouth? *Does it all feel good?*

 AFTERTASTE: Finally, evaluate the aftertaste. Does it linger or dissipate? Is it refreshingly crisp or lingering sweet? Did you notice any sharp astringency or was it smooth? *Does it all go down nicely?*

 REPEAT: Now give the beer a little swirl to release some more aromatics before you start from the top again, and again, and again. . . .

Common Off-Flavors

With all this goodness happening, there is some bad news we need to come to terms with: Not all beer is created equal and some will even be bad. How bad? Well, some foul flavors are bad enough to pour a beer down-the-drain-bad.

If you've ever had the pleasure of a leisurely stroll through a botanical garden, you're keenly aware Mother Nature has bestowed upon us a seemingly infinite menagerie of olfactory blessings. Unfortunately, if you encounter a bird's rotting carcass in this enchanting garden, you immediately recognize this blessing as a two-way street. Such is the world of craft beer, where invisible chemical reactions can determine whether we experience such things as ethyl butyrate, which is most often described as bubblegum and tropical fruit flavors, or its constituent butyric acid, which unfortunately most resembles the aroma of a baby's vomit. Here are the nastiest of no-no's you may encounter as you navigate the (beer) gardens.

MBT AKA SKUNKY

HOW IT PRESENTS: Mercaptan (see "Thiols," page 17) is a chemical family responsible for the foul-smelling sulfur compound that's added to odorless natural gas so leaks can be detected. It's also responsible for the nasty spray you might experience if you startle a skunk. So, if you can recognize either of those odors, that's pretty much what a skunky beer smells like. Some drinkers may enjoy a little subtle skunkiness or *lightstruck* in certain styles, but by and large skunked beer is flawed.

WHY IT HAPPENS: If you expose beer to high energy light wavelengths (350 to 500 nm), like sunlight, it chemically reacts with the isomerized humulone compounds in the alpha acids of the hops to create the chemical 3-methyl-2-butene-1-thiol (MBT), which is part of the mercaptan family. Green and clear bottles are most susceptible to skunking, so keep those out of the sun because it can happen faster than you think.

DMS AKA CREAMED CORN

HOW IT PRESENTS: DMS (dimethyl sulfide) is a sulfur compound that tastes like creamed corn and/or canned vegetables in lighter color styles or more tomato soupy in darker color styles. Although considered acceptable in trace amounts in some light Lagers, this is generally an off-flavor to be avoided.

WHY IT HAPPENS: Most commonly caused by failing to boil wort long enough or with a vigorous enough boil, this off-flavor is a direct result of a precursor related to malt kilning, with lighter-kilned malts possessing more SMM (s-methyl methionine) and thus more vulnerable to converting to DMS.

DIACETYL AKA BUTTERY

HOW IT PRESENTS: A natural by-product of fermentation, diacetyl is so universally described as buttered popcorn that it's what is added to some food snacks to mimic that exact flavor. In beer it's no different, but these caramel and butterscotch flavors are rarely desirable (except for in a few British styles and even then only in trace amounts).

WHY IT HAPPENS: After primary fermentation is complete and while conditioning, yeast is still actively consuming residual diacetyl, effectively scrubbing out these unwanted, buttery off-flavors. If this "diacetyl rest" period is not allowed to run its course, the beer is vulnerable to this off-flavor. If, however, this butteriness is accompanied by acidity, it is often the result of a bacterial infection instead.

ACETALDEHYDE AKA GREEN APPLE

HOW IT PRESENTS: Never appropriate in beer, acetaldehyde is a chemical compound created during fermentation that is essentially a precursor to alcohol. It is best described as having the aroma of green apples, fresh-cut grass, and even green leaves.

WHY IT HAPPENS: A defining characteristic of young or green beer, this off-flavor is often the result of an incomplete fermentation or not allowing a beer to fully condition.

ACETIC ACID AKA VINEGAR

HOW IT PRESENTS: Almost never a welcoming flavor, this sharp, harsh, vinegary sourness is even an off-flavor in most Sour beer styles.

WHY IT HAPPENS: Poor sanitation in a brewery's production process leaves beer vulnerable to infection by acetic acid—producing bacteria, like acetobacter, which turns a perfectly palatable beer into undrinkable acrid vinegar.

OXIDATION AKA CARDBOARD

HOW IT PRESENTS: Oxygen, time, and temperature all contribute to degradation in beer. One of the most predominate off-flavors associated with oxidation is wet cardboard, a tell-tale sign of stale beer.

WHY IT HAPPENS: Beer gets exposed to oxygen during production. When the exposure surpasses certain thresholds, this exacerbates the formation of the compound trans-2-nonenal, which is responsible for this papery off-flavor.

SHELF LIFE

Many of the packaged beer cans and bottles you buy are shelf-stable, meaning they can last at room temperature for several months. Some styles can even be aged or cellared for years. That being said, when it come to the hoppiest of beer styles, freshness has become a factor. Heavily hop-forward IPAs tend to offer their most vibrant and brightest hoppy flavors when consumed within three to four weeks after production, with nearly all the intended hop flavors in full force for around twelve weeks, if packaged properly and always stored cold. After this three-month window, the hop flavors will simply start to mellow or fall-off, as the malt backbone begins to take over the flavor profile over time. Again, the beer is still fine to drink, and to some may even be more enjoyable.

BEAUTY'S IN THE EYE OF THE BEER HOLDER

Sometimes looks can be deceiving and other times
they can enhance all your other senses. Here's what
to look for when drinking with your eyes:

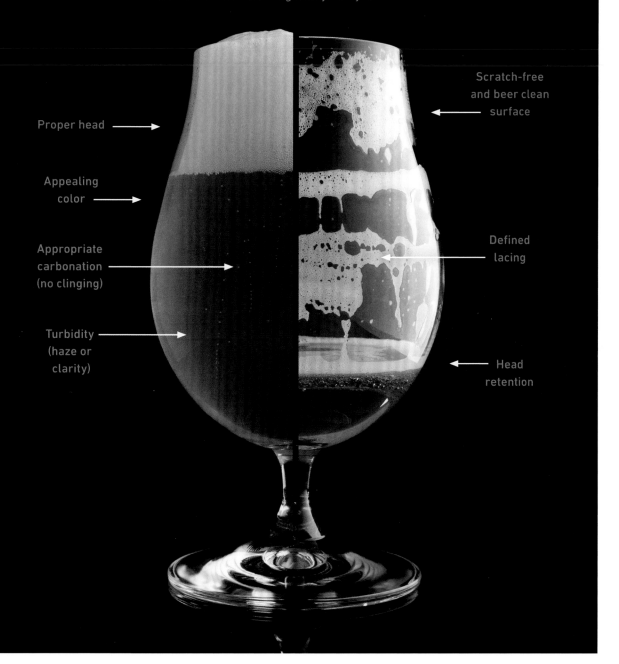

Proper head →

Appealing
color →

Appropriate
carbonation
(no clinging) →

Turbidity
(haze or
clarity) →

← Scratch-free
and beer clean
surface

Defined
lacing

← Head
retention

PART 2:
A GUIDE TO HOPPINESS

Hop Varieties and Beer Styles

Hops are the driving force behind craft brewing. Most of today's most popular and sought-after beers are a direct result of hops. Luckily, creative minds across the planet continue to meticulously cultivate and crossbreed even more fresh hop varieties to feed our insatiable appetite for hop-forward beer. Innovative brewers then incorporate these wonderful ticking hop bombs into liquids that make our tastebuds explode with hoppiness. The following pages guide you through some of the world's best hop varieties and the beer styles that showcase them and all their goodness.

Hop Varieties

Every hop has its own story to tell. Presented in alphabetical order, these profiles unpack the characteristics that make each individual hop so special. The full-color, focus-stacked images give an eye-poppingly high-def visual of their appearance, and the accompanying information provides all the supporting details, including:

NAME: The name given to the hop by the original breeder or grower

DESCRIPTION: An outline of other important distinctions of the hop

TYPE: The classification and country of origin of the hop

SENSORY: The most common primary aromas and flavors specific to the hop

ACIDS: The percent level of alpha, beta, and cohumulone acids in the hop

OILS: Total oil content of the hop in milliliters per 100 grams

USE: How the hop is most commonly used in the brewing process: aroma, bittering, or dual-use (both aroma and bittering)

TASTE IT IN: Beers that showcase the hop

Beer Styles

During our journey through the hop field of dreams, we will also showcase some popular beer styles that feature hops in a variety of leading roles. Each profile highlights the defining characteristics of the beer style while breaking down what makes each one so unique. Here's what we include to help expand your craft beer acumen:

BITTERNESS: Common range of the IBU-measured bitterness of the beer style

COLOR: Common range of the SRM-measured color density of the beer style

ALCOHOL: Common range of the alcohol by volume (ABV) of the beer style

MOUTHFEEL: Typical physical characteristics, including body

CARBONATION: Range of expected CO_2 levels

SERVING TEMP: Ideal temperature range for drinking

SENSORY: Typical aromas and flavors to expect

GLASSWARE: Options for appropriate glassware

DESCRIPTION: An outline of pertinent information about the beer style

Brewery Spotlight

This section spotlights a few eminent craft brewers whose expert insight, wisdom, and hop mastery are legendary.

AMARILLO

Accidentally discovered in 1989 growing wild among the hop fields, the striking yellow lupulin of the Amarillo (*amarillo* means yellow in Spanish) stood out among the other bines where it was found growing. It wasn't until 2003 that Virgil Gamache Farms in Yakima officially released Amarillo, or VGXP01. Their patent states it is most similar to a Yugoslavian hop variety named Buket, citing its high-alpha acid levels and the presence of rare terpenes.

The high oil content of Amarillo has led to widespread late-kettle, whirlpool, and dry-hopping applications that coax distinct overtones of orange, tangerine, and grapefruit from the conspicuously high myrcene content of the hop. Notes of melon, tropical fruit, and peaches are balanced with subdued floral, spicy, and dank elements. This diverse sensory profile correlates with the picking time, with early- to midharvest ripeness yielding the brighter fruity and floral notes.

The relatively low cohumulone content of Amarillo translates to a pleasant bitterness many find less astringent, and Amarillo is often used to add complex citrus elements to a variety of hop-forward American beers. Despite high demand among IPA fanatics and its famously lower agricultural yields, steady cultivation in the United States and Germany has kept Amarillo readily available to the home and commercial brewer alike.

TYPE
New World American
(proprietary)

SENSORY
Citrus, tropical, floral

ACIDS
Alpha 7–11%
Beta 5.5–8%
Cohumulone 21–24%

OILS (ML/100G)
1–2.3

USE
Dual-use, but largely
aroma and flavor

TASTE IT IN
Frothy Brewing Hop Mafia DIPA,
Three Floyd Gumball Wheat Beer

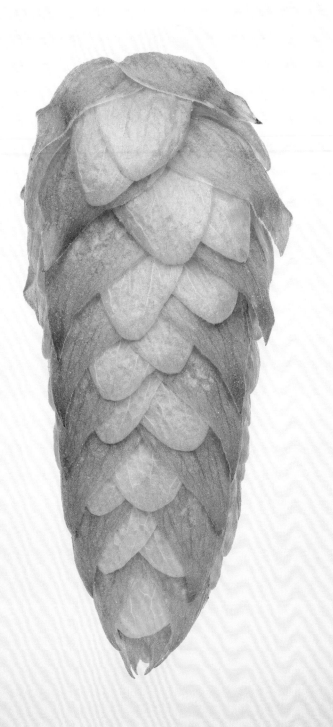

BRAVO

Released in 2006 through New York hop supplier Hopsteiner's integrated hop-breeding program, Bravo is a trusted super-alpha variety. In 2000, Bravo was created in a controlled cross-pollination with a Zeus (CTZ) female and male of Nugget lineage. Developed by Roger Jeske among several potential genotypes in 2002, second-generation testing from 2004 to 2006 eventually led to the Bravo variety currently available today. Known for its vigorous growth, excellent yield, and resistance to powdery mildew, Bravo is a late-harvested, bittering variety with a small but dedicated following.

Amid the aroma hop craze, Bravo works behind the scenes, but its unique aroma profile makes it much more than just your average bittering addition. With fruity, floral, and spicy character accented by stone fruit, orange, vanilla, and candied lime, Bravo packs a pleasant and smooth bitterness. While you may not find many breweries advertising Bravo single-hopped IPAs, it has served as a quiet workhorse in American bitter bombs for more than a decade.

OLD NEW YORK

Before the Yakima Valley became the worldwide leader in hops, New York was the hub for almost all of the American hop production and trade up until the late-nineteenth century, when downy mildew destroyed most of the state's hop farms, and then Prohibition devastated most of the country's beer consumption.

TYPE
New World American
(proprietary)

SENSORY
Orange, candied lime,
fruity, floral

ACIDS
Alpha 15–17%
Beta 3–5%
Cohumulone 29–34%

OILS (ML/100G)
1.6–2.4

USE
Bittering

TASTE IT IN
Captain Lawrence Brewing
Hop Commander IPA,
Yuengling IPL

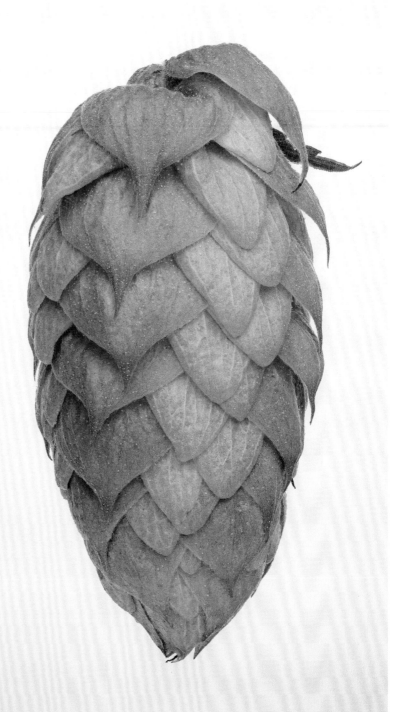

CASCADE

The hop that helped launch the American craft beer revolution, Cascade was developed in the 1960s through the USDA hop-breeding program at Oregon State University by Dr. Stanley Nelson Brooks and Jack Horner. While looking for a hop variety resistant to downy mildew, a major threat to the Cluster hops that dominated American fields at the time, they bred USDA 56013 from English Fuggle and Russian Serebrianka hop genetics.

Named for the nearby Cascade Range, the resulting spicy, floral, citrus, and grapefruit character had potential as an aroma variety, but it would take time to catch on. Thankfully, when Dr. Al Haunold took over the USDA program in 1965, he recognized the potential of Cascade and never gave up on commercializing this special hop. After an unsuccessful attempt by Adolph Coors in 1972 to incorporate Cascade into the Coors portfolio, Fritz Maytag's Anchor Brewing Company became the first brewery to showcase this American aroma hop with their 1975 release, Liberty Ale, which marked the two-hundredth anniversary of Paul Revere's famous ride. Five years later, Ken Grossman (see page 74) launched the Sierra Nevada empire with a Pale Ale that featured generous doses of Cascade. His Pale Ale not only gave rise to a new era of hop-forward craft beers, but to this day it still tops industry experts' lists of all-time best and most important American beers.

Most commonly used for late kettle, whirlpool, or dry-hopping additions, Cascade can have a high enough alpha acid content to also be used for bittering. Its extreme popularity among craft beer enthusiasts has led to the long-term dominance of Cascade among American hop fields, and it continually ranks among the top five hops produced annually.

TYPE
New World American

SENSORY
Grapefruit, citrus, floral

ACIDS
Alpha 4.5–7%
Beta 4.8–7%
Cohumulone 33–40%

OILS (ML/100G)
0.7–1.4

USE
Dual-use, but largely
aroma and flavor

TASTE IT IN
Sierra Nevada Pale Ale,
Founders Pale Ale

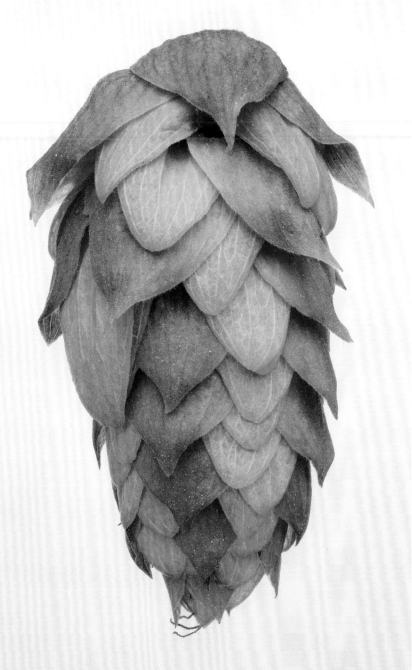

BITTERNESS
30–50 IBU

COLOR
6–14 SRM

ALCOHOL
4.5–6.2% ABV

MOUTHFEEL
Medium body

CARBONATION
Medium to high

SERVING TEMP
45°–55°F

SENSORY
Floral, fruity, pine,
biscuit, tropical

GLASSWARE
Pint, tulip pint
(pictured)

AMERICAN PALE ALE

Before IPAs hijacked the American craft beer revolution, APAs were the darling of hopheads and outsold all other craft beer styles. In the 1980s and 1990s, as more American aroma hop varieties became available to American brewers, they realized the potential for adding unique fruity notes through late-addition hopping. It did not take long before classics such as Sierra Nevada Pale Ale were born, subsequently moving the American craft beer culture from monotonous American commercial Lagers to hoppy craft ales.

APAs are gold to amber, standard-strength ABV, top-fermented ales that have both nice hop bitterness and solid hop aroma and flavor. APAs generally have a medium body, medium carbonation, and often use specialty grains to add complexity to the expected notes of bread and toast from the supporting malt backbone used to balance the strong hop presence. Counterbalancing the grain aromas are the predictably fruity notes associated with American and New World hops—citrus, tropical fruit, berries, melon, and stone fruit.

While there is a good chance the first Pale Ale most old-school drinkers tried is from Bass Brewing from England, the American Pale Ale is an entirely different animal, with bittering and aroma hops exuding not just fruit character, but pine, resin, and marijuana traits. These hop-forward ales aren't as bitter or aromatic as American IPAs but they definitely still pack a punch, making them a perfect gateway beer when entering the wonderful world of more hoppy styles. There is no shortage of delicious APAs commercially available, but Sierra Nevada Pale Ale is still the tried-and-true bestselling example. If you're looking for a more contemporary take, try Hill Farmstead Edward for an unfiltered APA that's masterfully crafted in New England with a plethora of American hops.

SIERRA NEVADA BREWING COMPANY

Ken Grossman
founder and owner

FOUNDED: 1980

BREWERY LOCATION: Chico, California (1980), and Mills River, North Carolina (2012)

FIVE FAVORITES: Bigfoot Barleywine-Style Ale, Celebration Fresh Hop IPA, Hoptimum Triple IPA, Pale Ale, Torpedo Extra IPA

Ken Grossman started Sierra Nevada with a hand-built microbrewery and the odds of success stacked against him competing with the large-scale commercial breweries that dominated the beer industry at the time. In 1980, his patchwork of pipes, pumps, and tanks began making beers that forever changed the course of American craft brewing. His legendary Pale Ale pioneered a beer revolution and helped launch hops to stardom. Ever since, Sierra Nevada has continued to set the standard for craft brewers worldwide with their countless innovations in the brewhouse, their commitment to and advances in sustainability, and their wide variety of world-class beers. Today, Sierra Nevada Brewing Company is still 100 percent family owned and operated as they continue to push boundaries of independent craft beer and business. The pioneering spirit that launched Sierra Nevada now spans both coasts with breweries in Chico, California, and Mills River, North Carolina—making Sierra Nevada Brewing Company one of the largest independently owned breweries in the world.

How did you get started in beer making?

I was intrigued by the allure of the alchemy of brewing—the ability to take the raw bitterness of hops, the sweetness from malted barley, and the magic of yeast to bring flavor nuances and joy to the finished product. My very first brewing experiment was as a young teenager in 1969 using canned grape juice and baking yeast, and ever since I've continued to

experiment with brewing. Beer is not only my livelihood, it's my family and my family's business as well.

What inspired you to experiment and showcase American hops at a time when no one was embracing them?

My interest in hops goes back to my first visits to the Yakima Valley in 1976, where I went to buy hops just after I opened my home brew shop. I wanted to see firsthand the hop farms, and I fell in love with hops early on. In those early days I attempted to buy every variety that was grown, which at the time wasn't that many. Up until that point, the American crop was primarily Cluster, and then Cascade got picked up by some of the family farms. Cascade was sort of the first American-bred aroma hop. And with our Pale Ale, I wanted to do something unique and distinctive and American, rather than using European hops. So we featured Cascade and used a lot

of it and that started Cascade on its path to wider acceptance. A few years later, Centennial came and we featured it in our Celebration Ale in 1981. Both of those hops still have a pretty big place in the United States brewing industry, even though there are lots of new ones that have been developed since then.

We started growing hops on our property nearly twenty years ago now. I got into growing hops primarily so people could understand what they were. Most people had no clue what hops looked like, so I planted a few acres and then we expanded it. I got a picking machine, and we got more serious about it. The area between the Sacramento Valley and the foothills of Chico, California, where our brewery is located, was actually a hop-growing region up until the early 1980s. We still have some of the original rootstock growing in our fields that we originally acquired from farms I visited in California. We're continuing to keep those varieties alive.

When you started Sierra Nevada, there wasn't a real craft beer scene. How did that movement get started?

Between 1978 and 1981, there were six of us that started up, sort of as the new generation. And by 1982, I think there were seven or eight, but a number of those original six had already gone out of business. There was a lot of turnover, and it was a challenging time to try to get a business going, figure out how to make quality beer, educate the consumers, and educate the wholesalers. The consumer today is so far advanced from the consumer back then. The average beer geek today knows more than all the brewers did back in the 1980s when there was very little public knowledge. You had to seek out information on things such as different hop varieties, which meant you really had to be passionate about your profession and learning about it. We spent a lot of our time both learning and educating.

A sort of revolution started on the West Coast and Colorado. Boulder Brewing was on that first wave, but all the rest of us were from California. A little bit later Seattle, Washington, Portland, Oregon, and a few of the "cool" cities in the West started seeing more small breweries. It was all really localized and based around what was happening with food and wine and a bit of the back-to-the-land movement with bakeries and coffee roasters. All of this happened around the same time and more craft beer was being made, and we were part of that. Consumers were seeking a different kind of connection, with more locally sourced foods and beverages.

Did using American hops set you apart?

Back in the early days we used only American hops. We made the decision to do that from the very beginning. If I'm going to make American beers, I had to use American hops.

But we didn't have a lot of options when we started—we could use Cluster, Bullion, Brewer's Gold, Northern Brewer, or Cascade, and that was pretty much the whole industry in the United States. We decided Cascade was best suited for our Pale Ale because it offered a lot of flavor without high levels of bitterness. Since Cascade's flavor was off-putting to many beer drinkers at the time, there weren't many big breweries using much of it. Thankfully, we didn't have to compete to buy our hops—they were easy to get and of high quality. In 1983, I remember that Cascade got to five to six dollars a pound back then, which was double or triple the previous year. That's when we started to use contracts so we would be assured of supply. But in those early years, somebody could always help out a small brewer with a few bales.

Later on, Centennial and Chinook came along. The original American Chinook was a great dual-use hop, so you could use it for bittering, and it had a nice aroma. Centennial was referred to as "the super Cascade." It had a little bit more rose character, but it was a hop that had a good following, and it still does. We expanded and explored other beer styles over the years, and we now utilize hops from nearly every hop-growing region in the world but still primarily use American hops and continue to use American hops in our original lineup. Today, there are so many new varieties hitting the market, and some of them are really interesting. Some smell really great when you rub them, but they don't taste as good when you brew with them. You've got a whole palette of hops you can choose from today. And you don't need to do a single-hop version because you can expand the range of aromas by a judicious blending of different hop varieties to pick up some additional interest.

I remember some of the early IPAs we did. We wanted to do a special Christmas beer. I had a bale of Centennial hops that I picked myself at a baby hop yard up in Yakima, meaning a first-year hop yard. They were beautiful, small cones just full of lupulin and really wonderful aromas. I dry-hopped an IPA with them, and I will never forget how much I loved the character and the blend of Cascade and Centennial aromas and flavors. That became a staple for us. We brewed it right at hop harvest time and called it Celebration Ale.

You actually designed your own special dry-hopping equipment, correct?

I started designing what would eventually become our "Hop Torpedo" when we were trying to expand Celebration Ale production. One of the limitations we had was the amount of dry-hopping-capable tanks we had. So, I started fooling with a new piece of equipment that could be attached to our existing tanks. The idea started as a napkin sketch for a device that would boost hop aroma without adding more bitterness. We built the sketch and the Hop Torpedo revolutionized dry-hopping. Beer circulates out of a fermenter, flows through the column of hops, and back into the tank. By adjusting the time, temperature, and speed of circulation, we can control the aromas and flavors in a finished beer. A lot of our beers now get "torpedoed."

CASHMERE

Another outstanding addition from the lineup of Washington State University's publicly available hop offerings, Cashmere is a dual-use variety that really shines as a later aroma hop addition. Released to the masses in 2013, Cashmere is the lucky daughter of a female Cascade and male Northern Brewer—both well-known, heavy-hitting hop varieties in craft beer. Cashmere's exotic and intense aroma profile sets it apart from other publicly available hop varieties. Tropical fruits such as coconut, melon, and pineapple are present. Stone fruit and citrus are also present, including peach, tangerine, lemon, and lime. Finally, an herbal element, bordering on spice, helps balance the otherwise fruit-forward Cashmere.

Living up to its name, Cashmere's low cohumulone levels result in a delicate and smooth bitterness that allows its unique sensory profile to shine through. Breweries seeking that smoothness are producing many stellar Cashmere-hopped styles, including Saisons, Sours, and plenty of modern IPAs.

TYPE
New World American

SENSORY
Tropical fruit,
citrus, spicy

ACIDS
Alpha 6.9–10%
Beta 3.5–7.1%
Cohumulone 22–24%

OILS (ML/100G)
0.5–1.8

USE
Dual-use

TASTE IT IN
Revision Brewing
Hazy Life NEIPA,
Tree House Brewing
Company Cachet DIPA

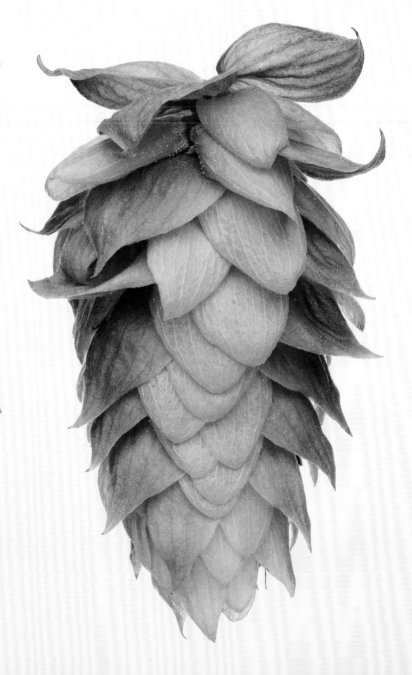

CENTENNIAL

Developed in 1974 and released in 1990 by Chuck Zimmerman and S. T. Kenny at Washington State University, Centennial is a dual-purpose hop often referred to as a "super Cascade" because it possesses similar citrus characteristics but with considerably more alpha acids for bittering. Brewers appreciate its versatility, and craft beer drinkers cannot get enough of the intense citrus, floral, and pine characteristics. Named for the state of Washington's one-hundredth anniversary, Centennial's stellar reputation has earned its spot among the classic American C hops, joining Cascade, Chinook, and Columbus (CTZ).

Centennial's complex sensory profile has notes of lemon, vanilla, orange blossom, and dankness, and many believe it to be an excellent substitute for any of the other C hops. The presence of cis-rose oxide, an oxygenated hydrocarbon contained in Centennial's essential oils, might be responsible for its uniquely fruity and herbal aromas.

Brewers have put hop farmers' hard work to good use, creating a menagerie of delicious concoctions that exploit Centennial's dual-use capability for bittering, flavor, aroma, and dry-hopping. Centennial is without question among the most popular hops in American craft beer history and perhaps one of the best examples of its application is Two Hearted Ale from Bell's, which uses 100 percent Centennial hops as both kettle and dry-hopping additions.

TYPE
New World American

SENSORY
Citrus, floral, dank

ACIDS
Alpha 9.5–11.5%
Beta 3.5–4.5%
Cohumulone 29–30%

OILS (ML/100G)
1.5–2.5

USE
Dual-use

TASTE IT IN
Bell's Two Hearted
Ale, Dogfish Head
60 Minute IPA

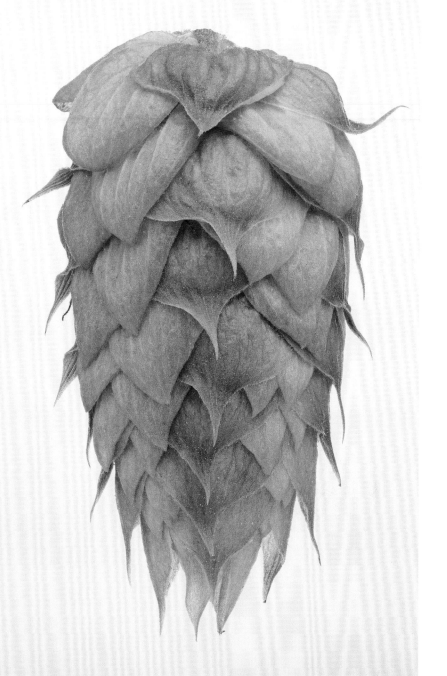

BITTERNESS
50–70 IBU

COLOR
6–14 SRM

ALCOHOL
5.5–7.5% ABV

MOUTHFEEL
Medium-light to
medium body

CARBONATION
Medium to high

SERVING TEMP
45°–50°F

SENSORY
Floral, citrus, fruity,
pine, resin, dank

GLASSWARE
Pint, custom tulip pint
(pictured)

AMERICAN IPA

American India Pale Ale is unquestionably hop-forward—a modern innovation that encompasses the independent spirit of American beer and culture. While the roots of the style lie in English India Pale Ale (see page 215), Anchor Brewing Company Liberty Ale may be the first IPA brewed in America after Prohibition. However, the first American beer actually labeled as an IPA was from Bert Grant's Yakima Brewing and Malting Company in 1983. But it wasn't until the advancement of all-American aroma hops in the 1990s that then-unknown breweries such as Lagunitas, Stone, and Bell's (among many others) pushed the limits of hop additions—crafting aggressively hopped and uniquely Americanized IPAs that revolutionized a new craft beer industry.

American IPAs are all about showcasing classic American hops. Intense New World hop aromas can be vast and often present as citrus, fruit (tropical fruit, stone fruit, berries), pine, and/or resin (dank, marijuana). Although they can get quite boozy, the higher ABV specimens are reserved for the Imperial or Double IPA category (see page 203). Since hops are the star in these recipes, expect low to medium-low malt character.

As plenty of new and more flavorful American hop varieties become available, it only makes sense that brewers will continue to explore this popular beer style by devising innumerable twists on the American IPA—black, brown, red, white, and sour versions to name a few. Just remember that the American IPA and its derivatives are unquestionably hop-forward and what distinguishes them most from their IPA counterparts is their comparative bitterness. Look for AIPAs perceived bitterness to be medium-high to high, and they should finish dry and crisp.

WEST COAST IPA VS. EAST COAST IPA

IPAs reign supreme. With old school breweries pumping out aggressively hopped, crispy clean IPAs on the West Coast since the days of Biggie and Tupac, it was only a matter of time before East Coast brewers concocted a new style of hopped-up ales they can proudly call their own. Although both are unquestionably American, what distinguishes these two delicious but different IPAs may be more than what meets the eye.

	APPEARANCE	MOUTHFEEL	BITTERNESS	FLAVOR
East Coast	Unfiltered and hazy	Soft and fuller body	Low to medium-high	More juicy, fruity
West Coast	Filtered, clearer (typically)	Crisp, more carbonated	Medium to extreme	More tropical and piney

CHINOOK

Like many wonderful hop varieties, Chinook began at the USDA hop-breeding program at Washington State University and was developed in the famed Yakima Valley. Originally released as a high-alpha bittering variety in 1985, brewers have recently come to appreciate the aroma profile of Chinook enough to put its high oil content to good use in late-boil, whirlpool, and dry-hop additions.

A tenured member of the famous American C hops, the notable grapefruit, pine, and spice flavors and aromas found in Chinook are the stuff of legends. That said, while some report clean and assertive bitterness, others claim that high hopping rates can elicit harsh bitterness and even cat pee aromas in the final beer. In any case, brewers and beer drinkers alike love Chinook-hopped American beer styles from Porters and Stouts to Pale Ales and IPAs, and one need only consider the longevity of Stone Brewing Company Arrogant Bastard for proof.

CATTY

Certain hop varieties may elicit aromas of cat pee and are often described as catty. While this may sound awful, keep in mind that this is a common sensory descriptor and is even associated with many high-quality Sauvignon Blanc wines to describe their funky and/or tangy aroma.

TYPE
New World American

SENSORY
Grapefruit, pine, spicy

ACIDS
Alpha 12–14%
Beta 3–4%
Cohumulone 27–35%

OILS (ML/100G)
1.7–2.7

USE
Dual-use

TASTE IT IN
Arizona Wilderness
Brewing Refuge IPA,
Stone Brewing Company
Arrogant Bastard

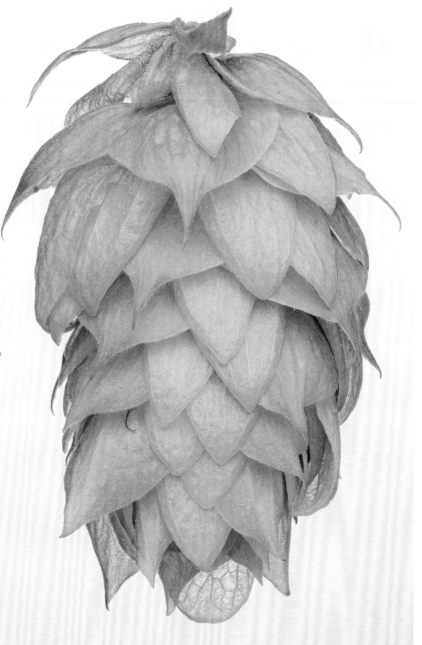

CITRA

Unsurprisingly named for its intense citrus character, the palette of flavors bursting from Citra includes fresh squeezed fruit flavors of peach, orange, papaya, guava, passionfruit, pineapple, lime, and gooseberry. If you've had a craft beer recently, you've most likely already experienced the allure of Citra. Citra, or HBC 394, is, without question, the most popular hop in American craft beer today. Accounting for nearly 20 percent of the total hop production in the United States, it is the most cultivated variety in the country.

Patented by Eugene Probasco and Jason Perrault from the Hop Breeding Company, Citra found its humble beginnings in 1992 as a single plant in their controlled-breeding program in Toppenish, Washington. Its plantings increased to four in 1993, twenty-one in 2003, and then a four-acre test plot in 2007 that was cofounded by Widmer Brothers, Sierra Nevada, and Deschutes breweries. This juicy hop experienced immediate success, with Widmer Brothers winning the gold medal for a Pale Ale featuring Citra at the 2008 World Beer Cup. Citra has since become standard in the American IPA market, and you can find great examples of its use in distro all over the country.

High alpha acids and low cohumulone make Citra a likely candidate for a more pleasant bitterness, but its outstanding oil content sets it apart as an unrivaled dry-hopping addition. Citra-hopped IPAs have become a must-have offering at any craft brewery. Many stellar examples are brewed only with Citra, putting its single-hop versatility and virtues on full display. Citra will forever and invariably be associated with the modern American juicy and hazy craft beer boom.

"The real surprise has been the shift in beer in the last decade-plus. Gene Probasco made the cross that resulted in Citra in 1992. Yet there was not a real demand for that profile, and it was held in the wings until we decided to release it in 2007. I am not sure anyone could have predicted its level of success."

—JASON PERRAULT, COCREATOR OF CITRA

TYPE
New World American
(proprietary)

SENSORY
Citrus, tropical, stone fruit

ACIDS
Alpha 11–13%
Beta 3.5–4.5%
Cohumulone 22–24%

OILS (ML/100G)
2.2–3

USE
Dual-use, but largely
aroma and flavor

TASTE IT IN
Parish Brewing Ghost in
the Machine DIPA, Toppling
Goliath King Sue DIPA

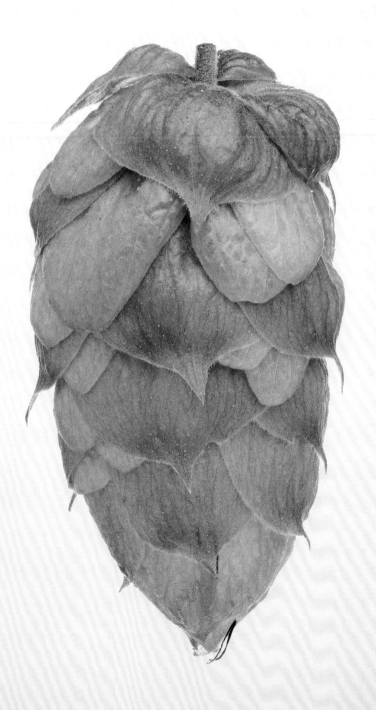

BITTERNESS
30–60 IBU

COLOR
4–7 SRM

ALCOHOL
6–8% ABV

MOUTHFEEL
Medium to full
body, soft

CARBONATION
Low

SERVING TEMP
45°–55° F

SENSORY
Juicy, grapefruit,
tropical, melon, dank

GLASSWARE
Pint, stemmed tulip,
Teku (pictured)

NEW ENGLAND IPA

New England IPA was the natural response to American IPAs uncontrollable IBU outbreak of the 2000s. Thanks in part to new American flavor hops such as Citra and Mosaic hitting the scene, the pendulum began swinging from increasingly bitter, palate-wrecking IPAs to the more approachably smooth and juicy flavor NEIPAs are now famous for. Though NEIPAs evolved organically, many believe early Vermont breweries popularized the hallmark cloudy appearance, including Hill Farmstead Brewery (see page 190) with their special "pillowy" mouthfeel and The Alchemist Heady Topper Double IPA's newfound "drink from the can" mentality that defines the style today.

While Heady Topper is on the more dank bitter end of the NEIPA spectrum, the style has trended to the opposite end—juicy. The overflowing citrus, tropical, and stone fruit flavors and aromas associated with modern New World hops is due to brewers using little to no bittering hop additions in favor of whirlpool and dry-hopping additions. Huge dry-hopping additions, often made before fermentation is even complete, also lend to the characteristic hazy appearance. There are many hazy IPAs that present very high perceived bitterness and crisp mouthfeel; these are not NEIPAs.

NEIPAs are notoriously opaque and typically unfiltered—exhibiting varying levels of particulate matter suspended in solution. They are usually straw-yellow to almost orange in color, as if mocking a glass of pulpy OJ. With different brewers touting different methodologies and standards, high-protein grains such as wheat and oats are often used in brewing to contribute to the soft mouthfeel all New Englanders expect. With super-flavorful aroma hops headlining this show, expect a largely forgettable cameo appearance from the malt. If you're looking to experience some quintessential NEIPAs, Foam Brewing in Vermont and Tree House Brewing in Massachusetts are good places to start. If you want to get out of New England, try any of the fine examples from Monkish Brewing Company in California or Heist Brewery in North Carolina if you can.

DRINK FROM THE CAN

Now a gold standard in packaging, canned craft beer wasn't always a thing. Prior to New England IPA pioneers embracing the tallboy for its airtight, lightweight, light-blocking, and highly recyclable aluminum, the can was reserved mainly for mass-produced Lagers and considered substandard to glass bottles. Not only are cans an ideal glass alternative, they helped NEIPAs travel safely, easily, and with a bigger canvas for beautiful artwork—all helping to get the style noticed, spreading quickly through the trade and changing the perception of this once-frowned-upon vessel.

PARISH BREWING COMPANY

Andrew Godley
founder and owner

FOUNDED: 2008

BREWERY LOCATION: Broussard, Louisiana

FIVE FAVORITES: Attacus Atlas IPA, Canebrake Wheat Ale, Dr. Juice IPA, Envie Pale Ale, Ghost in the Machine Double IPA

Andrew Godley first bucked the system using his hand-built fifty-gallon brewhouse in a region not known for craft beer. As a self-taught brewer with a DIY mentality, Andrew does not believe in limitations on techniques or ingredients; as a result his innovative beers quickly appealed to both light Lager drinkers and die-hard craft beer nerds alike. To meet demand, he built a new brewery and assembled a team made up mostly of people who have never worked in other breweries before. Over the next several years Parish Brewing Company experimented with hops and learned how to use them through their own unique techniques and methods. That critical development time led to their modern and now very popular Double IPA known as Ghost in the Machine, which put Parish on the map in the craft beer world outside of Louisiana. Today, Parish continues to innovate in the industry by doing things their own way, and they are proud of it.

Why do you prefer brewing hazy IPA vs. traditional American India Pale Ale?

Hazy IPAs are just softer and more pleasant, in my opinion. I don't think people like bitterness, but they tolerate it in old-school IPAs because with that bitterness does come some very nice hoppy aromas and flavor. A hazy IPA is like an old-school IPA but with the good parts of the hops (the essential oils) dialed up and the bad part of the hops (the bitterness) dialed down. I may be wrong, but I believe Parish was the first brewery south of New England to sell a hazy IPA when we made Envie hazy and

introduced Ghost back in 2013. We have always called them Hazy IPAs around here because to us it has never been a style being made only in one region. But we are pretty indifferent about what name is used. Hazy, juicy, and New England–style IPAs all mean the same thing to us. I would offer Modern IPA as another option to call these beers. It is nomenclature we use a lot around Parish.

What is your approach to hop selection?

Bitterness is gross and not enjoyable. The juicier the better! We want hops with the maximum oils per kilogram of hops. I call them the super hops, and they include Citra and Galaxy, among others. They all have two or three times the oil content density of most other varietals.

Our goal with hoppy beers is very simple— maximize the good parts of the hops, like the aromatic properties of the hop oils, while minimizing the bad stuff, like astringency, bitterness, and green-grassy properties. We have great relationships with a few hop growers in the Pacific Northwest and work with them to grow, harvest, and provide hops with the greatest amounts of fruity and juicy oils possible. The only way to really assess hop quality is to go up and physically rub hops from every field and lot and find the ones that are perfect for us. Hops become optimally ripe, with the maximum aroma oils desired, in a very small window of a few days. If a field is harvested too early or too late, you miss the window. This is why selection is so important. If you don't work with your hop growers and select the best hops, you will get any old lot that was probably picked early or late, and the beers made will not be as awesome. Not all Citra is the same. Not all Simcoe is the same. We have some extra-fragrant and tropical Nugget that we put in one of our most popular IPAs ever, even though most brewers don't think of

Nugget as a sexy aroma hop. We found it at our favorite farm in Oregon, and there is definitely something about the climate, terroir, and maybe their harvesting method that makes their Nugget particularly fruity.

How have you been able to differentiate yourself in the hop-forward-beer landscape?

In our hop experiments, we thought it would be interesting to see how much we could push the envelope and make something so saturated in hops, it would be a novelty product. We learned about hop biotransformation (see page 53) before it was talked about in the brewing world. We discovered that yeast was creating these awesome juicy and fruity components from the hops through a kind of refermentation if the conditions were right. Many books about brewing beer were espousing

techniques used by the big brewers, and the hopping techniques were what we now call old school. We wanted to differentiate and find our own learned knowledge about the best way to make a hoppy beer. The ability to have the freedom to experiment and not sell an IPA for our first few years was irreplaceable.

Our first IPA was developed as an attempt to create a hoppy beer so intense you would dare your friend to drink it. The first batch we made had ten times more dry hops than any other beer recipe we had ever seen either online or in a book about IPAs. We thought it would be potentially disgusting. The liquid was green like broccoli soup, not like beer. But we were using our biotransformation method of allowing the yeast to actively work and ferment on the hops, and a day or so after dry-hopping the beer, it smelled like a can of peaches and tropical fruit. It was the

best-smelling beer we had ever experienced. The hops dropped out and we put the no-longer-green test batch in a keg. We were all blown away that this novelty beer was such a deviously rich and hoppy liquid that tasted and smelled like a peach-and-tropical-fruit cocktail. That recipe became Ghost in the Machine, and we bottled it for sale about a year later.

As a self-taught brewer, are there any innovative hopping techniques you've discovered?

It is not well known, but several brewers we've collaborated with do know about our "sub iso" technique that we started using with Ghost in the Machine IPA almost eight years ago. The most important place in the brewing process to maximize hop flavor is in dry-hopping. Our goal is to maximize the amount of hop essential oils that are

in solution during and after dry-hopping so that the yeast can metabolize and biotransform these oils into a new and better tropical or citrus mix of oils in the final product. We have two opportunities to add to and maximize hop oils in the beer—once in the kettle and again when dry-hopping in the fermenter. For us, the most important innovation in hopping is how we add hops in the kettle or hot-side. Traditionally, and to this day, most brewers will boil their wort and add hops, just like cooking. We don't do that. We add tons of hops and extracts to the kettle, but we do it at temperatures below where isomerization occurs and we call these *sub iso additions*. We lower the temperature of the wort in an intermediate vessel after boiling and then we add the massive sub iso dose of hops before sending the beer into a fermenter. Without revealing our exact temperature target for sub iso additions, most isomerization slows to negligible rates below 190°F and is almost not existent below 180°F. The result is maximized hop aromas and minimized hop bitterness.

Have any industry trends influenced your perspective on hoppy beer?

Modern IPAs are here to stay because they are better. Old-school brewers used to judge the quality of beer on whether it was clear or not, and that was the big knock on hazy IPAs. But once you get past the arbitrary rule that beer must be clear, you are now in the future and better IPAs abound! I brew what our customers are really excited about, not what the technical beer experts and brewers want to drink.

CLUSTER

Before Cascade began its dominance of the American hop landscape, Cluster was king of the fields, accounting for more than 90 percent of all US hop production from the end of Prohibition to the 1970s. The original C hop is thought to be the result of an open pollination of a European import by a wild American variety. It was then further developed as Early and Late subvarieties named for when the cones mature and ripen. Cluster, more specifically Late Cluster, is considered America's longest continuously grown commercial hop variety.

The Cluster hop plant is known for having great vigor, and its pellets are prized for excellent storability. Sadly, Cluster's popularity has taken a backseat as craft fans flock to beers brewed with hops known for more fruit-forward character. As the unsung bittering hero of many of the most storied beer brands in the United States, Cluster was used in most American beers during its heyday. Today, Cluster still remains a valuable weapon in a brewer's arsenal. It provides clean, neutral bittering with floral, herbal, and spicy flavors and aromas. Cluster is most suitable for ales, Lagers, Porters, and Stouts where a clean bittering canvas is required to allow the malt to shine.

TYPE
New World American

SENSORY
Floral, herbal, resinous

ACIDS
Alpha 5.5–9%
Beta 4–6%
Cohumulone 36–42%

OILS (ML/100G)
0.5–1

USE
Dual-use, but
mostly bittering

TASTE IT IN
Carton Brewing Company
Red Rye Returning,
Double Mountain Brewery
Hazy Clusterf#k IPA

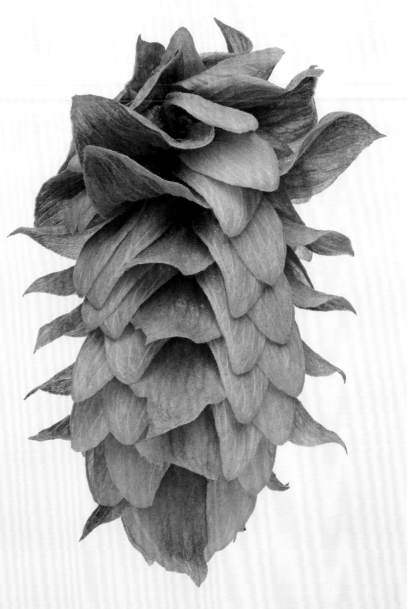

BITTERNESS
5–12 IBU

COLOR
2–4 SRM

ALCOHOL
4.1–5.3% ABV

MOUTHFEEL
Low body;
crisp, clean

CARBONATION
High

SERVING TEMP
33°–38°F

SENSORY
Nearly neutral, crisp,
refreshing

GLASSWARE
Stein, pint,
shaker (pictured)

AMERICAN LAGER

Few beer styles offer the same level of thirst-quenching hydration that one finds in American Lagers. Sure, much of the craft beer elite have attempted to smear the name, but these are meticulously engineered, perfectly balanced, and crushable brewskis. While our first experiences with beer may have begun with giant American Lager brands such as Budweiser, Coors, and Miller, our present-day choices in this category of super-pale, clean and crisp, light-bodied Lagers are nearly infinite.

Born from the Pilsner (see page 197) and Helles (see page 179) style Lagers brewed by German immigrants during the nineteenth century, American Lagers evolved to appeal to those looking for an easy-drinking, refreshing option that wouldn't overwhelm the senses. Highly fermentable adjuncts such as corn and rice are added in large amounts to decrease the body and thin out mouthfeel. Highly attenuating yeast is pitched to guarantee full fermentation, and no residual sugar in the final product further accentuates the dry, crisp mouthfeel synonymous with American Lagers. Above-average carbonation further highlights the drinkability of American Lagers, while its lower hop profile, generally composed of traditional Old World hops, exists only to balance the sweeter adjunct and malt profile.

The American Lager category is a catchall, with the aforementioned large-scale breweries accounting for upward of 80 percent of total beer sales worldwide. However, these beers are no longer the only heavyweights in this category. Today, regional contenders across the country, from National Bohemian of Baltimore and Narragansett of Rhode Island to aspiring newcomers, like Montucky Cold Snacks, are directly competing with big beer. Not to be outdone, other craft beers such as Brooklyn Lager and Stillwater Artisanal Ales Yacht have a strategic, subtle dry hop that adds complexity and dimension to this occasionally maligned category. Regardless of your brand loyalty, the tradition of the American Lager is synonymous with backyard barbecues, ball games, beer pong, and of course, the satisfying lawn mower and shower beer.

COMET

Perhaps no hop variety owes more to the American craft beer revolution than Comet. Selected for breeding by the USDA in 1961 and commercially released in 1974, Comet's commercial production ceased in the 1980s in favor of higher alpha varieties. However, with the exploding demand for aroma hops in the 1990s, this descendant of a variety from England's prestigious Wye College hop-breeding program and the wild American *Neomexicanus* landrace made a triumphant return.

Comet functions as both a high-performing bittering hop and an offbeat aroma hop. Brewers often use it as a late addition to famously entice grapefruit zest and earthy, grassy dankness from its ample oil content. Furthermore, many detect a unique love-it-or-hate-it "wild American aroma" in beers that feature Comet. It works with a wide variety of styles, from Lager and IPA to Farmhouse Ale and Sour Ale. Although annual production is modest, Comet is an old-school hop that offers some of the most unique flavors one can find in hoppy beer.

TYPE
New World American

SENSORY
Grapefruit, grassy

ACIDS
Alpha 9–12.4%
Beta 3–6 %
Cohumulone 34–45%

OILS (ML/100G)
1.4–3.9

USE
Dual-use

TASTE IT IN
Oskar Blues Dale Pale Ale,
Left Hand Brewing Galactic
Cowboy Nitro Imperial Stout

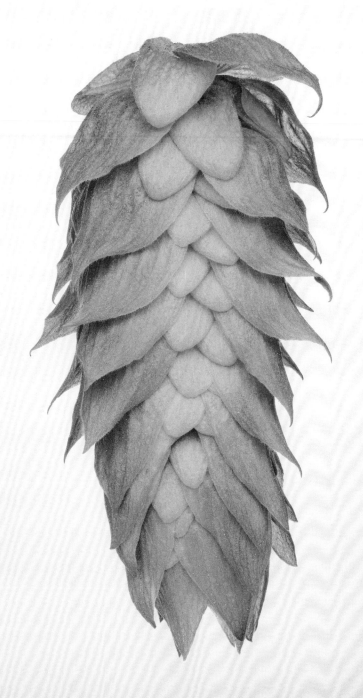

CRYSTAL

Another of Dr. Alfred Haunold's creations originating from the Oregon State University Hops Breeding Program in Corvallis, Crystal was intentionally bred to substitute for German noble hops, specifically the landrace Hallertauer Mittelfrüh. Before America's craft beer revolution, brewers were primarily focused on producing European-style Lagers, using pale or Pilsner malt and noble hops. The problem was sourcing the hops; American hop growers were largely unsuccessful growing noble hops, and importing from Europe could be prohibitively expensive. In 1983, to address this conundrum, Dr. Haunold crossed Hallertauer Mittelfrüh with a male of Brewer's Gold, Cascade, and Early Green lineage. There were four resulting varieties, Ultra, Mt. Hood, Liberty, and Crystal.

While Crystal lacks the fruit-driven nose of many New World hops, its delicate floral and spicy woody elements are anchored by notes of green forest floor. With low alpha acid content, Crystal isn't as popular for bittering additions, but is nonetheless incorporated into a vast array of styles, from IPAs and Lagers to English Bitters, Belgian Ales, and Wheat beers.

> "As more of a complementary hop addition, Crystal has a nice blend of citrus and spice that accentuates what we get from the coriander and Curaçao orange peel that we brew our Allagash White with."
>
> —JASON PERKINS, BREWMASTER AT ALLAGASH BREWING COMPANY

TYPE
New World American

SENSORY
Floral, spicy

ACIDS
Alpha 4–6%
Beta: 5.8–7%
Cohumulone 20–26%

OILS (ML/100G)
0.8–2

USE
Aroma

TASTE IT IN
Allagash White, Creature
Comforts Automatic Pale Ale

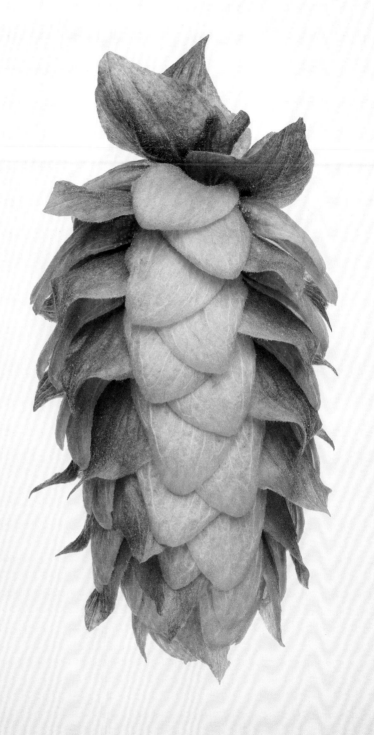

BITTERNESS
10–20 IBU

COLOR
2–4 SRM

ALCOHOL
4.5–5.6% ABV

MOUTHFEEL
Light to medium body;
soft, smooth, creamy, tart

CARBONATION
High

SERVING TEMP
40°–50°F

SENSORY
Spicy, citrus, herbal, peppery

GLASSWARE
Weizen vase,
pokal (pictured)

WITBIER

Known for its characteristic use of coriander, Witbier's origin story dates back more than six hundred years to a time when Belgium's farms and monasteries used locally grown, bittering herbs and spices, instead of hops, to transform the sweet wort into a liquid called *gruit*. As time passed, a shift in consumer tastes and an industry move toward hops led to this style all but disappearing by the mid-twentieth century. That is until a Belgian milkman named Pierre Celis resurrected the style in 1966, adding local grain, hops, milled coriander seeds, and Curaçao orange peel to his original recipe for the now well-known Hoegaarden Original Witbier. Clamor for this cloudy, unfiltered beer went wild, but the larger brewery Celis built to meet demand eventually burned down, and he was forced to sell his underinsured brewery to a company that would ultimately become AB Inbev, the largest beer conglomerate in the world.

Complex and balanced, Witbier, or White beer, has gained popularity in recent times for its refreshing drinkability, light and smooth body, effervescence from high carbonation, and pleasant citrus finish from the introduction of orange peel into the brewing process. Today, Allagash Brewing in Maine produces a remarkable and award-winning Witbier interpretation that's a must-try called simply Allagash White.

"We'd say that the style itself is pretty approachable; it has a nice fruit profile, a really inviting, light golden and hazy appearance, and the orange peel and spice add a little something extra to the flavor," adds Jason Perkins, brewmaster at Allagash Brewing Company. "On our end, we really focus on balance, which, in our heads, means that you can perceive a bunch of different flavors when you drink Allagash White, but you won't necessarily be able to identify them. That balance, for us, means we can keep coming back to the beer again and again and still find something new to enjoy."

Witbiers were the original hazys well before hazy was a thing, but don't anticipate this style to have the hop-forward character of NEIPAs. Instead expect hops to complement the citrus and coriander and provide subtle balance to the multiple grains and wheat. "On the texture side, both oats and wheat add to that lightly creamy texture. Wheat is a part of the beer's hazy appearance and we also don't filter it," adds Jason Perkins. "We also condition the beer in the bottle or can, adding a bit of extra sugar and yeast right before packaging, so the beer comes up to full carbonation inside the can. We recommend that people 'rouse their yeast' before drinking Allagash White—a process that involves inverting the can or bottle before opening and swirling it gently to make sure that any yeast and protein that has fallen to the bottom of the package gets back into solution. In our experience, it really does give you the optimal experience with this beer."

CTZ

CTZ collectively refers to three very similar hop varieties sold under three separate trade names (Columbus, Tomahawk, Zeus); together they represent the second-most cultivated hop in the United States. Originally developed by Charles Zimmerman as part of the USDA hop-breeding program in the late 1970s, the parentage of this hop variety is unknown since it was open-pollinated and seeds collected en masse. Regardless, when released in the 1990s as Columbus, it was instantly in high demand due to its impressive alpha acid content.

Despite demonstrating similar metrics and traits, Zeus has been proven to be genetically different from its counterparts. There have also been patent disputes among several parties that have led to its unique nomenclature.

CTZ hops are late maturing and well-known for high yields, but they do not store well and must be quickly processed into pellets or other concentrates to assist in preventing oxidation. Prized for its bittering capacity, CTZ is also known for pungent hoppy aromas of citrus, balanced with herbal, spicy, and dank back notes. CTZ is a high-alpha hop with high oil content that provide brewers flexibility in their applications, be it bittering, finishing, or dry-hopping. Your local bottle shop will undoubtedly have countless examples of CTZ-hopped beers, from IPAs and APAs to Porters and Stouts.

TYPE
New World American

SENSORY
Citrus, spicy, herbal

ACIDS
Alpha 14–17%
Beta 4–6%
Cohumulone 28–32%

OILS (ML/100G)
2–3.5

USE
Dual-use

TASTE IT IN
Anderson Valley Hop
Ottin' IPA, Grey Sail Flying
Jenny Extra Pale Ale

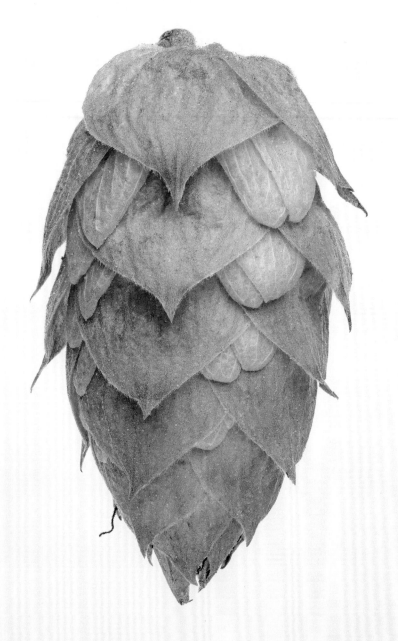

EAST KENT GOLDINGS

East Kent Goldings (EKG) is the preeminent English aroma hop—a delicious example of the gentle aromas that traditional English hops produce. East Kent Goldings was bred from a semiwild Canterbury Whitebine variety (Canterbury is a town in Kent) at the end of the eighteenth century and sold as East Kent Goldings since 1838. There are several Goldings variants known by the name of either the original grower or their village, but East Kent Golding is queen of them all and grown exclusively in East Kent by a handful of growers. The ideal soil conditions and sea air from the Thames Estuary in southeast England give EKG hops its sought-after and unique terroir. East Kent Goldings is a national treasure and received Protected Designation of Origin (PDO) status from the European Commission in 2013.

As versatile as an aroma hop can be, EKG is perfect for dry-hopping, whirlpooling, and late-boil additions. Its hallmark earthy, herbal, and spicy character is punctuated by surprising notes of sweet honey, with less prominent floral and citrus undertones adding further complexity. EKG is synonymous with English ales, delicate enough to preserve Lager integrity, and sophisticated enough to stand up to complex, yeast-driven Belgian ales.

TYPE
Old World British

SENSORY
Spicy, honey, earthy

ACIDS
Alpha 4–6%
Beta 2–3%
Cohumulone 25–30%

OILS (ML/100G)
0.4–1

USE
Aroma

TASTE IT IN
Fuller ESB, Fall City Pale Ale

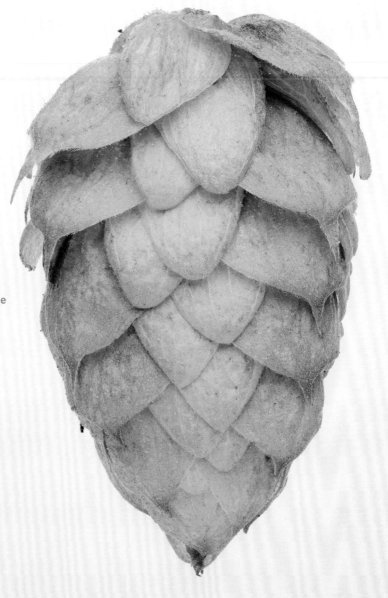

BITTERNESS
20–50 IBU

COLOR
5–18 SRM

ALCOHOL
3–5.8% ABV

MOUTHFEEL
Light to full body
(increasing with
strength)

CARBONATION
Low to medium

SERVING TEMP
50°–55°F

SENSORY
Balanced with hop
bitterness and fruity esters
(increasing with strength)

GLASSWARE
Pint, dimple jug,
nonic (pictured)

ENGLISH BITTERS

Don't let the name fool you, English Bitters don't come anywhere near the mouth-puckering, IBU bombs you might find in the States. These are sessionable and balanced ales, with toasted malt flavors in equilibrium with a crisp hop character and bitterness. They are lightly to moderately carbonated, quite flavorful, and very refreshing. Varying in strength, bitterness, and color, the substyles include Ordinary (Standard), Special (Best), Strong, and Extra Special—increasing in strength and hop intensity along the way.

Bitters are most certainly a British innovation. These are the session beers they've been crushing in pubs since the nineteenth century. That said, in the United Kingdom, Extra Special Bitter, or ESB, is simply a trademark referring to a specific beer brewed by Fuller Smith and Turner in London—Fuller's ESB. Also known as "The Champion Ale," this often-imitated Extra Special Bitter is a balanced and full-bodied ale that pioneered the style with its rich mahogany color and smooth bitterness. In the United States, ESB refers to a popular category of standard-strength amber ale known for being both malty and bitter. Redhook Brewery's flagship ESB sets the example and has been helping define Seattle's craft beer scene since the mid-1980s.

Naming discrepancies aside, English Bitters evolved from early Pale Ales and, with the addition of crystal malts in the twentieth century, gained in popularity as they transitioned from draught-only availability in local pubs to commercial bottling where alcohol and carbonation were both increased for home consumption.

CRYSTAL MALTS

Look for these unique grains to provide the trademark toasted bread flavors of English Bitters, often described as having a biscuit or nutty backbone. These grains are unique because they undergo lengthier kilning at higher temperatures during the malting process to achieve the intended variety and finished color (which is why they are sometimes called caramel malt). While cooling, the sugars harden, creating a unique crystalline texture. Unlike other malted grains, crystal malt only requires steeping, not mashing, to release the available sugars.

ECLIPSE

Eclipse is the newest New World hop from Hop Products Australia (HPA). Development began in 2004 at the hop-breeding program at HPA through several rounds of cross-pollination with primo varieties such as Fuggle, Brewer's Gold, Comet, and Pride of Ringwood, one of Australia's first high-alpha varieties from the 1950s. HPA took their time bringing Eclipse to market with field trials dating back to 2006, brewing trials dating back to 2010, and the intervening releases of superstars Vic Secret and Galaxy along the way. Finally in 2021, the unexpected sweet mandarin and orange character that radiates from this fruit-forward hop was perfected, consistent, and too juicy not to≈release to brewers seeking the full spectrum of Australian hop character.

Eclipse is bursting with sweet mandarin, zesty citrus peel, and fresh pine needle that immerses itself into beer styles from Witbiers, Saisons, and Pilsners to Pale Ales, IPAs, and NEIPAs with an unmistakable fruity character. Brewers quickly recognized the flavor impact of Eclipse both in the kettle and dry-hopping, even in small amounts, so much so that HPA preemptively planned—even before the worldwide release—to sustainably scale up production to make Eclipse its number-three hop behind Galaxy and Vic Secret by 2024.

"The name Eclipse has a double meaning. As a flavor reference it speaks to the lovely in-field aromatics and how that translates into the big, bold impact in beer. And as a celestial reference to its sister hop Galaxy."

—OWEN JOHNSTON, HEAD OF SALES AND MARKETING, HOP PRODUCTS AUSTRALIA

TYPE
New World Australian
(proprietary)

SENSORY
Mandarin, citrus, pine

ACIDS
Alpha 15.7–18.7%
Beta 5.9–9%
Cohumulone 33–37%

OILS (ML/100G)
1.7–1.9

USE
Dual-use

TASTE IT IN
Vocation First Eclipse IPA,
Cooper's Brewery Australian IPA

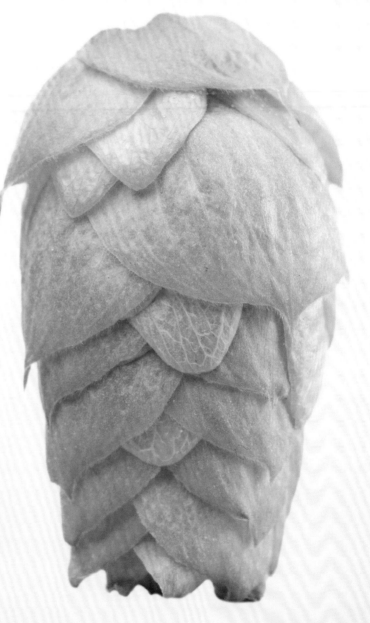

EKUANOT

The Hop Breeding Company hit another home run with HBC366, aka Ekuanot. Another of Jason Perrault and Eugene Probasco's fine creations, this variety was bred in 2001 but had a slow and rocky start. It was originally released as Equinox and later changed to Ekuanot for legal reasons. Regardless, Ekuanot's unique and intense aroma palette had brewers chomping at the bit even before its official release in 2014 (several high-profile breweries featured Ekuanot in some early hyped 2012 releases).

Ekuanot is known for combining concentrated fruit character with subtle, earthy spice. Among the fruity elements you can detect are melon, berry, citrus, apple, and papaya. On its zestier side, expect a distinct green pepper spice. According to its patent, Ekuanot is distinguished from other varieties by its high total oils, large and dense cones overflowing with lupulin, exceptional yields, and the unusually vibrant yellow color of its spring foliage prior to cone formation. Brewers are especially flocking to the concentrated lupulin pellets made from Ekuanot called Cryo Hops, to take advantage of the massive oil and resin content of the hop without any of the dense vegetal matter. If you haven't tried Ekuanot yet, you shouldn't have much trouble finding a good example; it's getting more popular by the day.

TYPE
New World American
(proprietary)

SENSORY
Fruit salad, spicy,
green pepper

ACIDS
Alpha 14.5–15.5%
Beta 4.5–5.5%
Cohumulone 32–38%

OILS (ML/100G)
2.5–4.5

USE
Dual-use

TASTE IT IN
Boulevard Brewing Space
Camper Cosmic IPA,
Lagunita Equinox Ale

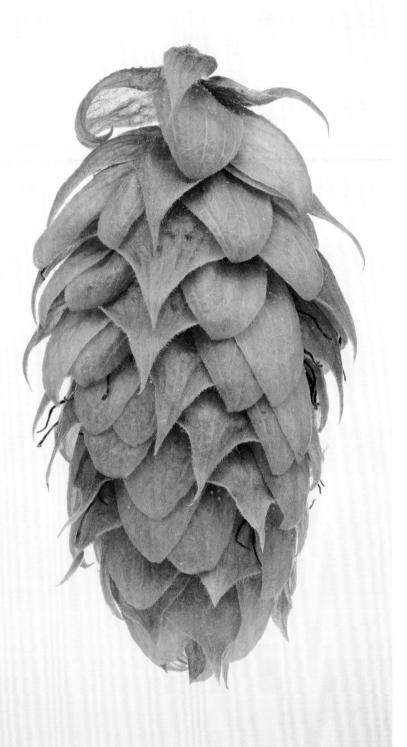

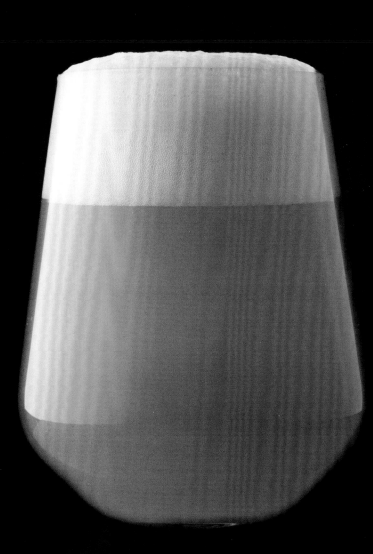

BITTERNESS
40–70 IBU

COLOR
4–10 SRM

ALCOHOL
5.5–7.5% ABV

MOUTHFEEL
Medium-full body, soft

CARBONATION
Low

SERVING TEMP
45°–50°F

SENSORY
Candied, fruity, creamy

GLASSWARE
Willi Becher, stemmed tulip,
Teku (pictured)

MILKSHAKE IPA

If you're not in the know, Milkshake IPAs are precisely what they sound like—thick, sweet, and often fruity. Born from brewers' never-ending experimentation within the IPA space, these new-school IPAs are also a lightning rod for controversy. Much like in the early days of the New England IPA (see page 89), many purists will tell you there's no room for it among traditional beer styles, and the old guard remains reluctant to even recognize Milkshake IPA as its own style category within the industry.

Not to be deterred, a new generation of brewers are taking their Hazy IPAs to new extremes by adding lactose (milk sugar), fruit purees, and vanilla to their recipes. The resulting IPA is hazier, velvety, confectionery, and absolutely unconventional. Much of the creativity in this style revolves around enhancing and complementing the aroma hop profiles with the almost endless variety of fruit choices—from simple fruits such as peach and berries to tropical mango and guava. These fruit puree additions balance the lactose with their acidity and tartness. They can also infuse their unique flavors and sweetness into the beer and physically change the overall texture and even the color of the liquid.

Omnipollo brewery in Sweden has been credited with pioneering the style, but outstanding examples can be found across the United States from Untitled Art in Wisconsin to Burlington Beer Company in Vermont.

PORCH BOMBS

One unintended consequence of the Milkshake IPA craze is that when packaged in cans, these dangerously delicious concoctions must be handled with care—and are often referred to as "hand grenades" or "porch bombs." If you remember our lesson on yeast and fermentation, you'll recall the byproducts are alcohol and carbon dioxide. Yeast (like many humans) is lactose intolerant and will not consume the milk sugars. It can, however, continue to consume the sugars in fruit puree even after packaging. If too much CO_2 is created inside a can, pressure builds and the can explodes—and countless Milkshake IPAs have done just that. The key here is to remember that yeast will only begin to feast if the liquid warms up, so be sure to keep any Milkshake IPA cold right up until you drink them.

EL DORADO

The mythical city of El Dorado was made of gold, and so are the lupulin glands of the El Dorado hop, bursting with bright flavors and aromas. El Dorado is a superb dual-use variety developed in the cooler climate of northern Yakima's Moxee Valley and released in 2010 by CLS Farms.

El Dorado combines exceptional alpha acid content with respectable levels of oils that are saturated with bright tropical fruit, watermelon, and stone fruit flavors. Its sweet, candied fruit elements are balanced by rind-like bitterness and finish with subdued, resinous herb and spice.

Its immediate success led to significant expansion in cultivation around 2012, making El Dorado, sometimes nicknamed "Eldo," widely available to commercial and home brewers alike. Brewers quickly realized this special hop pairs well with other hops by complementing rather than competing with the more citrusy aroma hop varieties. Perhaps that is why Eldo has quickly risen to become a top-ten US hop variety and is coveted among brewers looking for a strong hop aroma that plays well with others.

"Many brewers have turned to El Dorado to give their beers a deeper, more nuanced flavor. El Dorado elicits flavors dependent on harvest maturity dates. Early maturity evokes aromas of citrus, while middle maturity evokes watermelon and pear. For deeper aromas, peak maturity elicits tropical aromas of pineapple and mango, stone fruit, and candy lemon and cherry. While primarily used in Hazy IPAs and IPAs, this hop also works well in Lagers, Pale Ales, and Blondes."

—CLAIRE DESMARAIS, FIFTH-GENERATION HOP FARMER AT CLS FARMS

TYPE
New World American
(proprietary)

SENSORY
Tropical, pear, watermelon,
stone fruit

ACIDS
Alpha 13.5–16%
Beta 6–8%
Cohumulone 21–24%

OILS (ML/100G)
2.2–2.9

USE
Dual-use

TASTE IT IN
Precarious Beer Project
Kung Fu Kittens IPA,
Three Weavers Expatriate IPA

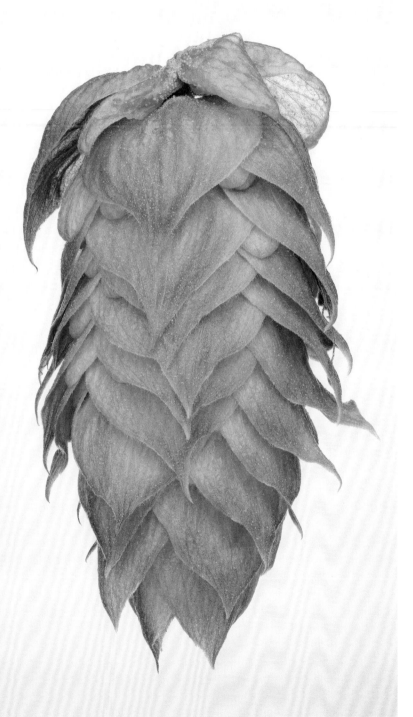

ELLA

Ella is a lupulin-loaded, super-alpha hop cultivar developed by the hop masterminds at Hop Products Australia. They successfully cross-pollinated a high-alpha Australian variety with a European landrace hop called Spalt, a Bavarian noble hop known for its woody, earthy, and spicy qualities. Ella, once known as Stella, is sister to another Aussie hop sensation, Galaxy. First crossbred in 2001, Ella took a decade of trials to perfect before being commercially released in 2011.

The genetics and hard work paid off; Ella demonstrates great farming productivity, and its alphas and oils can both get quite high. As with any hop with big oil levels, the flavors and aromas expressed are largely dependent on how the hops are used. If used in smaller amounts, it offers complex floral and spicy qualities, leaning towards anise, bergamot, and sage. In these smaller doses, Ella works great for boil additions in crisp, clean Lagers such as Pilsner. For IPAs and more hop-forward styles, Ella shines in late-boil and whirlpool additions in larger doses to extract more fruity elements. When dry-hopping, a huge tropical character with notes of citrus, particularly grapefruit, is expressed from this exemplar of an Australian hop.

TYPE
New World Australian
(proprietary)

SENSORY
Floral, spice

ACIDS
Alpha 13.4–19.2%
Beta 5.2–7.5%
Cohumulone 33–44%

OILS (ML/100G)
1.2–2.3

USE
Dual-use

TASTE IT IN
Epiphany Brewing
Foundation DIPA, Pelican
Brewing Umbrella IPA

BITTERNESS
20–40 IBU

COLOR
5–20 SRM

ALCOHOL
3.5–9.5% ABV

MOUTHFEEL
Light to medium body,
dry, possibly tart

CARBONATION
High

SERVING TEMP
50°–55°F

SENSORY
Spicy, hoppy, fruity

GLASSWARE
Pokal, stemmed tulip,
wine glass (pictured)

SAISON

Created in the Belgian farming region of Wallonia in the eighteenth century, a Saison beer will use ingredients and show expressions that are as diverse as the farms and farmers responsible for its development. Meaning "season" in French, Saison was historically brewed in the fall and conditioned throughout the cold winter to be consumed by farmworkers during the more temperate farming seasons. Due to this long storage time, Saison beers all shared certain characteristics, like moderately high alcohol content, very low residual sugars (very dry), and heavy hop additions to take advantage of the antimicrobial properties of the hops—all attempts to decrease the likelihood of spoilage during maturation.

Often referred to as Farmhouse Ales in America, these unfiltered, highly carbonated, moderately bitter, and dry ales are also known for incorporating high-ester yeast strains that produce a peppery spice and citrus fruit character. In homage to its roots among farmers who used whatever agricultural products were on hand, modern brewers continue to incorporate a variety of cereal grains other than barley, including oats, wheat, and rye, as well as unique spice, herb, and fruit blends to accentuate the complex bouquet of the style.

The style guidelines of Saison allow considerable IBU, SRM, and ABV variability, and it remains popular all over the world as a canvas for experimentation with grains, yeast, adjuncts, and of course, hops. Hop flavor and aroma are not nearly as pronounced as hop bitterness in more old-fashioned versions where noble hop varieties have commonly been used. However, modern American brewers have had great success substituting New World varieties for more contemporary interpretations of this style. Oxbow Brewing Company Farmhouse Pale Ale and TRVE Brewing Company Ancient Bole are two such examples that beautifully showcase more fruity aromatics and hoppy flavors. If tradition is what you seek, Belgium's Saison Dupont Vieille Provision (often simply called "Saison Dupont") is a luscious and refreshing choice and overwhelmingly considered the epitome of this style.

ENIGMA

What's green on the outside but gold on the inside? Has super-high alphas plus extremely high oils? And depending on how you use it, has the uncanny ability to unleash diverse flavors and aromatics in unique and different ways? The name Enigma speaks for itself in this powerful hop variety from Hop Products Australia. Released in 2004, Enigma has come to be known as a chameleon in the brewhouse—infusing distinctive aspects of hop character depending on how it's used throughout the brewing process.

Surprisingly high-alpha paired with extraordinary cohumulone content will solve all bittering conundrums with ease, while late additions and dry-hopping really maximizes the massive oil potential of Enigma. Raspberry and red currant riddle the light tropical fruit notes that underscore the refreshing white wine grape crispness that has become the trademark characteristic of this variety. Engima works well with other fruit-forward New World hop varieties but can also stand alone as a truly enigmatic single-hop selection in any hop-forward beer style.

TYPE
New World Australian
(proprietary)

SENSORY
White grape, raspberry,
melon

ACIDS
Alpha 16.7–19.4%
Beta 5.2–7.1%
Cohumulone 37–43%

OILS (ML/100G)
1.9–2.8

USE
Dual-use

TASTE IT IN
Sixpoint Trail Haze IPA,
Westbound & Down
Westbound DIPA

FUGGLE

Fuggle is the personification of a well-rounded, classic low-alpha hop variety. Introduced in 1875 by Richard Fuggle of Brenchley in Kent, England, its popularity and impact on the beer industry has been remarkable. At its peak in 1949, Fuggle accounted for nearly 80 percent of total British hop production before the cultivation of high-alpha varieties eventually diminished its footprint. It is regarded as one of the two chief English hop varieties (East Kent Goldings being the other) and is also widely grown in Slovenia as Styrian Golding. It has even "hopped the pond," where it's used in the breeding of two of the most storied hop varieties in the United States: Cascade and Willamette.

Like most English hop varieties, expect prominent woody, earthy, and herbal overtones, with spicy, floral, and fruity undertones. Pleasant, subtle, and mild, Fuggle can function solo or complement other varieties. It is best used as a late-boil and/or dry-hopping addition. Fuggle is often used in combination with East Kent Goldings (EKG) to improve the drinkability of a beer and add roundness and fullness to the palate. Like EKG, Fuggle is ubiquitous in the United Kingdom, celebrated in British styles from Milds and Bitters to Porters and Stouts. Today, Fuggle and its United States and Slovenian offshoots are hopping styles across the board.

> "The importance of Goldings and Fuggles to breeding programs around the world cannot be overstated."
>
> —DR. PETER DARBY, WYE HOPS

TYPE
Old World British

SENSORY
Woody, minty, herbal

ACIDS
Alpha 2.4–6.5%
Beta 2.1–4%
Cohumulone 27–33%

OILS (ML/100G)
0.4—0.8

USE
Dual-use

TASTE IT IN
Samuel Adams Boston Ale,
Brewery Huyghe Delirium
Tremens Belgian Ale

BITTERNESS
20–50 IBU

COLOR
20–40 SRM

ALCOHOL
4.5–9.5% ABV

MOUTHFEEL
Medium-light to full body

CARBONATION
Variable

SERVING TEMP
45°–55°F

SENSORY
Chocolate, caramel, nutty,
toffee, roasty

GLASSWARE
Pint, tulip pint (pictured)

PORTER

Dark and malty, roasted and robust, Porter can feel like a meal—indeed, it was for the hard-working London laborers of the nineteenth century for whom this style was most likely named. Despite its blue-collar beginnings, this style eventually splintered into variations throughout Europe and the world. In Ireland, the introduction of Porter ultimately led to Arthur Guinness inventing his famed Irish Stout. Historically, the terms Porter and Stout (see page 167) are used interchangeably and attempts to distinguish them even now are often futile. Porter also traveled north to Russian Imperial Courts and was dubbed (Russian) Imperial Stout. Even the Baltic States joined in, utilizing the German tradition of bottom-fermenting Lager yeast to create a high-ABV Baltic Porter.

America created its own Porter as well by spawning a less malty pre-Prohibition style reminiscent of the original English version. Unsurprisingly, modern American versions have more hop character, higher ABVs, and are more roast forward. Regardless of which side of the pond you're on, expect a dark, malty beer with chocolate, caramel, toffee, and nutty flavors. There'll be varying levels of carbonation, body, hop character, and color depending on brewer's preference, but you'll know for certain you're not drinking IPA. Deschutes Brewery Black Butte Porter is acclaimed in the States, but try the Famous Taddy Porter from Samuel Smith Old Brewery, if you fancy a less intense pint from Tadcaster, North Yorkshire.

THREE RINGS

Thanks to the stiff and creamy foam head of Porters, there is an old tradition when drinking your first pint (seriously though, only your first pint). Grab the freshly poured pint and immediately gulp down at least a quarter of the beer. Now, to finish the beer, you must only take three more sips total. When you're done, there will be three distinct lacing lines, or foam rings in the glass, aka the Three Rings.

GALAXY

As the millennium came to a close and the eyes of the craft beer universe were narrowly fixed on the American Pacific Northwest, an Australian hop powerhouse was breeding a cultivar that would come to dominate the hop-forward landscape of craft beer. Hop Products Australia (HPA) owes much of its ascent to Galaxy.

Galaxy was created in 1994 by cross-pollinating German Perle with a high-alpha Australian cultivar. After fifteen years of fine-tuning, HPA finally sent Galaxy out to commercial sales in 2009. A versatile, high-alpha, dual-use variety, Galaxy is widely praised for possessing oil content rivaling just about any of its competitors. Dynamic enough to make incredible single-hop beers with luscious passion fruit, juicy peach, and piercing citrus, Galaxy generally lacks any of the earthy, herbal, floral, or spicy notes accompanying American fruit-forward varieties. The demand for this intensely bright, tropical fruit-bomb was so immediate that acreage was immediately expanded, and it quickly become the reigning hop from down under.

"Galaxy's high levels of total metabolite accumulation (alpha acids, beta acids, essential oils) challenged our kiln operations and pellet production facilities that were used to dealing with lower levels. The essential oil accumulation in Galaxy is at the top end of what we have measured over time in our breeding program, and the sheer size of the cones that develop in some circumstances is exceptional relative to other varieties."

—SIMON WHITTOCK, MANAGER OF AGRONOMIC SERVICES, HOP PRODUCTS AUSTRALIA

TYPE
New World Australian
(proprietary)

SENSORY
Passion fruit, peach, citrus

ACIDS
Alpha 13–18.5%
Beta 6.1–11.6%
Cohumulone 32–43%

OILS (ML/100G)
1.9–2.9

USE
Dual-use, but largely
aroma and flavor

TASTE IT IN
American Solera Terpy
Galaxy, Trillium Brewing
Congress Street IPA

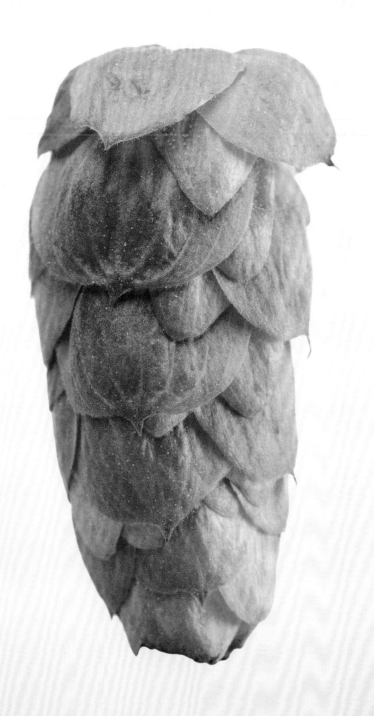

GALENA

Many believe Galena to be one of the most prolific bittering hops in American craft beer history. Credited to Dr. Richard Romanko in the Idaho fields of the USDA hop-breeding program around 1968, Galena is the result of an open-pollination of a female Brewer's Gold and an unknown male. Although it wouldn't be released for another decade, it arrived just in time for industry-wide hop shortages and became a staple for many large breweries, Miller and Corona rumored among them. Known for good yield, vigor, and storage, Galena inspired a new wave of American bittering hops and was even used to breed a similar, more disease-resistant variety of even higher alphas known as Super Galena.

Galena is a tried-and-true American bittering hop. It consistently provides a very clean, well-balanced, crisp bitterness that also works well with most aroma hop additions. The most common flavor and aroma descriptors are grapefruit citrus, tropical fruit, black currant, and green pepper spice. Because Galena rootstock is publicly available, it's not only widely available for commercial growers and brewers, but for home brewers as well. It works great in all styles, from Lager to Pale Ale and IPA to Porter and Stout.

TYPE
New World American

SENSORY
Citrus, tropical fruit,
black currant, spice

ACIDS
Alpha 11.5–13.5%
Beta 7.2–8.7%
Cohumulone 36–40%

OILS (ML/100G)
0.9–1.3

USE
Dual-use, but mostly
bittering

TASTE IT IN
Ninkasi Dawn of the Red
India Pale Ale, Grand Teton
Brewing 208 Session Ale

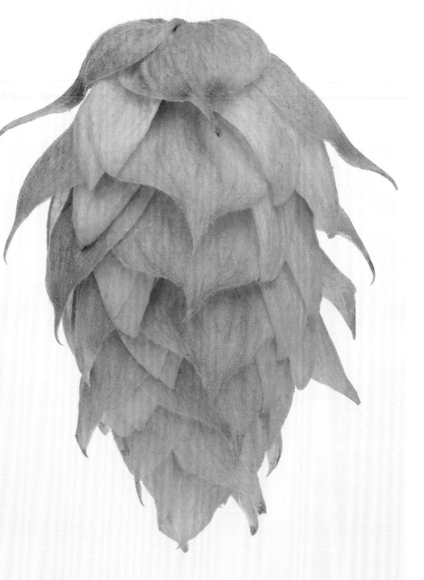

BITTERNESS
0–25 IBU

COLOR
SRM varies

ALCOHOL
ABV varies

MOUTHFEEL
Low to medium body

CARBONATION
Effervescent

SERVING TEMP
40°–50°F

SENSORY
Complex, leathery, funky,
barnyard, lemony citrus

GLASSWARE
Tumbler (pictured)

LAMBIC

Sour and funky, uncarbonated, and spontaneously fermented, Lambic embraces the rare opportunity for brewers to harness a specific region's microbiological terroir, to impart unique, geographically distinct combinations of flavors and aromas in their finished product. It also famously incorporates aged hops. Gueuze (sometimes spelled Geuze) is a popular, more complex, blended version of old (aged two plus years) and young Lambic (aged one year), which gets quite carbonated due to a second fermentation after bottling.

As far as beer production goes, Lambic might be one of the most intriguing. It requires at least 30 percent wheat and a rigorously turbid mashing process that uses multiple temperature rests and the removal and reintroduction of the mash liquid to create a complex carbohydrate- and protein-rich wort. The hops used are usually noble or low-alpha varieties that have been aged for several years; they are then applied in heavy doses to prevent excessive microbiological growth during the year(s) of barrel-aging Lambic requires to condition. This labor-intensive process is all to ensure the one hundred plus different kinds of microorganisms naturally introduced into the wort—while cooling overnight in a flat, shallow, metal vessel called a coolship—will be happy enough to spontaneously ferment the wort. No cultured yeast or bacteria is ever intentionally added.

With a murky history dating back over four hundred years, Lambic continues to inspire curiosity among beer nerds the world over. Like Champagne in France, Lambic and Gueuze are limited to the beers produced in the Brussels area of Belgium. To truly experience the wonders of this style firsthand, you'll have to go to a traditional Lambic brewery or Gueuze blendery like Brasserie Cantillon, Gueuzerie Tilquin, or Brouwerij 3 Fonteinen. Of course, brewers around the world have re-created the style using their own region's unique microflora to innoculate their wort. Although there has been disagreement with the High Council for Artisanal Lambic Beers (HORAL) on the terminology for foreign beer made in this tradition, the label *Méthode Traditionnelle* has gained acceptance in the American craft community as an indicator that a producer is adhering to traditional production standards. For beer inspired by Lambic or Gueuze, American breweries such as Jolly Pumpkin, Black Project, and Jester King are defining a new way forward for spontaneous beer in America.

JESTER KING BREWERY

**Jeffrey Stuffings
cofounder and owner**

FOUNDED: 2009

BREWERY LOCATION: Austin, Texas

FIVE FAVORITES: Atrial Rubicite, Black Metal, Le Petit Prince, Nobel King, SPON beers

Jester King is an authentic farmhouse brewery offering mixed culture and spontaneous fermentation beer, as well as pure culture from a local yeast source. Cofounder Jeffrey Stuffings was working at Austin Homebrew Supply while developing the recipes and business plan for the brewery in 2007. With his brother, Michael Stuffings, they rebuilt an old machine shop into what is now a world-renowned craft beer destination. Since opening their doors in 2010, Jester King has been inspired by their surroundings and continually evolved to become an authentic farmhouse brewery through their brewing practices and their land conservation initiatives. They currently total 165 acres with an inn, restaurant, fruit and vegetable farms, pastures, hopyards, vineyards, and nature trails that comprise their Texas Hill Country ranch.

Do you need to think differently about hops for your distinctive beer styles?

There are three major areas for us to think about—farmhouse, spontaneous, and clean beer styles. For what I generally describe as new Farmhouse Ales, these are typically stainless-steel fermentations, and we hop these beers aggressively with mainly noble or noble-esque hop varieties such as Perle, Fuggle, Saaz, and Goldings to get that nice spicy and earthy profile.

For spontaneous, we're using exclusively aged hops. We started off using some pellets but found, surprisingly, that pellets, despite serious age, still carry a fair amount of bitterness. That's why we've switched

exclusively to aged whole cone hops. Typically, we'll buy some old low-alpha varieties and let those age for a minimum of two years. By that point, pretty much all the bitterness, from a sensory perspective, is gone. From a scientific perspective, we still get IBU from these really old hops. Like most folks who experiment with spontaneous fermentation, I discovered the impact of aged hops from the Lambic tradition. We've really borrowed that for our own inspired versions, and that's actually my favorite aroma in spontaneous fermentation—the character from aged hops.

Finally, the newest thing for us is we started a clean-side fermentation program. I've been getting into all kinds of new hop products, like Cryo Hops and, of course, all the new and sexy flavor hop varietals for our modern IPAs.

How do you age hops?

We have a barn next to the brewery that's an ideal spot for aging hops because it gets extremely hot in the summer, well above

100°F. We start by breaking down the bales by hand, put the hops into burlap bags, and store them in the barn's attic. The hops start fairly bright green and smell fresh and floral, and over time they go through the classic cheesy and funky phase pretty fast. After six to twelve months, they become very earthy and smell like our farm, kind of like a bale of hay. Once they become well aged, they are so dry and brittle that if you rub them gently between your fingers, they disintegrate.

What do aged hops contribute to spontaneously fermented beer?

Hops are a protective mechanism for the beer from the get-go. It's weird that a beer where you don't pitch yeast and don't go through any type of traditional cleaning and sanitation methods other than the boil, actually turns out quite delightful more often than not. Typically, we boil for three to four hours and add the aged hops for the last two hours. It's essential that you use hops and a fairly big dose—three-quarters to a full pound per

barrel, which is like old-school IPA ratios. Since we're exposing the beer to a vast array of microbes, some of which early on in the life of the beer could potentially be harmful to consume, the impact of the hops is to keep it from getting truly sick and then kind of staying there. It's the antimicrobial properties of the hops that keep the beer from really going off the rails. There's a fine line between beautiful funk that's really interesting and enjoyable and funk that's just off-putting and ruins the experience of drinking the beer. I feel there is a linear relationship between the amount of hops we use and how nice or not nice the funk from fermentation presents itself. It's also very important to note that pH level is the other gatekeeper. If you go from 5 pH on brew day down to 3.4 pH by the time the beer is mature, that will certainly cause some of those nastier microorganisms to perish. But we've experimented with un-hopped wort and the acidity becomes so extreme so fast that it's unpalatable. The arch enemy of our fermentation is acetic acid. We dump anything that's even mildly acidic.

How important is hop flavor in spontaneous fermentation?

When I was first getting into Lambic, especially beers from Brouwerij 3 Fonteinen or Brasserie Cantillon, I bought into the mythology of the unique terroir of the microflora from the valley where they originate. I do think there is something to that. It's part of what Lambic is, but as I learned more about producing the style, I discovered I can achieve a lot of that character from hops. Many people think of Lambic as being not hop-forward, but there's a really beautiful hop character underlying that traditional barnyard funk or acidity you get from fermentation. I'm doing this style an ocean away from Belgium, but I still get more of that traditional Lambic and Gueuze character from my aged hops than I would on microflora and fermentation.

Some producers are very sensitive about using the L word or the G word. We are sympathetic to the fact that these styles

have only been kept alive by a small number of families that generationally focused on very authentic and traditional Lambic and Gueuze. Early on in the existence of our brewery, we developed a friendship with Jean-Pierre Van Roy at Cantillon and were very excited to see if Jester King could pursue our own Lambic-inspired beers in a place like Texas, but in a fashion that didn't tread upon or co-opt their family tradition. We essentially follow the same traditional Lambic style but make it clear that this is not an authentic product from Belgium.

How important is hop character in Farmhouse Ales?

Farmhouse Ales are hoppy beers. When beer folks think of Farmhouse, they think of wild yeast and agricultural ingredients that are close to the brewery setting in an effort to achieve a kind of terroir, a sense of place in beer. All that's important, but what really drew me into Farmhouse Ales was actually how nice and refreshing and dry and bitter they are. I love how bitter isn't a negative, like the way it's perceived in newer takes on IPA.

The key is using hefty doses of low-alpha hops. We'll hop at around two pounds per barrel to really build up a nice layer of herbal bitterness and herbal spicy flavor and aroma. It's not going to wreck your palate, but it's still plentiful in terms of their hops flavor and aroma. Then, of course, the hop character gets melded with the yeast and fermentation

character, which gives Farmhouse Ales their unique signature. I love the spontaneous and the aged hops, but Farmhouse Ales are probably one of my favorite presentations of hops.

Classic Franco-Belgian Farmhouse Ales sometimes have a "lightstruck" hop character, too. To an extent, I think the green glass used to traditionally bottle those beers influenced the hop character in those Farmhouse beers. Green glass, or "trashy glass" as I like to call it, is terrible for preserving fresh hop character, but we intentionally use green glass with some of our Farmhouse beers as a nod to the originators and, more so, to add a bit of "Euro-skunk" to our beers. When we release our table beer, called Le Petit Prince, I'll take the bottles and set them on a picnic table in the direct sun just before drinking to get some of that same classic lightstruck hop character into my beer.

My favorite Farmhouse beer of all time is Dupont Avril, which is basically just like the table version of Saison Dupont. You can literally drink liters of that beer and not be too intoxicated. My favorite thing to do is have a three-hour beer-drinking session outdoors with family and friends and some nice snacks, cheeses, and meats. That, for me, is the most enjoyable form of human interaction. And I think these low-ABV beers are so conducive to that, and that's why I love the Franco-Belgian farmhouse tradition so much.

HALLERTAU BLANC

Released in 2012 by the Hop Research Center Hüll in Bavaria's Hallertau region of Germany, Hallertau Blanc was specifically bred for American craft brewers. A descendant of Cascade, Hallertau Blanc's American lineage combines with Hüll's breeding mastery to bring to life one-of-kind flavor and aroma characteristics.

Hallertau Blanc is most known for its distinctive white grape character. Beers made with this variety are often compared to wines made with Sauvignon Blanc grapes. Hallertau Blanc is also praised for huge tropical fruit flavor and aroma and is most aptly described as having fruity, herbal complexity. The unmistakable lemongrass and lime character makes this one of the most interesting options available to brewers looking to push their hopping boundaries. Additional gooseberry, grapefruit, passion fruit, pineapple, and elderflower notes round out Hallertau Blanc's surprising sensory profile.

This new Hallertau variety has become a highly sought-after ingredient in everything from IPAs and Belgian Ales to Witbier and Sours. True to its objective, Hallertau Blanc has scratched an itch for American brewers looking for something new.

TYPE
New World German

SENSORY
Tropical, white wine,
grapefruit

ACIDS
Alpha 9–12%
Beta 4.5–5.5%
Cohumulone 22–26%

OILS (ML/100G)
1.5–1.8

USE
Dual-use, but largely
aroma and flavor

TASTE IT IN
Birds Fly South Rustic
Sunday Farmhouse Ale,
Zebulon Artisan Ale
House Saizon

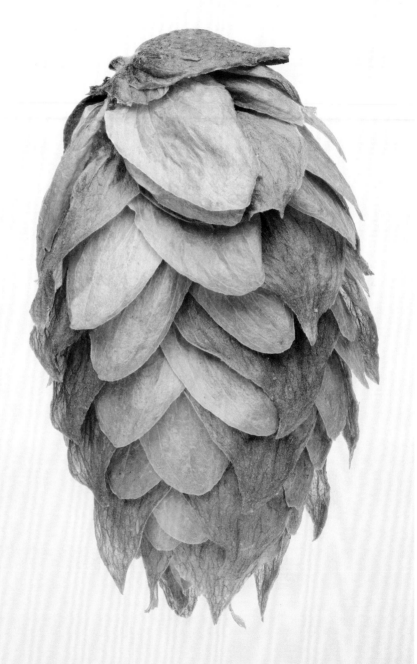

HALLERTAU TAURUS

Hallertau Taurus is a bittering bull. Another hop bred in the Hop Research Center Hüll in Bavaria's Hallertau region of Germany, this high-alpha bittering steamroller was released in 1995 as a dual-use hop, but it gained popularity mainly for bittering. Its quality is best expressed when added at the beginning of the boil to impart a harmonious, less-pronounced bitterness.

The small compact cones possess an unusually high linalool and xanthohumol content. The linalool terpenes are what gives Taurus its dual-use tag and proves its value in dry-hopping. The earthy floral aroma is subtle and uniform while spicy hop notes are evident in the flavor with hints of chocolate and banana. The xanthohumol is a chemical compound found in many other hop varieties (but only in tiny amounts) that adds to the bitterness and flavor. More remarkably, xanthohumol has been studied in-depth for its health benefits as a therapeutic agent—a potent antioxidant, anti-inflammatory, and antiviral. Some "healthy" beer styles that pair well with Taurus include German Ales, Lagers, Oktoberfests, and Schwarzbiers.

TYPE
New World German

SENSORY
Peppery, spicy, lime

ACIDS
Alpha 14–19%
Beta 4–6%
Cohumulone 27–32%

OILS (ML/100G)
0.9–1.5

USE
Dual-use, but mostly
bittering

TASTE IT IN
Paulaner Salvator
Dopplebock, Radeberger
Pilsener

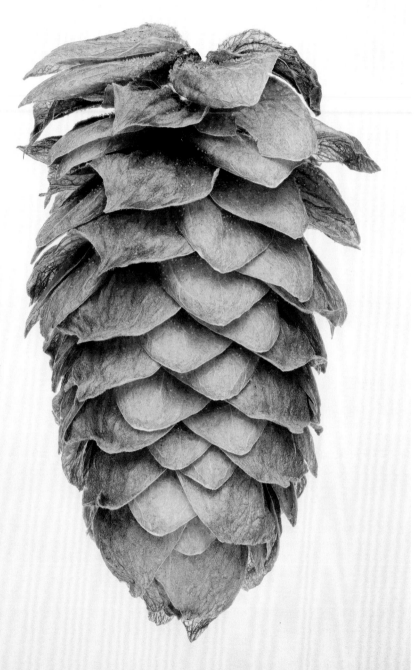

BITTERNESS
20–30 IBU

COLOR
3–6 SRM

ALCOHOL
4.1–5.2% ABV

MOUTHFEEL
Medium-low body,
smooth, dry, crisp

CARBONATION
Medium to high

SERVING TEMP
45°–50°F

SENSORY
Subdued and balanced
bready malt and spicy, herbal,
and floral hop character

GLASSWARE
Stange (pictured)

KÖLSCH

A perfectly balanced showcase for lightly kilned malt and mellow hop character, Kölsch is a hoppy hybrid beer fermented relatively cold with top-fermented ale yeast and then further conditioned at cold temperature. Kölsch often achieves the same brilliant clarity of Lagers but is highlighted by the classic, spicy, floral character of noble hops.

Kölsch originated centuries ago in the German city of Cologne (Köln in German), where the practice of cold-conditioning ale stems from a regional commitment to traditional ales. These soft and delicate, well-attenuated hybrids from Köln were designed to compete against the rising tide of the new *Lagerbier* sweeping the region. With their Kölsch, breweries were resisting the hype of the bottom-fermented Lagers—legend has it some rebellious Köln brewers even added wheat to their recipes (the Bavarian Purity Law outlawed wheat) to further snub Bavarian Lagers and help set their Kölsch further apart with an added pillowy mouthfeel, subtle fruity aroma, and sharp crispness.

Officially formalized in 1986 during the Kölsch Konvention, Kölsch was codified to be top-fermented, pale, clear, attenuated, brewed in Cologne, and served in a stange glass. Kölsch remains among southern Germany's favorite beverages. As the term "Kölsch" is a protected label, Reissdorf Kölsch and Fruh Kölsch are two traditional examples from Köln worth trying. Otherwise, there are numerous terrific examples of Kölsch-style beers made by many American craft breweries, including New Glarus Brewing Kid Kölsch and New Holland Full Circle.

AMERICAN HYBRID STYLES

CALIFORNIA COMMON: Originating in San Francisco where it was simply called steam beer, these brews are fermented in wide vessels with Lager yeast at higher temperatures to speed up the process. It is often packaged with little to no conditioning. The name comes from the steam that was produced from open-air vessels used to cool the wort on the rooftops of the original breweries.

BLONDE ALE: This easy-drinking all-American session beer has light color, light body, and light flavor. It can be brewed with either Lager or ale yeast and can also be referred to as a Golden Ale.

CREAM ALE: Basically a Blonde Ale brewed with Lager yeasts, this crisp, smooth ale gets its name not from its mouthfeel or any dairy ingredients, but from the addition of corn adjuncts used to booze up this hybrid style.

HBC 682

HBC 682 is the first super-alpha bittering hop variety from hop-breeding masters the Hop Breeding Company (HBC). The perfect bittering addition, HBC 682 is a high-yield, late-maturing variety that is resistant to both powdery and downy mildew. Growers love this variety because of its efficiency in the fields, and brewers love it for the clean canvas of bitterness it provides in a wide variety of beer styles. Diverging sharply from what many expect from an American hop, this variety's mellow aromatic profile is most commonly described as herbal, earthy, floral, woody, and resinous. Boil additions can be expected to have a relatively neutral flavor and provide a smooth bitterness that does not linger.

With strong genes and a lineage that traces back to the breeding program at Wye College in Kent, England, this new breed of super high-alpha hop has quickly gained popularity in the brewhouse since it was formally released in 2018. The bittering capacity from the extract of HBC 682 is indisputable, and brewers are increasingly incorporating it into more and more styles. As a result, HBC 682 has quietly made its way in the top ten of all hop varieties grown in the United States.

TYPE
New World American
(proprietary)

SENSORY
Herbal, earthy, floral

ACIDS
Alpha 17–20%
Beta 4.5–6%
Cohumulone 30–32%

OILS (ML/100G)
1–2.5

USE
Bittering

TASTE IT IN
Karl Straus Brewing New
California IPA, Saint Arnold
Double Down DIPA

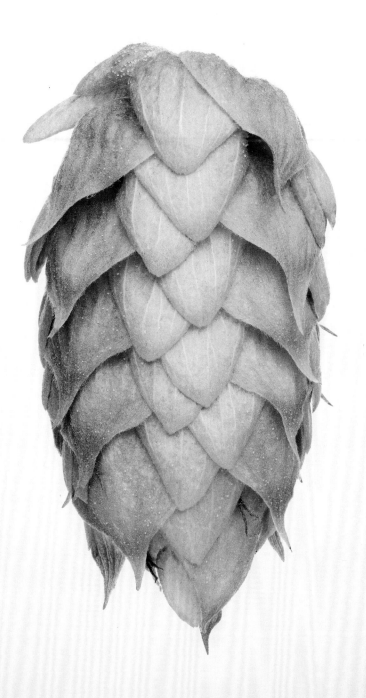

HERKULES

Unlike its namesake, the clean, crisp bitterness of Herkules is not a myth. Herkules is a robust, high-alpha bittering hop variety released in 2006 by the Hop Research Center Hüll, after being bred from a mother Hallertau Taurus variety. The strong genetics have created a high-yielding juggernaut of the hop fields that has become the most widely grown variety in Germany today. Its resistance to diseases further accentuates the prowess Herkules exhibits as a hero among bittering hops.

Boiling with Herkules imparts a crisp, clean bitterness; in later additions, a pepper and spice character is layered with a tangy citrusy resin character. Everything from ales, Altbiers, Bocks, Lagers, Saisons, and more have all harnessed the power of Herkules to become elixirs fit for the gods.

TYPE
New World German

SENSORY
Peppery, citrus, resinous

ACIDS
Alpha 14–19%
Beta 4–5.5%
Cohumulone 32–38%

OILS (ML/100G)
1.4–2.4

USE
Bittering

TASTE IT IN
Lefmans Goudenband,
Schilling Beer Company
Herkules Kölsch-style Ale

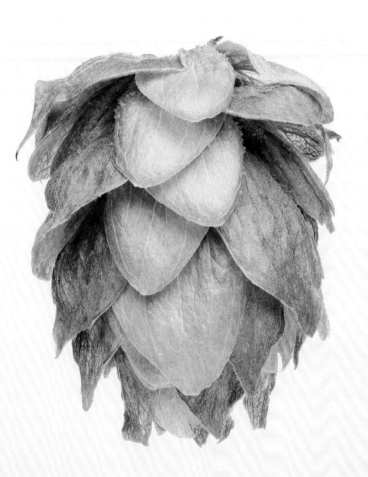

IDAHO 7

The Idaho 7 hop variety has been likened to a stick of Juicy Fruit chewing gum. A neweraddition to the ever-growing menu of exotic North American aroma hops, the 2015 release of Idaho 7 was the first from Nate Jackson of Jackson Hop Farm, just outside Boise, Idaho. Prized for its otherworldly pungent aroma and flavor, Idaho 7 is versatile enough to serve as a world-class dual-use variety—often compared to the multifaceted Mosaic variety. No longer just a product of Idaho, Idaho 7 is now managed by Yakima Chief Ranches and is gaining acreage in American hop fields as a high-yielding, late-maturing variety exhibiting dense, sticky cones, known to some as 007 Golden Hop.

The full cones exude pungent tropical fruits such as pineapple and mango with notes of ripe peach and tangerine citrus, balanced by a dankness of pine and black tea. All these translate perfectly into the wonderful aromas and flavors of any beer lucky enough to be hopped with this one-of-a-kind variety. Idaho 7 can go it alone but it pairs well with other hops in a variety of hop-forward beer styles, including, of course, IPA and Pale Ale.

TYPE
New World American
(proprietary)

SENSORY
Tropical, stone fruit,
dank

ACIDS
Alpha 9–14%
Beta 3.5–5%
Cohumulone 30–40%

OILS (ML/100G)
1–2

USE
Dual-use

TASTE IT IN
Mikkeller the Idaho Seven:
Modern IPA, Modern Times
Thundera IPA

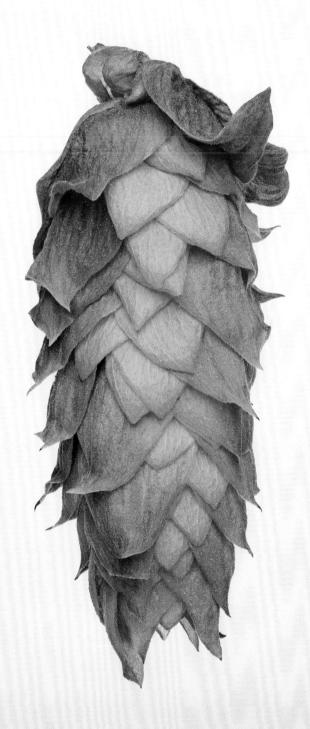

BITTERNESS
35–100 IBU

COLOR
8–22 SRM

ALCOHOL
8–12% ABV

MOUTHFEEL
Full-bodied, rich, chewy

CARBONATION
Low to none

SERVING TEMP
55°–60°F

SENSORY
Bready, toffee, caramel,
molasses, dried fruit

GLASSWARE
Snifter (pictured)

BARLEYWINE

Although it has been traced back to the ancient Greek drink of choice known as *Kykeon*, the term Barleywine took more than fifteen hundred years to find its way into commercial brewing with England's Bass Brewing No. 1 Burton Ale. Barleywine (the English spelling is Barley Wine) follows in the British tradition of "old ale," where strong malty ales are aged for extended periods, allowing them to oxidize and develop entirely new flavor profiles. They are rich and complex sippers known for very high alcohol and intense, sweet malt flavors characterized by toast, caramel, toffee, and molasses. Although hop character and bitterness is low to medium, expect the earthy, herbal, and floral aromas associated with classic British hop varieties such as Fuggle and East Kent Goldings.

The addition of hops, with their valuable antimicrobial properties, was a blessing for these sugary elixirs, which are prone to bacterial spoilage during aging. Predictably, American brewers evaluated this foreign beer style and determined it needed more hops, so expect American Barleywines to be considerably more aggressive with hop bitterness and character. American examples are lighter in color, and they are more likely to incorporate American hops that substitute citrus, tropical fruit, and pine for the traditional herbs and earthiness. If you're in the market for an English version, you can't go wrong with J. W. Lees Harvest Ale. In America, Great Divide Brewing Company makes Old Ruffian and Anchorage Brewing Company makes A Deal with the Devil—two Barleywines that are white whales.

KOHATU

It takes a special variety to be selected for both bittering and aroma additions, and Kohatu's dual-use characteristics are considered to be solid as a rock. Meaning "stone" in New Zealand's indigenous Maori language, Kohatu works extremely well in most hop additions by offering a consistent bitterness and quality finish that perfectly balances its own intense fruity aroma and fresh tropical flavor profiles.

The tenacious landrace Hallertauer Mittelfrüh strikes again as one of three proud parents of this 2011 variety from the New Zealand Institute for Plant and Food Research hop-breeding program. The high humulene and myrcene inherited from its German mother imparts a complex resinous and tropical fruit-driven punch that pairs well with other hops and in many beer styles, too. The clean bitterness and fresh flavors of Kohatu mingles nicely with the lighter body and delicate flavors of Wheat, Blonde, and Pale Ales, or they can be amplified with multiple additions and/or easily complemented by other hop varieties to bring a New World edge into bigger ales, IPAs, and NEIPAs.

TYPE
New World New Zealand
(proprietary)

SENSORY
Fruity

ACIDS
Alpha 6–7%
Beta 4–5%
Cohumulone 21%

OILS (ML/100G)
1

USE
Dual-use

TASTE IT IN
Cigar City Tropical
Heatwave Wheat Ale,
Goose Island So-Lo IPA

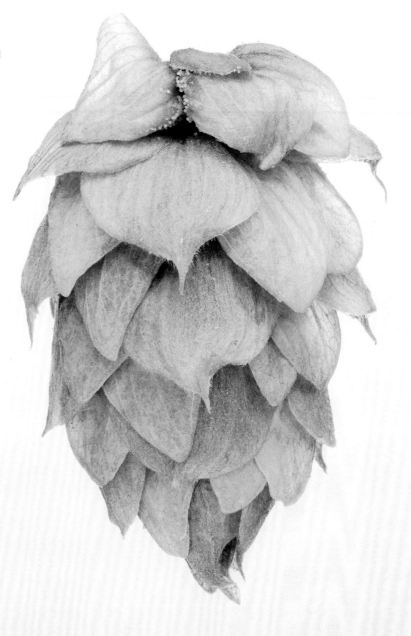

MANDARINA BAVARIA

Germany may be renowned for their bittering hops, but when the American craft beer industry began demanding more flavor, the Hop Research Center Hüll answered with Mandarina Bavaria. A daughter of American sweetheart Cascade, Mandarina Bavaria was released in 2012 as the darling of the flavor hop–breeding program.

Fruity, citrus, and fresh floral bouquets are complemented by the concentrated tangerine character for which this hop is named and now famous for (*mandarina* in German translates to tangerine). Brewers have been able to coax out these intense flavors in the brewing process through late-boil additions, in the whirlpool, or with dry-hopping. The fruity citrus and unmistakable tangerine notes translate beautifully into any hop-thirsty beer style and plays well with other varieties to design a layered and expanded cocktail of fresh flavors.

TYPE
New World German

SENSORY
Fruity, citrus, tangerine

ACIDS
Alpha 7–10%
Beta 5–6.5%
Cohumulone 31–35%

OILS (ML/100G)
1.5–2.2

USE
Aroma

TASTE IT IN
Rhinegeist Whiffle Witbier,
Ska Brewing Modus
Mandarina IPA

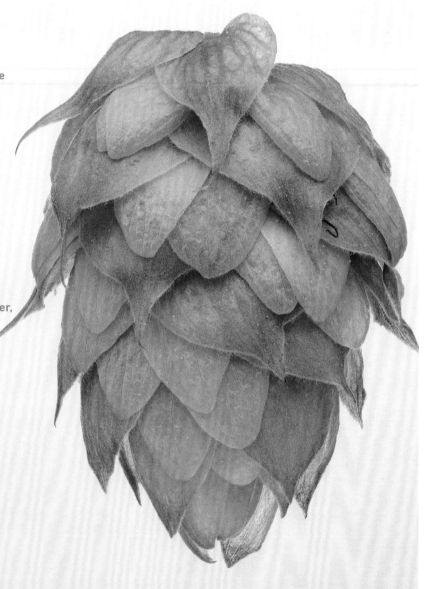

BITTERNESS
20–30 IBU

COLOR
25–40 SRM

ALCOHOL
4–5.4% ABV

MOUTHFEEL
Medium body, smooth,
no astringency

CARBONATION
Medium to high

SERVING TEMP
45°–50°F

SENSORY
Malty, crisp

GLASSWARE
Tulip pint, pokal,
footed pilsner (pictured)

SCHWARZBIER

Widely considered one of the oldest beer styles still in production, Schwarzbier is the darkest Lager you are likely find, literally translating from German as "black beer." The long and debated history of Schwarzbier often starts in Thuringia and Braunschweig at the end of the fourteenth century, but archaeological discoveries potentially date it back to the ancient Celts near what we now know as a Schwarzbier brewing center at Kulmbach. Regardless of its origin, this almost black Lager looks bold but is easy drinking, sessionable, and light-bodied enough to tempt any light Lager lover over to the dark side.

Schwarzbier is a smooth, clean, malt-forward Lager that is very dark and displays restrained roasted qualities. Its soft body, medium-high carbonation, and dry finish create a quaffable and somewhat balanced experience, despite the general lack of any prominent hop bitterness. That said, expect German noble varieties to let their delicate herbal, spicy, and floral hop character shine.

Schwarzbier's longevity as a style is only getting started in the United States. With centuries-old brewers such as Germany's Köstritzer still producing quintessential, old-school recipes, Schwarzbier is finally getting the attention of a new generation of creative, boundary pushing American craft brewers. Try Uinta Brewing Company Baba Black Lager or Dark Helmet from Westbrook Brewing for some American twists on this German classic.

MEDUSA

Named for its multiheaded cones, Medusa is a low-alpha aroma variety that is actually the very first member of the *Neomexicanus* subspecies native to New Mexico and Colorado to be commercially farmed. Although Medusa is exclusively grown by CLS Farms in Yakima, Washington, it was a gentleman named Todd Bates who was responsible for its propagation. After discovering and selectively breeding *Neomexicanus* specimens found growing wild in New Mexico, he sold his stock to CLS Farms. Medusa and her hoppy sibling Zappa (see page 234) were the two varieties selected for commercial propagation.

Look for pungent and bright fruit flavors such as guava, melon, apricot, and citrus. Its wild lineage is on display as well, sprinkling rustic notes among its ripe fruit character. Its low alpha acids make it an ideal candidate for large doses. As a fairly new variety, there isn't much acreage dedicated to this niche aroma hop, but IPA luminaries such as Sierra Nevada, Other Half, Tröegs, and Burlington Beer Company have all successfully experimented with this bined temptress.

"Whereas many of the other American hop varieties come from European genetics, the *Neomexicanus* varieties are unique agronomically as well as aroma-wise. Since they are essentially native varieties, they still carry unique traits, such as highly exposed nettles on their bines for protection. They are quite dwarfing in nature, meaning they are not used to growing vertical and can fall off the string quite easily."

—ERIC DESMARAIS, OWNER OF CLS FARMS

TYPE
New World American
(proprietary)

SENSORY
Guava, melon, lemon,
apricot, citrus

ACIDS
Alpha 2.5–4.8%
Beta 5.8–6.5%
Cohumulone 32–35%

OILS (ML/100G)
0.8–1.2

USE
Aroma

TASTE IT IN
Crazy Mountain Brewing
Neomexicanus Native Pale Ale,
Sierra Nevada Wild Hop IPA

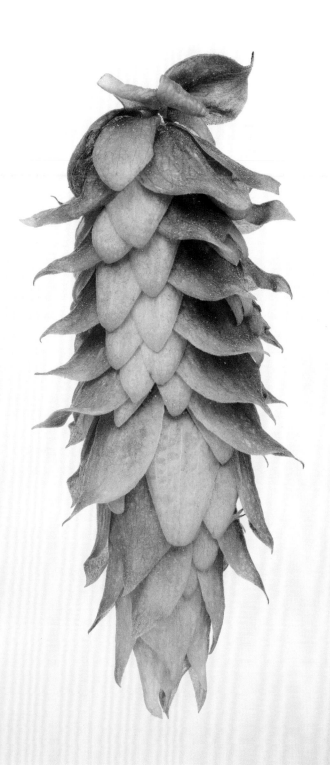

MOSAIC

With such a colorful sensory palette, it is no surprise this favorite variety was named Mosaic, which captures the cornucopia of flavors and aromas it manifests. Mosaic can be considered a triple-use hop for its bittering, flavoring, and aromatizing capacity; it is widely recognized as being a more intense version of Citra. The distinct pine-berry flavor Mosaic adds has led many to describe this punchy hop as "purple." It has good alpha acid content for bittering but really shines with a unique essential-oil profile. This name only hints at the multifaceted flavor and aroma characteristics it exudes—tropical fruit, blueberry, peach, mango, citrus, lime, mandarin orange, dank, and herbal earthiness.

Mosaic, or HBC 369, was released in 2012 by the Hop Breeding Company to much fanfare as the darling daughter to the Simcoe hop variety. Bred from a male of Nugget heritage, Mosaic has the highly beneficial trait of possessing high-alpha acid content but low cohumulone, giving it a clean and pleasant bitterness. It immediately amplified brewers' toolboxes and delighted craft drinkers' tastebuds and has experienced a meteoric rise in popularity and cultivation since it was introduced. Mosaic is currently the third most-grown hop in the United States.

Mosaic has found its most fervent devotees among IPA fanatics, but it has dosed everything from Pale Ales to Saisons and is robust enough to be optimized in single-hop brews. There are top-notch examples of the vast array of tropical and stone fruit complexity that can be coaxed from this hop on brewery menus everywhere.

"There's not that many hops that are really great for single-hop IPA. Sometimes it's obvious when you smell the hop, but sometimes how you brew with it versus what you smell can be totally different. I look for a classic profile with a blueberry-forward flavor profile and a little bit of light tropical fruit in the background. The blueberry notes are the hardest thing to get these days, and that's why Mosaic is so special. Our Mosiac IPAs have been some of our top single-hop beers for a long time."

—SAM RICHARDSON, BREWER AND COFOUNDER OF OTHER HALF BREWING COMPANY

TYPE
New World American
(proprietary)

SENSORY
Citrus, fruity, berry,
pine, dank

ACIDS
Alpha 11.5–13.5%
Beta 3.2–3.9%
Cohumulone 24–26%

OILS (ML/100G)
1–1.5

USE
Dual-use

TASTE IT IN
Other Half Mosaic Dream,
Alchemist Focal Banger

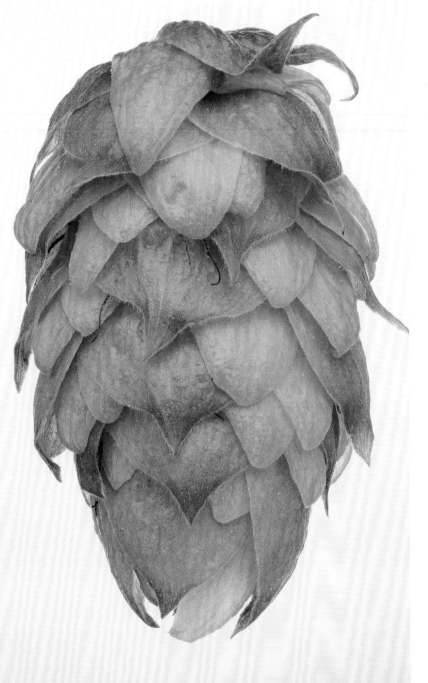

OTHER HALF BREWING COMPANY

Sam Richardson
cofounder and brewer

FOUNDED: 2014

BREWERY LOCATION: New York, NY

FIVE FAVORITES: All Citra Everything IPA, Broccoli IPA, Green Diamonds Imperial IPA, Mosaic Daydream IPA, Mylar Bags Imperial IPA

Sam Richardson, Matt Monahan, and Andrew Burman founded Other Half Brewing Company with a simple mission: to create beers they wanted to drink in a company they wanted to be a part of. Their vision was to assemble a passionate team to brew great beers and they were among the first to build their brewery business on New England–style IPAs. Demand for their pristine hazy brews continues to grow, as does their brewing prowess, with additional production locations now in Washington, DC, and Bloomfield, NY. The Other Half team believes that local breweries play an important role in their communities, and they're dedicated to collaborating with other like-minded breweries across the country and the world in an effort to constantly move the industry forward while elevating craft beer.

What is your approach to hop selection?

Everything starts with hop selection; it's a huge priority for us. I personally love to visit the farms for hop selection, and I've traveled throughout the United States, Australia, New Zealand, and Argentina to pick hops. Forging a relationship with the people who are growing and even people who are breeding, seeing what they're thinking, and letting them know what we're thinking and what we're looking for is a super important part of the process. The growers need the feedback, too, because it's become competitive to grow the best hops. We've worked with a couple of farms where we pick the same lot on the same field several years in a row—randomly.

You discover what type of hops you want and it helps the growers understand what you are looking for. It also helps them focus on the things that they're doing, and all of that makes the hops better.

In your attempts to best express the particular character of a hop, what drives your process?

It starts with the hop selection, and then it's all about the brewing technique and our palate. If we have multiple lots of the same hop variety, we always perform intense sensory analysis to find the very best lot for our dry-hopping. We have a set of expectations for ourselves so it comes down to palate—figuring in everything from water profile and yeast management to the brewing processes and dry-hopping—all those need to be buttoned up to promote the best hop character.

Some brewers feel that hopping on the early side during fermentation tends to give a less defined but more broad tropical character. I feel that if you wait until later in the process, you'll get more focused hop flavor. I like both options, but if you have a great hop, you might as well focus on making sure that hop shines and doesn't get lost in the complex of polyphenols and ester-driven profiles in fermentation. I want specific hop flavor to come through in all my beers rather than a nondescript tropical character.

We've been playing around with enhancing the thiols in our beer to get more tropical character through hops that have more thiol precursors. It's all just experimenting and playing and seeing where we can push things to best express hop character.

Do you have any favorite hop varieties for single-hop beers?

There's really the big three—Citra, Mosaic, and Galaxy. We've always been very transparent about which hops we use in our beers, and most of our customers know what each of those hop varieties actually tastes like now. Almost everybody has one of those hops in their top three. Recently Strata has become one of my favorites. There are a lot of different flavor profiles with some really weird stuff going on, but in a good way. We have one lot that smells like creamy strawberries and another one that smells like tropical fruit and dankness. They're on different ends of the spectrum, but they're both amazing.

I am really interested in the whole hop spectrum, and I find ways to include other varieties into our production throughout the year. A lot of varieties are great team players—they add a lot to the beer if you find the right combos. I'm just looking for an expressive, clean hop.

How important is freshness when drinking New England IPAs?

If people keep them cold for three months, it isn't a problem. There are two enemies of New England IPA—warm temperatures and, this is for any beer, oxidation. As long as we're packaging properly, and people are storing the beer properly, it will last. With some of the bigger IPAs, I don't think they're even hitting their stride until after they're in package for three or four weeks. They meld together better, the rough edges get smoothed out in the can, and it becomes a more enjoyable, cohesive beer. I usually think that between three and six months, if a beer falls off a little bit, I'm not going to be surprised. That doesn't mean it's going to be bad, it's just going to be different.

Do you think there's any difference between New England IPA versus Hazy versus Juicy?

It's all New England–style, that's where it comes from. It's a more respectful way to approach it, kind of like Saisons and Lambics. That's the source of it. Nobody calls them Hazy IPAs on the East Coast—that's all the West Coast. For some the term was initially used derogatorily, but now it's been adopted as standard terminology on the West Coast. I think the intentions are good, but this would be similar to all NEIPA brewers referring to West Coast IPA as Clear IPA. I prefer West Coast IPA and New England IPA, personally; it's more respectful to their origin.

You can have a New England–style IPA that's hazy and not super juicy, and you can also have one that's juicy and not super hazy. It's a production technique, and they all fall into the same category. There's a set standard for what it has to be in terms of haziness, and then it's a hop flavor profile, juicy or not. Some hops lend themselves to a more juicy profile and some are more resinous, but they can all fit within the New England IPA category. Juicy or hazy are kind of like descriptors. If you brew a Mosaic-hopped New England IPA, it will not be as hazy as a Citra-hopped version that's the same recipe across the board. I do not know all the science, but for us, Mosaic always ends up a bit clearer no matter what we do.

Much like the early days of NEIPA, why is there a love/hate relationship with Pastry beers?

I don't know why anybody hates on what other people like. One of the things that we say all the time in our brewery is that beer should be fun. We try to provide things for everybody. If you hate Pastry Stout, don't drink it. We like making Pastry beer because they're fun for us. They're like gateway beers for people who don't typically drink beer, as well as a new outlet for people who already love beer.

What exactly makes a beer a Pastry style?

There are no parameters, the sky's the limit. I think it has to be nontraditional. Maybe the biggest possible requirement has to do with introducing something pastry dessert–focused in terms of the concept behind it—there's no set rules, no real set boundaries. You could make a Pastry Amber. It's a good thing that traditionalists don't want to make it an official style because it leaves a space for brewers and customers to experiment. None of those guidelines matter, so we're just going to make something fun. We started an annual festival called Pastrytown because so many of the breweries we're friends with were making really incredible Pastry beers. We wanted to do something that brings it all together and make it as ridiculous as possible—even our branding is ridiculous. The whole point is to make beer fun because that's what people want to do—get together with their friends, drink beer, and enjoy the community they've built.

BITTERNESS
25–80+ IBU

COLOR
25–100+ SRM

ALCOHOL
4–15+% ABV

MOUTHFEEL
Varies widely

CARBONATION
Low to medium

SERVING TEMP
50°–55°F

SENSORY
Roasted, bittersweet

GLASSWARE
Snifter, nonic,
custom (pictured)

STOUT

While hops may not be the main attraction in Stout, generous bittering hop additions do play a pivotal role in balancing this style's hallmark rich, malt-forward nature. Without hops, the robust toffee, caramel, chocolate, and coffee flavors provided by the highly kilned (and often roasted) grains used to make Stout would otherwise be cloyingly sweet and undrinkable. Because of this, Stouts traditionally tend to use only bittering hops. The notable exception is American Stouts, which tend to be considerably more hop-forward than their British ancestors.

Compared to its doppelganger style Porter (see page 127), Stout generally presents higher ABV, more roasty flavor, more black color, and offers plenty more varieties to explore. By no means exhaustive, the following list of Stout subcategories attempts to progress in intensity and strength: Irish, Sweet, Tropical, Cream (Milk), Irish Extra, Foreign Extra, Oatmeal, Coffee, British, American, Imperial, and Barrel-Aged.

Colorado's Left Hand Brewing Company changed craft beer history in 2011 when they introduced their Nitro Milk Stout in a bottle. "We view nitrogen as a key ingredient," says Adam Lawrence, head brewer at Left Hand Brewing Company. "Nitrogen creates a smooth texture and perfectly complements the creaminess of the lactose and oats in Milk Stouts. Nitrogen works well with any full-bodied Stout as it promotes the drinkability; it produces an extraordinary Stout that is both complex and accessible to new beer drinkers. The nitrogen allows the chocolate and dark berry notes to dominate, while helping to mask the fusel alcohol taste and burnt aroma. Suddenly, a 10% ABV Imperial Stout is made sessionable by nitrogen. Captivating bubbles further elevate the nitro experience and make the appearance of a Stout a thing of beauty. After all, we first experience the beer with our eyes."

To accentuate this appearance, Left Hand helped in the design of the custom glass pictured here, made exclusively for Stouts by Spiegelau, a five-hundred-year-old German fine glassmaker.

PASTRY STOUTS

New to the Stout game, Pastry Stouts have caused quite a kerfuffle among traditionalists who remain skeptical of this new "pastry-archy." These beers take the concept of a decadent dessert and literally incorporate confectionery ingredients to mimic their flavors, appearance, and even mouthfeel. All-natural ingredients from chocolates, cinnamons, maple syrups, milk sugars, coconuts, almonds, and nuts to less-natural ingredients like breakfast cereals, donuts, and marshmallows have been used in Pastry Stout recipes. With no rules or boundaries holding these beers back, the only limit seems to be the different variations of desserts that exist.

MOTUEKA

Motueka is a prime specimen of all the New Zealand triploid hops, meaning it was carefully bred from three distinct parent varieties. Developed by the New Zealand Institute for Plant and Food Research, Motueka shares the crown with Nelson Sauvin (see page 174) as the most-grown hop on the island and for good reason.

A hop even more lively and vibrant than the town it's named after, Motueka's fresh crushed citrus "mojito" lime character distinguishes this variety from its New World counterparts. Motueka is an aroma hop of absolute tropical fruit salad character, with a dash of basil and rosemary spice. It's also a practical dual-use hop that equally shines when added early to the kettle, right through to dry-hopping. The lemon-lime flavor sits well in any light-bodied style, or when employed in multiple additions. Motueka's weight of oil to alpha integrates well and shines against the malty sweetness and big body of stronger beer styles.

TYPE
New World New Zealand
(proprietary)

SENSORY
Citrus, lime, tropical fruit

ACIDS
Alpha 6.5–7.5%
Beta 5–5.5%
Cohumulone 29%

OILS (ML/100G)
0.6-1

USE
Dual-use, but mostly
aroma and flavor

TASTE IT IN
Prairie Artisan Ale Standard
Hoppy Farmhouse Ale,
Wayfinder Chronokinetic

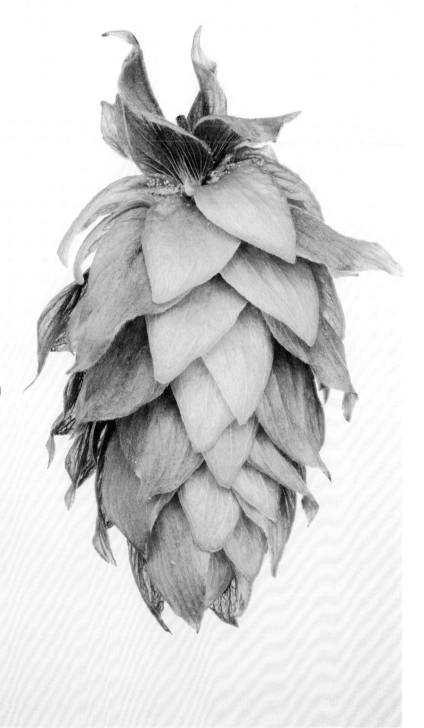

MOUTERE

This high-alpha variety hailing from New Zealand proudly possesses low cohumulone to offer soft, melt-in-your-mouth bitterness. Tropical fruit, citrus, and dank flavors and aromas only complement the easy-drinking bitterness of this exceptional hop, whose name means "island" in the Eastern Polynesian language spoken by the Maori people.

Originally sought-after for being an incredible bittering hop, the generous resins and oils of Moutere could not be contained. This is a big hop with a big dual-use purpose. Intense grapefruit, passion fruit, and earthy dank undertones are set free in late hop additions. Released to brewers worldwide in 2015, Moutere is steadily gaining acreage and popularity for its distinctive and well-structured hoppiness in a bunch of classic beer styles, including Lagers, Pale Ales, and big IPAs; it is also a solid choice for NEIPAs, Wheat, fruited, and mixed-culture styles.

TYPE
New World New Zealand
(proprietary)

SENSORY
Grapefruit, tropical,
resin, pine

ACIDS
Alpha 17.5–19.5%
Beta 8–10%
Cohumulone 26%

OILS (ML/100G)
1.7

USE
Dual-use

TASTE IT IN
Almanac Full Tilt Boogie
Hazy DIPA, LIC Beer Project
Perfectly Moutere IPA

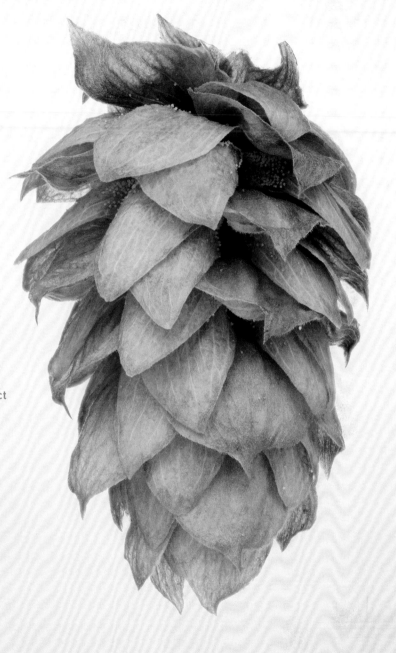

BITTERNESS
20–40 IBU

COLOR
4–7 SRM

ALCOHOL
7–10% ABV

MOUTHFEEL
Medium body, dry

CARBONATION
High

SERVING TEMP
40°–45°F

SENSORY
Complex, spicy, fruity

GLASSWARE
Pokal, goblet (pictured)

BELGIAN TRIPEL

The youngest of Belgium's famous Trappist Ales, Tripel is a style known for its strength, dryness, and spicy finish. This style was invented by Hendrik Verlinden of Drie Linden, but was popularized by Westmalle Brewery, who first brewed their Tripel in 1934, with the recipe supposedly remaining unchanged since 1956. Whether or not it is brewed at an authentic Trappist monastery, Tripel is a popular style worth exploring as a beer in which malt takes a back seat to yeast and hops. The term "tripel" refers to the fact that three times the amount of grain is needed to achieve the higher alcohol content. (Other Trappist styles include Dubbel, or "double," and Quadruple, or "quads.")

Traditionally using only lighter grains such as Pilsner Malt, Tripel also incorporates sugar adjuncts to boost alcohol content and lighten mouthfeel. It exhibits enough soft, clean malt character to balance a moderate, warming alcohol presence and support aggressive yeast fermentation characteristics, like peppery or clove-like phenols and citrus-like fruity esters. Adding to the style's intense aromatics is an intricate bouquet of traditional noble hop character—providing perfume-like spicy and floral overtones. The often-generous hop additions also give a medium-high bitterness that helps accentuate the style's dry finish. Although mild alcohol warmth can be present, expect it to be subtle and nuanced, allowing its highly carbonated, effervescent nature to dominate mouthfeel. Lastly, as with many Belgian styles, one should expect a persistent, creamy white foam to form while pouring this beer. As you consume this delicious beverage, rings should form on your glass to indicate the fill level after each sip; this is called Belgian lacing.

For the classics, try the aforementioned Westmalle Tripel or other fine examples from Chimay or La Trappe. If you're more interested in sampling a Tripel not brewed by Trappist monks, otherwise categorized as an Abbey beer, there is no shortage of examples to try. La Fin du Monde (End of the World) from Canadian brewery Unibroue and Trade Winds from the Bruery in California certainly won't disappoint.

TRAPPIST BEER

There is a limited number of breweries (twelve at the time of writing this book to be exact) producing beer recognized by the International Trappist Association, and whose labels may carry the Authentic Trappist Product label. Among other stipulations and criteria, these beers must be brewed by monks within the walls of a Trappist monastery in order to qualify.

NELSON SAUVIN

Developed by the New Zealand Institute for Plant and Food Research and released in 2000, the complexity of the flavor profile of Nelson Sauvin is often compared to, and partially named after, the country's equally famous wine grapes. Distinct winey aromas, bright gooseberry, peach, and lime characteristics have quickly made this hop variety not only the pride of Nelson (its hometown) but of the craft beer world.

This extremely versatile hop works its magic throughout the brewing process with an uncanny ability to produce a range of bold and unique hop character. Big punchy fruitiness, delicate nuanced aromas, or a rich complexity can all be achieved with judicious additions of Nelson Sauvin for aroma, flavor, or even bittering. The diversity of its oils and resins can evoke hints of kiwi and passion fruit to the one-of-a-kind, fruit-forward hoppiness that's welcome in Pale Ales and IPAs, through to more aroma-focused Lagers or any other New World style looking for unique world-class distinction.

"With their unusually high alpha acidity and their unique cool-climate flavors, the aroma and alpha hop varietals produced exclusively in New Zealand have achieved an almost cult status among craft brewers. This was kick-started by Nelson Sauvin, and New Zealand hops have now become renowned for their exotically fruity, savory, distinctive character and our varieties can be used to create clean or funky, hop-forward or really hop-forward beer styles."

—DR. SUSAN WHEELER, HOP REVOLUTION

TYPE
New World New Zealand
(proprietary)

SENSORY
Tropical fruit, berry, herbal

ACIDS
Alpha 12–13%
Beta 6–8%
Cohumulone 24%

OILS (ML/100G)
1–1.2

USE
Dual-use, but largely
aroma and flavor

TASTE IT IN
Alpine Beer Company
Nelson IPA, Garage Project
Pernicious Weed IIPA

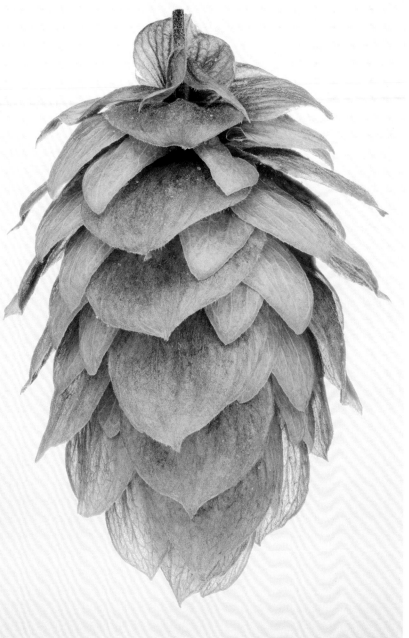

NORTHERN BREWER

Bred in England in 1934, Northern Brewer was one of the first hop varieties used to start the high-alpha breeding program at Wye College. Its release in 1944 marked the beginning of a steady increase in alpha-acid content in new varieties being bred across the world. These dark green hops were originally grown in Northern England, where the breweries in Newcastle and neighboring Scotland showcased the pleasing bittering and aroma qualities this hop has come to be known for.

Hints of pine and mint complement a woody character that has defined styles from English ales to California Commons. Northern Brewer is currently one of the main varieties now grown in Germany's Hallertau region, where it has adapted to the terroir to further develop more fragrant aroma qualities and a more refined evergreen mintiness.

"The success of Northern Brewer in Hallertau is attributable to its combination of high alpha-acid, good aroma, and resistance to wilt."

—DR. PETER DARBY, WYE HOPS

TYPE
Old World British
(Hallertau-grown)

SENSORY
Spicy, woody, grassy

ACIDS
Alpha 6–10%
Beta 3–5%
Cohumulone 27–32%

OILS (ML/100G)
1–1.6

USE
Dual-use, but mostly
bittering

TASTE IT IN
Anchor Brewing Anchor
Steam Beer, Theakson Brewery
Old Peculier Ale

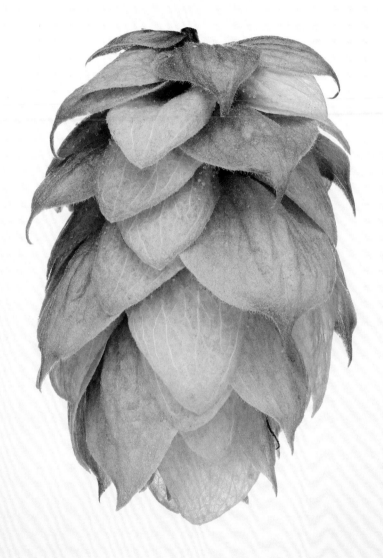

BITTERNESS
16–25 IBU

COLOR
3–5 SRM

ALCOHOL
4.7–5.6% ABV

MOUTHFEEL
Medium body,
smooth

CARBONATION
Medium to
medium-high

SERVING TEMP
40°–45°F

SENSORY
Bready malt,
restrained noble
hop character

GLASSWARE
Pint, footed pilsner,
Willi Becher,
tankard (pictured)

HELLES

Considered an everyday drinker in much of southern Germany's Bavaria, Helles is named after the word for "pale" or "bright." Popularized in Munich and thus often called Munich Helles, this medium-bodied, crisp, and clean Lager possesses subtle floral and spicy noble hop character with just enough bitterness to balance a soft, white-bready, quasi-sweetness that is further highlighted by clean yeast fermentation and thorough lagering. The simplicity of Helles makes it a joy to drink, but it takes precision and restraint to successfully brew this extremely well-balanced and highly sessionable treat.

Standing in stark contrast to the cloudy Weissbier, smoky Rauchbier, and darker Doppelbocks Bavaria was known for at the time, early Helles recipes were simply riffs on Josef Groll's popular Bohemian Pilsner (see page 197). Germany's Spaten Brewery created the first true Helles in 1894. A discernibly lower bitterness, a more refined Hallertau hop character, and a soft sweeter finish set their beer apart. A year later, Helles was officially recognized as a style with its acceptance by the German patent office for Spaten's trademark Helles Lagerbier. Despite initial concerns from traditionalists within the Association of Munich Breweries, Helles quickly gained popularity for its enticing appearance, unrivaled balance, and refreshing drinkability.

Although the popularity of Helles in Germany is largely concentrated in Bavaria, it's found appeal in craft beer markets across the globe, becoming a staple for any brewery showcasing Lager styles and brewing prowess. Naturally, look to the usual suspects such as Spaten, Hacker-Pschorr, Augustiner-Bräu, Paulaner, and Weihenstephaner for the classics, but American Helles styles coming out of Bierstadt Lagerhaus or Sly Fox Brewing will make any Munich Helles jealous.

NUGGET

For decades, brewers have turned to Nugget for clean bittering and, more recently, its essential oil content, which is best described as resinous, spicy, herbal, and earthy. Although name recognition for Nugget is lacking with the most recent wave of IPA connoisseurs, it's been a quiet workhorse in the hop-forward American craft beer market and accounted for 12 percent of Oregon's harvest in 2020, second only to Citra.

Another outstanding product of the USDA hops-breeding program, Nugget is a high-alpha variety introduced in the early 1970s. Developed in Corvallis, Oregon, from two high-alpha varieties, Nugget is five-eighths Brewer's Gold, but it hasn't inherited any of the catty aromas traditionally associated with the Brewer's Gold lineage. As connected as any hop cultivar you will currently find, Nugget is also father of Mosaic. Nugget stores well and is resistant to powdery and downy mildew but is sensitive to the deadly verticillium wilt.

THE CURIOUS CASES OF HOP DISEASES

VERTICILLIUM WILT: A soil-borne fungal disease that invades plants through the roots and wreaks havoc on hop fields, decimating many crops throughout Europe from the early to mid–1900s.

POWDERY AND DOWNY MILDEW: Fungal diseases that are visible on the shoots of the young plants and often contained by removal. Many new hop varieties are bred today to be resistant to either or both of these diseases.

PESKY PESTS: Outbreaks of pests such as the caterpillars, spider mites, and damsen-hop aphids can infiltrate and attack hop fields. As with all farming, pest control can be a major challenge.

TYPE
New World American

SENSORY
Citrus, herbal, earthy

ACIDS
Alpha 11.5–14%
Beta 3–6%
Cohumulone 22–23%

OILS (ML/100G)
1.8–2.2

USE
Dual-use

TASTE IT IN
Deschutes Brewery
Lil' Squeezy Juicy Pale Ale,
Tröegs Independent Brewing
Nugget Nectar

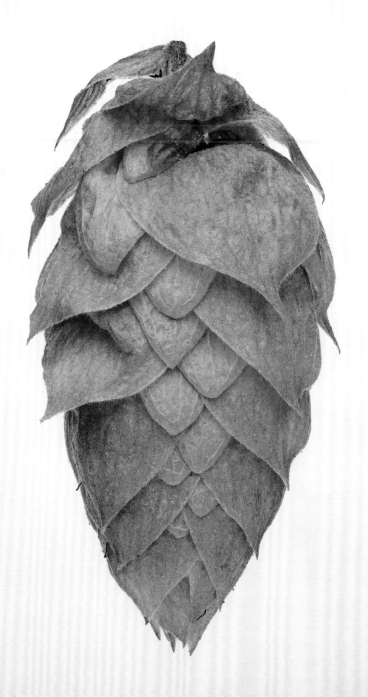

PACIFIC SUNRISE

Pacific Sunrise is a fly-under-the-radar variety released in 2000 and now grown by New Zealand's Hop Revolution on a commercial scale for the first time in 2021 in the pristine Nelson and Tasman hinterland. Its lineage is comprised of several varieties, including the great Late Cluster and Fuggle, so it should be no surprise this hop from the Southern Hemisphere is a resilient, high-yield crop that packs favorable aroma.

Lemon and clementine marmalade drive this fruit-forward variety with tropical hits of cantaloupe and mango riding shotgun. Stone fruit alongside sweet floral notes round out the overall profile with hints of pine and berry coming through an aroma of pleasant herbs that lingers. The search for new aromas and flavors has given rise to this variety in recent years. Pacific Sunrise's newfound glory has found a home in NEIPAs and modern IPA styles looking for a fresh, sweet, and jammy fruit medley for hop-forward goodness.

"Pacific Sunrise is a wonderful and vigorous variety. It grows robust, looks amazing in the field, and picks easily. We like to pick ours early because I prefer this particular hop's sensory profiles better than when they're fully matured and recommended for picking."

—DR. SUSAN WHEELER, HOP REVOLUTION

TYPE
New World New Zealand
(proprietary)

SENSORY
Lemon, citrus, tropical,
stone fruit, berry

ACIDS
Alpha 12.5–14.5%
Beta 5–7%
Cohumulone 27–30%

OILS (ML/100G)
1.5–2.5

USE
Dual-use, but largely
aroma and flavor

TASTE IT IN
Charles Towne Fermentory South
Pacific Sunrise IPA, Vitamin Sea
Brewing Pacific Sunrise IPA

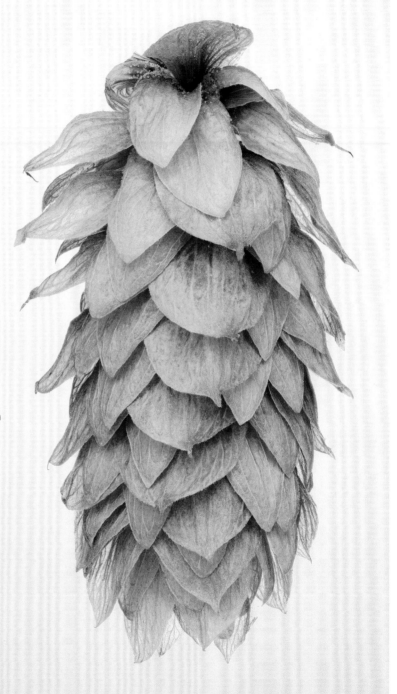

BITTERNESS
30–100 IBU

COLOR
3–6 SRM

ALCOHOL
5.6–7% ABV

MOUTHFEEL
Medium-low body;
crisp, clean

CARBONATION
Medium to medium-high

SERVING TEMP
42°–48°F

SENSORY
Bready, hoppy, varying
range of bitterness

GLASSWARE
Pint, stemmed tulip, stein,
custom tulip pint (pictured)

IPL

Considering the extent of American hop alchemists' creative endeavors, it should be no surprise that aggressively hopped Lager styles would enter the fray. In the most basic of definitions, India Pale Lagers, or IPLs, are intensely hoppy Lagers. Whereas you'll likely find noble hops highlighted in many traditional European-style Lagers, IPLs are bursting with bold and intense hop character, using fruit-forward American and New World hop varieties to give citrus, tropical, stone fruit, resin, and cannabis goodness.

Throughout the brewing process, generous whirlpool and dry-hop additions amplify and unleash aromatic bouquets and complexity over the crisp, clean, and drinkable qualities Lagers are known for. It's the Lager's inherently clean malt and fermentation profiles that allow this hop character to shine, and it is why IPL is often referred to as an "introductory IPA." IPLs usually have lower ABVs and are more carbonated, with seamlessly integrated hop profiles highlighting the bright and refreshing mouthfeel and crisp and clean finish.

Jack's Abby Brewing is trailblazing this style through their multitude of hoppy Lager renditions. So if you're in the market for a lighter, crisper, cleaner, hop-forward beverage, try their Hoponius Union for an archetypal IPL. If you're looking for a fresh take, Django IPL from OEC Brewing is a coolshipped and open fermented hoppy Lager brewed using a double decoction mash and hopped-up with all American hops.

PERLE

Perle is a well-rounded German variety with good alphas and pleasant oils. Perle has gained popularity since its release in 1978 to become one of the most prevalent German hop varieties grown around the world today. Perle is renowned for its high yields, high resistance to disease, and high oil profile. In Germany, Perle is widely used in commercial brewing in a variety of beers, starring in Lagers or employing its high humulene levels (see page 18) as a welcoming and clean bittering agent to many other sessionable styles.

What may be the most valuable asset of this workhorse is its DNA. The Hop Research Center Hüll developed Perle as a disease-resistant alternative to the noble hop Hallertauer Mittelfrüh—a highly esteemed landrace that was extremely susceptible to mildew. Bred from Northern Brewer, Perle has since been used to breed a stable of impressive offspring, including modern-day marvels Galaxy and Strata.

TYPE
Old World German

SENSORY
Herbal, spicy, piney, minty

ACIDS
Alpha 4–9%
Beta 2.5–4.5%
Cohumulone 29–35%

OILS (ML/100G)
0.5–1.5

USE
Dual-use

TASTE IT IN
Abita Brewing Amber Lager,
Schlafly Brewing Kölsch

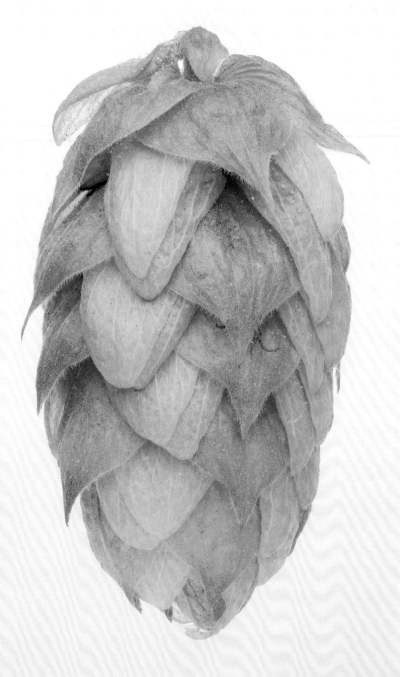

RIWAKA

This bold, fruity hop variety was born for big-beer styles and is considered the rock star hop of all the Kiwis. Bred from an old-school Saaz variety and specially developed New Zealand breeding selections, Riwaka, aka D-Saaz, was released in 1997 and boasts higher than average oil content and an almost 1:1 ratio of alpha and beta acids to give it the powerful grapefruit, sweet citrus hop character its fans lose their minds over.

A super-charged tropical passion fruit character carries straight through from the fields to the fermenters where dry-hopped Pale Ales and IPAs become the perfect stage for Riwaka to shine. This temperamental hop is in high demand but takes dedication to grow. According to Dave Dunbar of Freestyle Hops, "In a great beer, our Riwaka is undeniably our favorite hop, which is why we grow it despite being very challenging and even in the best of times rather low yielding. Having someone like Shaun Hill walking the fields with us during harvest each year and pinpointing when a block is just right for his beers provides a wealth of information that just wouldn't be possible without the meaningful collaboration we have with craft brewers."

"We were perhaps the first brewery in the United States to brew a single-hop Pale Ale with Riwaka, immediately falling in love with it and designing an IPA named Susan around this hop character. It proved impossible to acquire, and I found myself traveling to New Zealand to try and forge partnerships."

—SHAUN HILL, BREWER AND FOUNDER OF HILL FARMSTEAD BREWERY

TYPE
New World New Zealand
(proprietary)

SENSORY
Grapefruit, tropical fruit,
kumquat

ACIDS
Alpha 4.5–6.5%
Beta 4–5%
Cohumulone 32%

OILS (ML/100G)
0.8–1.5

USE
Aroma

TASTE IT IN
Hill Farmstead
Susan IPA, Hop Butcher
Riwakamania IPA

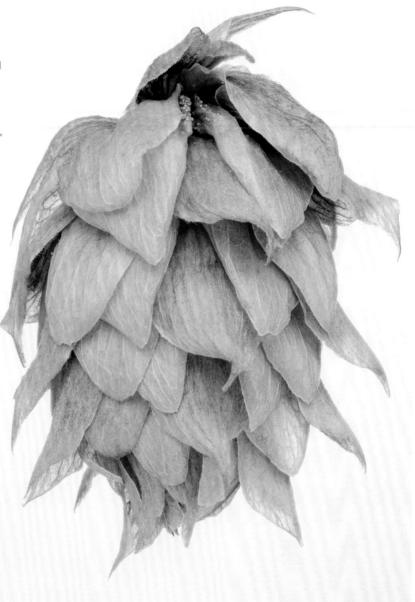

HILL FARMSTEAD BREWERY

Shaun Hill
founder and brewer

FOUNDED: 2010

BREWERY LOCATION: Greensboro Bend, Vermont

FIVE FAVORITES: Abner Imperial IPA, Art Farmstead Ale, Damon Imperial Stout, Edward Pale Ale, Poetica Pilsner

Hill Farmstead is the craft-brewing beacon of Shaun E. Hill. This little brewery nestled atop the rise on Hill Road in Vermont's Northeast Kingdom has become a trendsetter and an icon of the craft-brewing world. Those fortunate enough to have made the pilgrimage to Hill Farmstead have all sensed its magnetism as you enter the final stretch up that remote gravel road. Shaun has spent his entire professional career in pursuit of the purest pinnacle expressions of beer, often elevating the sophistication of a particular style to the realm of fine art. His uncompromising attempts toward elegance and tasteful simplicity have resulted in many of the most highly regarded, most sought-after, and most frequently acclaimed craft beers being made today.

What influences your perspective on hop choice and selection?

Our hop choices remain relatively frozen in time. For the first several years of the brewery, I was experimenting with every new variety that I could source. That voracious experimentation led to some rather poorly performing beers and lackluster experiences. We brew with the same hop varieties now that we were brewing with in 2012: Simcoe, Amarillo, Citra, Mosaic, Galaxy, Nelson Sauvin, Motueka, Riwaka, Centennial, Chinook. We still experiment here and there with newer varieties, but have ceded the desire to be an early adopter.

What led you to these hop varieties, especially when formulating your single-hop beers?

Nothing in particular about formulating them, really. I keep the malt base the same throughout, and I often find that I prefer the single-hop Pale over the IPAs—less alcohol and more space for the hops to present themselves. We keep the hopping rate the same across each hop variety so that we can learn a bit about each variety's intensity through the actualized beer.

I began the single-hop project in 2005 when I was brewing at the Shed Brewery in Stowe, Vermont, after happening upon a similar project by Sly Fox. I wanted to rebuild the Shed IPA and figured that first brewing a single IPA with each of the hop varieties in the catalog would be a knowledge-building exercise. My plan was to construct the redesigned Shed IPA from our favorites from the single series. Amarillo, Simcoe, and others became our favorites and worked their way into my beer. I first brewed with Citra in May 2010, and it was on draft at the grand opening of Hill Farmstead Brewery. Having only had Sierra Nevada Torpedo, I had never tasted anything else like it. I have been chasing the same Citra character since 2010, and hop selection itself has brought me a bit closer. I am convinced that the hop has somehow changed since it was harvested in autumn 2009.

What hop industry trends are you interested in?

Once upon a time, a brewer using pellets rather than whole-leaf hops was likely to have been stigmatized. I recall having been judged for choosing to use CO_2 extract for bittering back in 2010—and later watched those same brewers incorporate CO_2 extract into their recipes. We have made no adaptations to the new market trends of products since 2010. I have tested Cryo Hops, powders, German-packaged wet-hops, and various extracts, but none have stuck nor altered the origins of our recipes. I am sure that large brewers have much more exciting information to report in relation to new products and equipment!

Any trends you're not so interested in?

I am not excited about coconut and savory-flavored hops. I believe that beer should have an approachable and discernable bitterness. I am also concerned about the approaching, albeit still distant, extinction and reduction in acreage of hop varieties such as Chinook and Centennial. Currently, I am energized by the possibilities of the Hāpi program in New Zealand [see page 34].

The unsustainable usage of aluminum and single-use packaging is concerning to me, as is the lack of industry dialogue surrounding the taboo link between alcohol consumption and America's declining mental health. I'd like to see a pivot away from high-alcohol, Double IPA and a shift toward what I have coined as *conscious consumption*. At Hill Farmstead we collectively strive toward an understanding of our moral and ethical obligation, in ourselves and in our customers, to appreciate and respect our beer's intoxicating effects. When we are fully present, experiencing and engaging with a singular beverage, we are granted a doorway to a sensory, spiritual, and emotional experience that is fulfilling and finite.

What common pitfalls can brewers run into when making hoppy beers?

Subjectively, I'd say that whirlpool-only hopping is wasteful and the beer lacks depth and complexity. Water chemistry has one of the most substantial impacts on hop presence and articulation as well as the yeast and fermentation profile. Ultimately, I'd suggest that most brewers could improve their beers substantially by giving them more time in the tank prior to package. Too many hoppy beers taste incomplete and display incomplete fermentation characteristics.

How have you been able to differentiate yourself in the hop-forward beer landscape?

Critical control checkpoints and attention with intention to the entire process are extremely important. I certainly have a strategy and a process, which does not vary substantially from that of many brewers that I have met. However, I think that many of the brewers have a fragmented and lethargic approach toward testing and analysis of the beer during its process. Charlie Papazian's book *The Complete Joy of Homebrewing* and its catchy mantra "Relax, Don't Worry, Have a Homebrew" worked wonders for reducing anxiety in the kitchen of a home brewer, but that approach has flooded the market with mediocrity.

At Hill Farmstead, we learn from *each* temporary defeat and look for the seed of an equivalent advantage. It is tireless, but if I was a consumer, I'd rather invest my money in consuming beer that was produced by someone who was only interested in presenting me with their attempt at *perfection* and enriching my life, rather than someone who was only focused on getting beer out the door as easily as possible. There are myriad imitators in this respect. We should be cautious of any brewery that uses the words *authentic* or *integrity* in order to provide the groundwork of what a consumer should think.

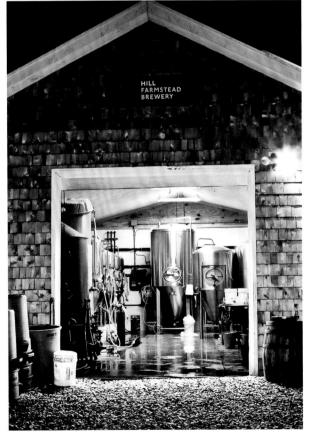

SAAZ

The only non-German member of the noble hop family (including Hallertauer Mittelfrüh, Tettnang, and Spalt), the Saaz hop is a central European landrace named after the Czech town of Zatec, pronounced Saaz in German. Famous for its spicy, floral, earthy, and grassy notes, Saaz has distinct characteristics and a noble pedigree that goes back to the Middle Ages. Since that time, Saaz production in the Czech Republic has experienced several governmental regulations and world wars but persevered nonetheless, officially registering in 1952. Today, Saaz is synonymous with classic Old World hop character and "Saazer-type" is often used as a common descriptor for all noble hops.

An early-maturing and low-yielding variety, Saaz's floral and herbal characteristics can be attributed to its relatively higher content of the terpene farnesene, while its myrcene content, typically present in higher concentrations for fruitier oil profiles, is notably lower. This unique profile is desired and used by many hop-breeding programs around the world.

The Czech hop industry relies heavily on Saaz, with nearly 90 percent of its fields devoted to this important noble hop. Global production has also increased, with high-alpha acid versions growing in the United States. Although this noble hop sensory profile is found in European Lagers across the spectrum, anyone on the planet can get an instant snapshot of Saaz with the world-renowned Pilsner Urquell.

TYPE
Old World Czech (noble)

SENSORY
Citrus, tropical, floral

ACIDS
Alpha 2.5–6%
Beta 4–8%
Cohumulone 23–26%

OILS (ML/100G)
0.4–1

USE
Aroma

TASTE IT IN
Pilsner Urquell,
Stella Artois

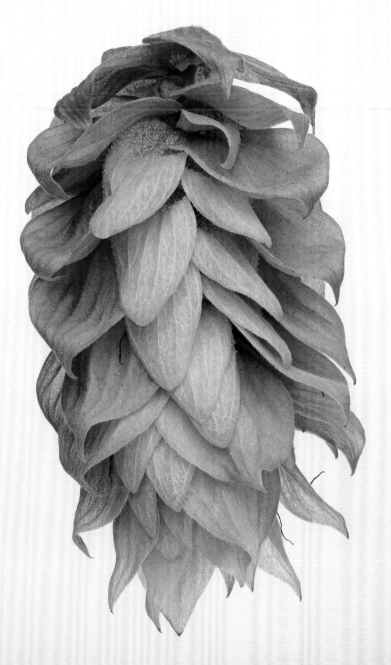

BITTERNESS
30–45 IBU

COLOR
3–6 SRM

ALCOHOL
4.2–5.8% ABV

MOUTHFEEL
Medium body

CARBONATION
Medium to medium-high

SERVING TEMP
40°–45°F

SENSORY
Spicy, floral, bready,
cracker

GLASSWARE
Pint, pokal, footed pilsner,
pilsner vase (pictured)

PILSNER

Pilsner is a crisp and refreshing light Lager that flaunts noble hops, pale malts, bottom-fermenting yeast, and cold-fermentation and conditioning for a bright and clear appearance. Pilsner originated in the Bohemian city of Plzen, Czech Republic, where the famously soft, low-ion water benefits the prominent Saaz hop profile—which Josef Groll took advantage of when brewing the very first Pilsner in 1842. The essence of any great Pilsner will forever be strongly connected to Urquell, the name given to Groll's masterpiece, which translates to "original source."

The transparent golden appearance of Pilsner may seem universal today, but when it was first released, this was a sight for sore eyes and proudly displayed in clear glass—unusual at that time. Another hallmark of Pilsner is the delicate balance among rich, bready, malt flavors and soft but assertive hop bitterness. Known for being quite aromatic, Pilsners traditionally boast the spicy and floral hoppy bouquets famously associated with the Saazer-type hop family, with which they were originally hopped. Pilsners are standard strength ABV, highly carbonated, have medium body, and possess incredible head retention.

Pilsner Urquell is still the undisputed, heavyweight champion of the commercial Pilsner market, but you can find other great Pilsners that reinvent this Bohemian style just about anywhere in the world, including distinct German, Italian, and new American sub-styles. Try Bitburger or Einbecker for a proper German "Pils" or Tipopils from Birrificio Italiano for an archetypal dry-hopped Pilsner with an Italian flair. American Pilsner has historically been limited to "big beer" brands but modern American craft breweries such as Firestone Walker, Half Acre, and Suarez Family Brewery are pushing the boundaries of the American Pilsner style.

DECOCTING PILSNER

A critical and distinguishing component to authentically crafting Pilsner is the old-school mashing technique in which a portion of the mash liquid is removed, boiled, and then returned. There are single-, double-, and even triple-decocting methods, each with their own intricacies and contributions to beer making. But for general purposes, decoction enhances color clarity, amplifies toastier malt characters, and adds to a chewy mouthfeel. A thick head of dense, rich, wet foam is often a telltale sign of an artfully decocted Pilsner.

SABRO

This expressive hop is another descendant of the subspecies *Humulus lupulus* var. *neomexicanus* that is indigenous to the mountains of New Mexico and genetically distinct from all its European cousins. Created in 2004 when Jason Perrault of Hop Breeding Company open-pollinated legendary Chuck Zimmerman's *Neomexicanus* strain with other desirable domesticated parents, HBC 438 was finally released as Sabro for commercial sale in 2018.

Brewers' admiration of Sabro is escalating due to its good alpha acid numbers and extremely high oil content, as well as for its vigorous performance in the brewing process, which manifests beautifully in the finished product. Drinkers will enjoy a complex bouquet of big citrus juiciness, with both tropical (coconut) and stone fruit (peach) aromas; many can also distinguish more subtle notes of cedar and mint. Already among the top varieties being grown in the Yakima Valley, the popularity of Sabro continues to rise as it rides the wave of new and eccentric American S hop varieties, alongside Simcoe and Strata.

TYPE
New World American
(proprietary)

SENSORY
Tangerine, tropical fruit,
stone fruit, cedar,
mint, cream

ACIDS
Alpha 12–16%
Beta 4–7%
Cohumulone 20–24%

OILS (ML/100G)
2.5–3.5

USE
Dual-use

TASTE IT IN
WeldWerks Brewery
Sabro DDH Juicy Bits, Crowns
and Hops BPLB DIPA

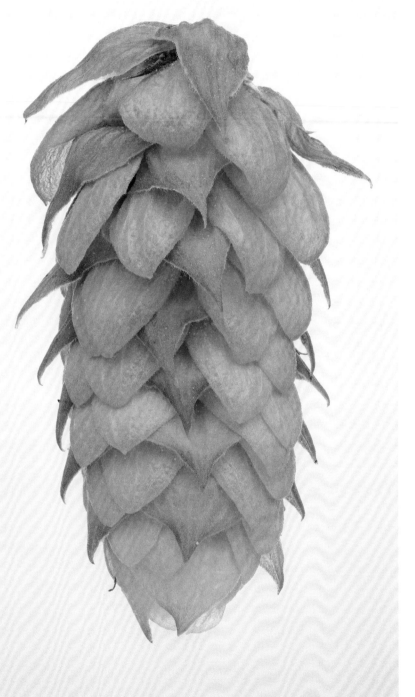

SIMCOE

Simcoe has been best described as Cascade on steroids for its famously pungent and sticky sensory profile that can be too much to handle in the wrong brewer's hands. In the right hands, it is versatile enough to be used in boil, whirlpool, and dry-hopping additions, offering abundant citrus and tropical fruit flavors augmented by subdued earthy and dank resinous undertones. It is a must-have for brewers looking for a multipurpose hop with low cohumulone to provide clean bitterness, but also enough oil to provide ample flavor and aroma. Developed by Yakima Chief Ranches and released in 2000, Simcoe is the hop that almost never was.

"We were well aware of Simcoe's attributes when first released in 2000, but could not have predicted the rise of IPA and the pivotal role it would play in that," recalls Jason Perrault, a cocreator of Simcoe. "In fact, in the early 2000s we had such a tough time moving Simcoe inventory that we nearly gave up on it. It wasn't until it was used in big hoppy beers that it found its place in the world."

Decades later, Simcoe continues to be a sought-after variety with brewers putting its exceptionally high-alphas to good work bittering some of America's favorite hop bombs. Simcoe is used often in harmony with other juicy New World varieties to provide demanding craft beer drinkers with more interesting and more intensely hop-forward brews such as Russian River Brewing Company's masterpiece Pliny the Elder (see page 204).

"I first used Simcoe when it was an experiment called YCR-014. Soon thereafter I started making Pliny the Elder [PTE], and it quickly became the main hop in PTE. I still think of those days because I was so enamored with Simcoe. There was nothing like it on the market. In 2004 PTE became a year-round beer, about the same time I started making annual trips to Yakima. I met the Smith family from Loftus Farms, the Perrault family, and the Carpenter family, all of whom own the Simcoe hop. Years later, I learned from these three families that the rise of Simcoe was directly correlated to the rise of PTE. Mike Smith and I once graphed it on the back of a napkin. This is one of my proudest moments, as all three of these families were struggling at the time, and the hop industry was a mess. It is nice to know one of our beers helped sell some hops for them."

—VINNIE CILURZO, BREWER AND COFOUNDER OF RUSSIAN RIVER BREWING COMPANY

TYPE
New World American
(proprietary)

SENSORY
Citrus, earth,
herbal, pine

ACIDS
Alpha 12–14%
Beta 4–5%
Cohumulone 15–20%

OILS (ML/100G)
2–2.5

USE
Dual-use, but largely
for aroma and flavor

TASTE IT IN
Russian River Pliny the Elder,
Weyerbacher Double
Simcoe IPA

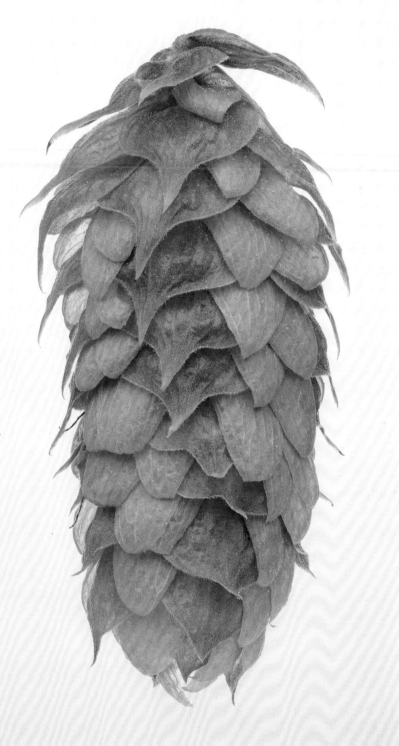

BITTERNESS
60–120 IBU

COLOR
6–14 SRM

ALCOHOL
7.5–10% ABV

MOUTHFEEL
Medium body, smooth

CARBONATION
Medium to medium-high

SERVING TEMP
45°–50°F

SENSORY
Crisp bitterness, fresh
hoppy aromas and flavors

GLASSWARE
Tulip pint, snifter,
stemmed tulip (pictured)

DOUBLE IPA

Hold on tight: Double IPA (DIPA), otherwise known as Imperial IPA (IIPA), is not for the faint of heart. This bigger and bolder version of the IPA was inevitable, given the trajectory of hop-forward beers in America at the close of the twentieth century. As consumer palates became progressively thirstier for more intense hop character, alcohol, and bitterness, the Double IPA was a natural evolution.

Stronger than an IPA but with less body than a Barleywine, IIPA is an intensely hopped, clean, dry ale showcasing both the alpha and oil characteristics of New World hop varieties. With the booziest versions exceeding 10 percent ABV, slight alcohol burn is acceptable although hop burn is not. Most modern IIPAs are dry-hopped (often aggressively) to intensify the full gamut of the American hop bouquet, like tropical and stone fruit, citrus and berry, pine, and resin. These massive dry-hopping additions—and their potential to cause hop burn—has created an increased demand for and use of innovative hop concentrates, allowing brewers to avoid vegetative burn. This beautiful collaboration between brewers and hop producers has pushed the industry forward.

IIPAs generally demonstrate medium body and medium carbonation. Their golden to copper color can be highlighted through filtration and appear transparent or can exhibit varying levels of turbidity in unfiltered specimens. Russian River Brewing (see page 204) set the standard on the West Coast with their pioneering Pliny the Elder Double IPA. On the East Coast, Sixpoint Brewery combined a variety of dank hops to produce their complex Resin IIPA, while down South, Parish Brewing Company (see page 90) continues to push the envelope in this category with their juicy Double IPA, Ghost in the Machine.

RUSSIAN RIVER BREWING COMPANY

Vinnie Cilurzo
co-owner and brewer

FOUNDED: 1997

BREWERY LOCATION: Santa Rosa, California (2004), and Windsor, California (2018)

FIVE FAVORITES: Beatification Sonambic, Blind Pig IPA, Pliny the Elder Imperial IPA, Pliny the Younger Triple IPA, Temptation Sour Blonde Ale

Russian River Brewing Company (RRBC) was established in 1997 by Korbel Champagne Cellars among the majestic redwoods in west Sonoma County. After six years, Korbel decided to get out of the beer business and agreed to transfer the brand and all recipes to their head brewer, Vinnie Cilurzo. Vinnie and his wife, Natalie, were excited to pursue their passion for craft beer together and officially opened their first brewpub in Santa Rosa in April 2004. Regarded as one of the most innovative and cutting-edge brewers in the industry today, Vinnie is credited with creating the Double IPA and Triple IPA styles now commonplace in many breweries. Aside from developing his coveted hop bombs, he is also a pioneer in barrel-aging as well as in the use of *Brettanomyces* yeast and *Lactobacillus* bacteria in many beers since 1999—long before it was the cool thing to do in the United States. Craft brewing today simply would not be the same without Vinnie, Natalie, and Russian River Brewing Company.

What is your approach to hop selection?

When we approach hop selection, we first look for what we don't want in our hops. For example, we don't want onion or garlic, so if we smell OG we will pass. Some hops have a stewed aroma, and if we notice that on the selection table, we will pass. Once we eliminate what we don't like, we can focus on what we do like. Keep in mind that we are looking at a small sample, sometimes as small as four ounces. If we start using the hops, and they don't smell exactly like what

we smelled at selection, I don't get bothered by it. What is more important to me is knowing where our hops come from. There are growers we have worked with for years, in some cases over a decade, whom I trust to grow and deliver amazing hops to me. Having boots on the ground at the hop farms is critical and enables us to discuss with the hop grower what we like or don't like about a certain variety or crop year.

How do you think about ripeness when evaluating hops in the field?

Evaluating hops in the field is hard, at least for me. I often smell the green hop notes and grape must in hops that are still on the bine. I grew up in a winery so it is a smell that is obvious to me and a smell I associate with hops on the bine. I rely on our hop-growing partners to determine the best harvest time. Once we know the picking window of a hop, a brewer can drill down into a specific time frame. Simcoe, for example, has a ten-day picking window; Simcoe picked earlier in that window will be more on the grapefruit side, while in the middle of that picking window, the hops will be more pine-like, and toward the end it will be more pungent (think dank). Learning the aroma and flavor contributions of a hop based on its picking window is vitally important.

How have you been able to differentiate yourself in the hop-forward beer landscape?

It is the art of writing a beer recipe that makes each brewery different. At RRBC, we are focused on how to get more out of our hops. Take the Guth tank mixing port I built into all of our tanks at our production brewery in Windsor, California. A Guth is a tank mixer that has a retractable arm with an impeller on the end that can be inserted into a tank through a ball valve to mix a tank. A Guth is the standard in the wine industry for mixing a tank of wine. It has been well documented that mixing your tank of beer after dry-hopping helps extract more of the oils, and many brewers mix their hops after dry-hopping by either bubbling CO_2 through the beer from the bottom of the tank or by connecting a pump and beer hoses to the tank. In my opinion both techniques have their potential flaws, so I came up with the idea to use the Guth. We saw a big increase in aroma when we started doing this.

In your attempts to best express the particular character of a hop, what drives your process?

The first thing I look at when making an IPA isn't the hop, but the malt bill and the yeast. I'll design the malt bill around what I'm trying to get out of the hops; in some cases, it is a blend of a couple base malts and in others it is our standard 2-row malt. Yeast can also be a huge component in making an IPA, and we often want our yeast to do its work and then get out of the way to let the hops shine through.

One technique that differentiates our beers from others is using many hop varieties—up to nine—in a beer. The point is to have layers of flavors that contribute lots of different aromas and flavors. A blend of hops can also help offset a hop variety that had a bad harvest year—making it easier to transition or at least lower its quantity.

As a pioneer in hop-forward American IPA, your IPAs have been described as quintessential West Coast style. Do you agree with this label?

Being told that any of our IPAs are quintessential West Coast–style IPAs is humbling and flattering. There is a lot of great beer out there, and I hope that I have done a good job at giving back to the generation of brewers that came after me, hopefully like the way Ken Grossman has inspired and helped Natalie and me over the years.

When I started making and selling IPA in the mid-1990s, there was almost nobody making beers as hoppy as I was. I could count them on my ten fingers, and I probably would have had some fingers left. Then in the 2000s it became a race for who could make the most bitter beer. Thankfully, I never took part in that and always tried to have some balance and still have a very strong hop component. Nowadays, many brewers are trying to get the most hop aroma and flavor into their beer; sometimes it comes at the expense of balance, or in many cases some progressive IPAs have hop burn, which can be a detractor.

STRATA

Originally bred in 2009 through the Oregon State University (OSU) hop-breeding program, Strata was the first commercial success resulting from the generous donation made by Oregon-based Indie Hops as part of their Aroma Hops Breeding Program partnership with OSU. It was created through open-pollination of German Perle at the OSU experimental hop yard. Dr. Shaun Townsend, director of the Aroma Hops Breeding Program, used the donation to generate nearly ten thousand seeds to start the program in 2009, one of which was his experimental genotype OR9-1-331 that sailed through evaluations to eventually be launched commercially as Strata.

A perfect dual-use hop, Strata has very high-alphas and oils, as well as low cohumulone levels. Known for balancing fresh tropical fruit, citrus, and strawberry with pungent and dank cannabis, Strata is used for its layered sensory presentation and for providing a balance normally achieved only through carefully blending multiple hop varieties. Indie Hops describes the hop as having a "chili-cannabis-funk that does not have any diesel, machine oil, or catty baggage." If that doesn't float your boat, what does?

Strata was immediately recognized as something special in the craft beer community and has experienced rapid acreage increases since its 2018 release. "Shortly after the trial harvest in 2017, we were aware that we likely had a game-changer hop," remembers Jim Solberg of Indie Hops. "While beer drinkers are enjoying beer that utilizes Strata's flavor and aroma contributions, we'd like them to know that the hop is not only a joy for them, but for everyone along the way, all the way back to the hop grower. This hop is consistently easy to care for, requires very little chemical input, and so brings a reduced environmental footprint and provides a strong yield—all of which result in a profitable crop for growers."

TYPE
New World American
(proprietary)

SENSORY
Tropical fruit,
cannabis, citrus

ACIDS
Alpha 11–12.5%
Beta 5–6%
Cohumulone 21%

OILS (ML/100G)
2.3–3.5

USE
Dual-use, but largely
aroma and flavor

TASTE IT IN
Fair State Brewing
Strata NEIPA, Worthy
Brewing Strata IPA

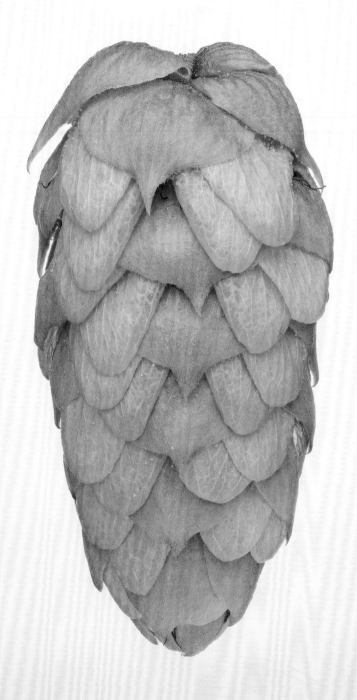

SUMMIT

Summit is a super-alpha variety born in the Yakima Valley from complicated ancestry. Known for having some of the highest alpha acids content in the game, Summit is the first semi-dwarf hop variety bred in the United States. Its bines don't climb as tall as conventional hop bines and are referred to as a low-trellis variety. Summit was creatively bred by Roger Jeske for the American Dwarf Hop Association and released in 2003. First, a Nugget-Zeus cross was open-pollinated. This hybrid was then crossed again with Zeus, creating a variety known as Lexus. Lexus was then open-pollinated and the cream of the crop moved on to ultimately become Summit.

Despite, or perhaps because of, this convoluted family tree, Summit is a serious hop with a powerful punch. With an insanely high content of alpha acids and a concentrated oil profile of unique flavors and aromas, Summit remains a cult favorite among brewers and craft beer enthusiasts alike. It's not for rookies. Lending crisp and clean bitterness, Summit also brings intense grapefruit peel–like aromas that fade into anise and black pepper spice. Growers also love Summit because it's largely disease-resistant and susceptible neither to powdery mildew nor verticillium wilt.

DWARF HOPS

Dwarf hop varieties (called "hedge hops" in England, where they were originally bred) grow to much shorter heights than standard varieties and are cultivated on low-trellis systems that are less than half the height of regular twenty-foot-plus systems. Advantages include hardier plants and harvesting efficiency—allowing the grower to pick only the cones and leaving the bine intact. The big disadvantage is short-trellis varieties can yield up to 50 percent less than regular varieties.

TYPE
New World American
(proprietary)

SENSORY
Tangerine, grapefruit,
earthy, spicy

ACIDS
Alpha 16–19%
Beta 3–6%
Cohumulone 26–33%

OILS (ML/100G)
1.5–2.5

USE
Dual-use

TASTE IT IN
Omission IPA, Widmer
Brothers Drifter Pale Ale

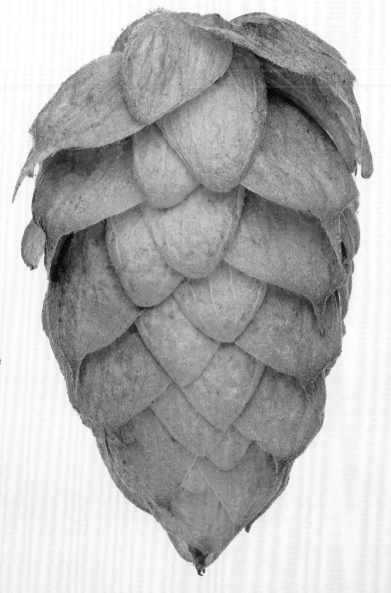

SUPER PRIDE

With all the bright, bold, and flavorful hops coming from Hop Product Australia, there was bound to be a bittering hop bomb among the arsenal of flavor-forward varieties from down under. Bred in 1987 at the Rostrevor Hop Gardens in Victoria, Super Pride is the proud daughter of Pride of Ringwood, a bittering variety once famous for being the hop highest in alpha acid content in the world when it was released in 1958—at one time even accounting for 90 percent of Australia's total hop production.

A lot has obviously changed since the 1960s, but Super Pride remixes the similar delicate aroma and the low cohumulone level from Pride of Ringwood but takes the alpha acids to the max. The classic bitter resin of Super Pride is accentuated with spicy, floral, caramel, and sweet herbal aromatics for a uniquely Australian spin on a super-high-alpha variety.

TYPE
New World Australian

SENSORY
Dank, spicy

ACIDS
Alpha 12.3–16.9%
Beta 5.2–10.7%
Cohumulone 24–30%

OILS (ML/100G)
1.3–2.7

USE
Dual-use

TASTE IT IN
Foster's Lager,
Victoria Bitter

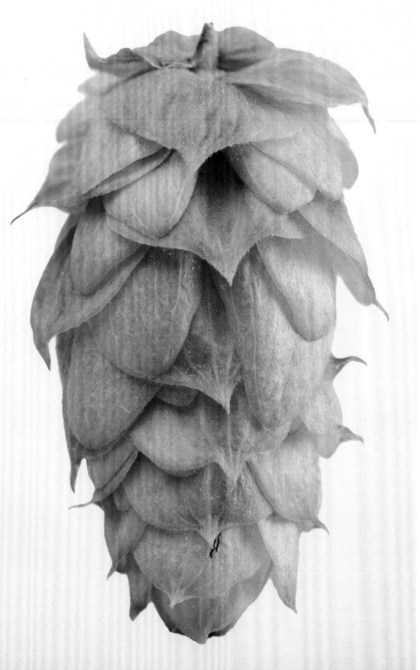

BITTERNESS
40–60 IBU

COLOR
6–14 SRM

ALCOHOL
5–7.5% ABV

MOUTHFEEL
Medium-light to
medium body,
smooth

CARBONATION
Medium to
medium-high

SERVING TEMP
45°–55°F

SENSORY
Balanced biscuits
and hoppy

GLASSWARE
Pint, dimple
jug (pictured)

ENGLISH IPA

As any beer nerd with internet access will tell you, English IPA was born of necessity. During the nineteenth century, the British struggled to successfully transport beer to India from home, as it would generally arrive undrinkable—infected or stale. Before long, creative minds (like George Hodgson of Bow Brewery) discovered that by harnessing hops antibacterial properties, one could preserve a barrel of beer for the months-long voyage to the East. There are plenty of old fables romanticizing this innovation, but suffice to say, the relatively higher dose of hops distinguishing this style began as a function of necessity not preference. This style gained prominence during the first half of the nineteenth century but would eventually diminish to near obscurity before gaining popularity again at the end of the twentieth century.

English IPA is very different from American IPA (see page 83). You may not find legions of devout hopheads camping out for the next hyped English IPA release; it's a much more balanced style relying on contributions from all its ingredients. Moderately strong, assertively bitter and crisp, English IPA has medium bready malt flavor, medium to high floral, herbal, and/or spicy hop character, and the fruit esters created by yeast during fermentation are medium to high. Even the water, natively high in minerality and sulfates, helps to contribute to the dry, crisp nature of English IPA. Additional earthy or grassy hop character and caramel notes from specialty malt is also completely suitable in English IPAs.

Since making a triumphant return to the craft beer scene, English IPA is a sessionable and classic IPA alternative worth revisiting. One of the most famous and historically accurate versions is Freeminer Brewery Trafalgar IPA, but also try CooperSmith's Punjabi Pale Ale or Great Lakes Commodore Perry IPA for modern takes on this time-honored style.

ALL IN THE FAMILY

English IPA is an old distant cousin in the IPA family tree. Here's a quick comparison of how it relates to its loud and hop-proud American relatives:

	ENGLISH IPA	AMERICAN IPA	NEW ENGLAND IPA	DOUBLE IPA
ABV	5–7.5%	5.5–7.5%	6–8%	8–10%+
Flavor	Malty, crisp, balanced	Crisp, hop-forward bitterness	Pillowy, hop-forward juiciness	Hoppy to the max
Hoppiness	Sessionable, floral, earthiness	Bold, clean, tropical, resin	Increased fruitiness	Extreme hop saturation
IBU	40–60	50–70	30–60	60–100

TALUS

The year 2020 wasn't a total throwaway. A decade of meticulous work paid off when the venerable Hop Breeding Company released their experimental HBC 692 under the proper name Talus. It's an offspring of Sabro (see page 198), whose *Neomexicanus* wild ancestry shines through in this newest addition to the daunting hop arsenal of HBC. Credited to hop whisperers Eugene Probasco and Jason Perrault, the name Talus is a tribute to the Yakima Valley scenery and refers to the rocky fragments protruding from the cliffs and slopes of the many mountain vistas visible from the growing fields of the hops.

Talus is one of a kind, with intense pink grapefruit, citrus rind, and tropical fruits complemented by a potpourri of pine, mint, cedar, and sage. Brewers praise Talus for both its versatility—it works well solo or in conjunction with other hops—and its longevity—it maintains both its flavor profile and intensity throughout the entire brewing process. This unique hop is currently imparting its new flavor to styles across the IPA spectrum and also finding solid applications in Lager, Wheat Ales, and Farmhouse Ales alike.

"The process of selection for HBC 692 was very much driven by the search for unique flavors and aromas; not a specific aroma, but rather 'unique' as a trait. There were about a dozen sisters selected from the original cross, each very unique and impactful (some better in aromatics than 692 in my opinion). HBC 692 rose to the top of the class due to the right combo of agronomics and aromatics. *Neomexicanus* genetics play an important role in this variety, the mechanism of which we are still studying."

—JASON PERRAULT, COCREATOR OF TALUS

TYPE
New World American
(proprietary)

SENSORY
Pink grapefruit, citrus rinds,
dried roses, pine,
tropical fruits, sage

ACIDS
Alpha 8.9–9.5%
Beta 8.3–10.2%
Cohumulone 34–39%

OILS (ML/100G)
1–2.2

USE
Aroma

TASTE IT IN
Slice Beer Company Hit the
Gas Triple IPA, Fremont
Brewing Space Rex Hazy IPA

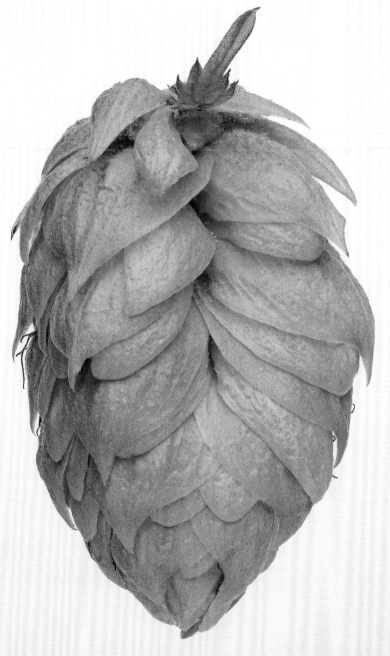

TOPAZ

Topaz was originally bred as a bittering hop by Hop Products Australia in the mid-1980s as a seedless variety intended for extract production. Massive cohumulone and desirable alpha acids offer a resinous, grassy bitterness when added in early additions, but Topaz was revitalized in the 2000s as a versatile dual-use variety after brewers successfully experimented with late hop additions of this Australian gem.

Sweet and tart lychee stone fruit flavors and a hint of tropical fruit come through when added late in larger doses. Dry-hopping will also infuse an extra layer of unique clove spice and an added fruity character that further develops a depth of flavors that work exceptionally well against the sweetness of higher ABV styles. Topaz is also known to be a great partner to other Aussie hops, especially Galaxy and Vic Secret, where their combo of hop characteristics integrates and excels in many classic and modern beer styles.

TYPE
New World Australian
(proprietary)

SENSORY
Tropical fruit,
resinous, herbal

ACIDS
Alpha 16.2–20.1%
Beta 4.9–6.7%
Cohumulone 47–53%

OILS (ML/100G)
1.3–1.8

USE
Dual-use

TASTE IT IN
Night Shift Fluffy NEIPA,
MadTree Brewing Galaxy
High Imperial IPA

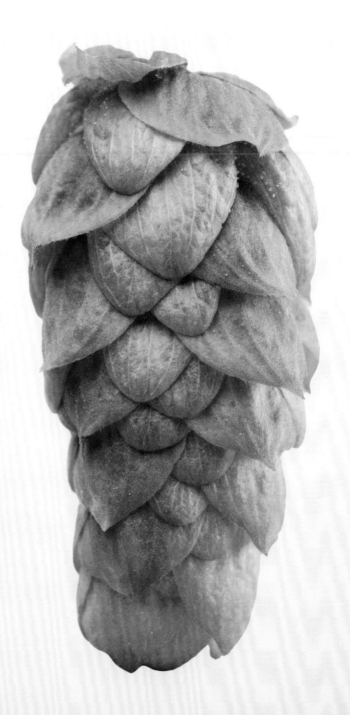

VIC SECRET

Yet another genetic masterpiece created by the folks down under at Hop Products Australia, Vic Secret is often compared to Galaxy, only not as intense. It shares a high-alpha-content Australian mother with its sister Topaz, and its father is a European variety from England's Wye College hop-breeding program. As a result, this super-alpha, dual-use variety boasts huge, clean fruit character when used for whirlpooling and dry-hopping, but more herbal and earthy tones when used late boil. This delicious dichotomy of fruity and herbal character comes from its split ancestry and can be more specifically compared to tropical fruits such as passion fruit and fresh pineapple, accented by subtle herbs, pine, and resin.

Vic Secret is the second most commonly grown hop in Australia, just behind Galaxy, and has grown in popularity every year since its release in 2013. Its versatility makes it broadly appealing for a variety of styles—crisp Lagers with clean bittering, malt-forward styles such as Porter with balanced bitterness, or hop-forward styles such as NEIPA, featuring big fruit from dry hops.

"Vic Secret lurks in the shadows of Galaxy, but in my opinion is the cleaner and more focused hop of the two. Vic Secret offers pure passion fruit and pineapple candy essence without all the funky peach and robust oil of Galaxy. Depending on the hops I partner it with, I can easily get a lot of green tropical notes for anything from light Lager all the way into dark Sour beer. I just love how ubiquitous that hop can be."

—DOUG REISER, COFOUNDER OF BURIAL BEER COMPANY

TYPE
New World Australian
(proprietary)

SENSORY
Pineapple, pine, herbal

ACIDS
Alpha 15.1–21.8%
Beta 6.4–8.1%
Cohumulone 51–56%

OILS (ML/100G)
2.1–2.8

USE
Dual-use

TASTE IT IN
Bissel Brothers Brewing
Company Reciprocal IPA,
Burial Beer Company
Ceremonial Session IPA

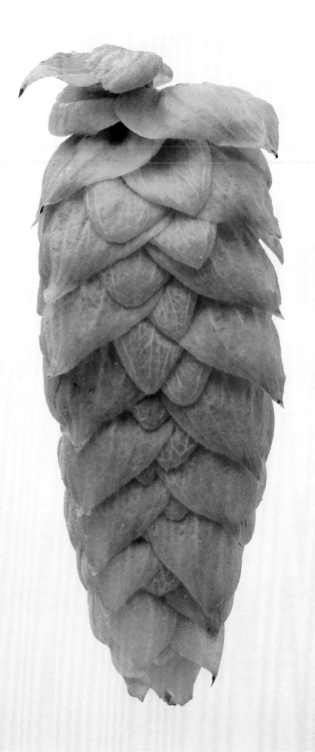

BURIAL BEER COMPANY

Doug Reiser
cofounder and owner

FOUNDED: 2013

BREWERY LOCATION: Asheville, North Carolina

FIVE FAVORITES: Blade and Sheath Saison, Skillet Donut Stout, Surf Wax IPA, Gang of Blades DIPA, Shadowclock Pilsner

Asheville, North Carolina, is arguably one of the top beer destinations in the United States, and Burial Beer Company is the brewery that gave rise to the South Slope neighborhood. Burial, for some, is a necessary step to reach the afterlife. At Burial Beer Company, they see burial as a celebration—of life, of the cyclical nature of harvest, and of the brewing process. The brewery began its life as a one-barrel system, and the bold, creative, and modern beer styles they brewed quickly allowed them to grow into the influential mavericks they are today. Kicking out Belgian Farmhouse Ales, German Lagers, and Hazy IPAs, Burial continues to innovate and elevate the craft industry with their second location in Asheville known as Forestry Camp.

What is your approach to hop selection?

I select for everything. All the way down to black Lager. But obviously hoppy ales and Pilsners are the driving force behind our contracts. Modern IPA takes immense amounts of hops, and Lagers are growing in usage rates. But we're also looking at more savory and rich varieties to give our dark ales a boost and make them more unique than those that try to ignore hops as a component to those styles. To me, hops will forever define beer. They are the grapes of wine, the apples of cider, the lifeblood that defines beer.

How have you been able to differentiate yourself in the hop-forward beer landscape?

I think hop selection is still widely overlooked, or perhaps underutilized as a process of connectivity. Brewers are not as well connected to the farms as they should be. I'm always flabbergasted by how few seem to take the opportunity to get in front of farmers and select their lots. I'd bet that many are unaware of how different lots of the same varieties, from the same growers, picked on the same day, can truly be. It's remarkable. And frustrating. And badass. We spend a week in Yakima Valley every year, often visiting the individual farms to smell the piles out of the kiln and chat up the growers about the variables impacting quality. It helps us better understand the conditions that contribute to the qualities we want. Sun, rain, soil, weather, picking time, processing, and pelletizing all offer volatilization. The goal is to locate the variables that impact steering Mosaic more

blueberry than pineapple, or what gives Cashmere curry instead of that righteous strawberry-lime combo I seek out each year.

I also think that customers are what drive all of us. It starts there. What are they rating through the roof, buying en masse, and screaming about? That drives brewers to focus on those varietals and combos, inevitably contract more, and if you're smart, track down the right type of hop via selection. I threw our ego out years ago. Our core values are centered around the notion that we provide an immersive experience to our customers. So we listen to them.

What industry trends are you interested in?

I adore hoppy Lager. It's a challenging beer to make excellently. It's difficult to balance the youthfulness of hop vibrancy and fermentation minerality against the harmful byproducts of Lager-making. It's science and art at their best. And the style

is the most widely appreciated, both reaching industry session pundits and your standard IPA drinker. I feel like they've usurped the space once inhabited by modern Pale Ale. I treat our hoppy Lagers as a marriage between West Coast IPA and American Pilsner. I rarely use old-world nobles at all, but I do want a zesty noble character matched with some brighter fruit. Clean fruity hops such as Vic, Galaxy, Strata, and Mosaic match nicely with more mineral and zesty hops such as Wai-iti, Motueka, Crystal, and Cashmere. I try not to go beyond two to three varieties though, as linear is the key with a Lager. You want that nose to be as sharp as the fermentation itself. If you add a bunch of complexity, you are going to make it too cloying to be a true Lager. You still want the consumer to be able to pick out the direction of the beer.

Any trends you're not so interested in?

Anything with unfermented fruit in it. We just decided we did not want to do it. My entire staff has ardently been against

it. Similarly, we don't do kettle sours. We invested in a process that we enjoyed years ago and continue to age low and slow. It's worth it to us, even though I understand it may not be the economically feasible choice of others.

What hop products and processing techniques are you most interested in?

I love the concentrated products. They dramatically changed how we make beer. I love using as many of these products at the same time as I can in order to get a full spectrum of hop aroma, flavor, and mouthfeel.

There is but one crucial piece of equipment at Burial—the centrifuge. Making great hoppy beer requires clean up and inevitably that used to take time. But getting hops and yeast away from each other quickly is the beauty of the centrifuge. It both alleviates risk of hop creep [refermentation from introduced enzymes in hops] and removes mouthfeel-murdering particulate. Most importantly, it speeds up

getting the beer to the customer. That way they get to witness the evolution of beer from max aroma to a more complex beast.

What common pitfalls can brewers run into when making hoppy beers?

Prioritizing volume and density over quality. Hoppy beers are being stuffed with immense amounts of hops at unreal gravity levels to blast people off to the moon. But when they come down, they're stuck with a cloying mess of yeast bite, syrup, and often yeast eaters. Brewers should slow down and ferment to soften esters, utilize efficient hop contact in dry hops, and ensure they take the time or process to remove particulate.

In your attempts to best express the particular character of a hop, what drives your process?

Truth. I find that a lot of people are at odds at the selection table. Some people are reaching for the classic characteristics, but they don't always exist. I have smelled Citra that reeks of diesel fuel and bad Sauvignon Blanc, and Mosaic that was rife with Play-Doh and Pine-Sol cleanser. The important part is recognizing your first reaction and not letting that go. It doesn't mean that it becomes the end-all-be-all of the hop itself, but you cannot dismiss it. That entry point is crucial for me. I also believe that hops seem to lose a step through processing,

and that if you have a delicate hop that you are appreciating on the table, you have to consider whether it will decline. We typically aim high.

I think that patience, process, and symbiosis are very important. Patience is about understanding how the hop works in extraction. I learned that from coffee, where time and exposure are so crucial to understanding what you get out of the plant. Understanding how long it takes to properly extract the right oils is important. Process is about knowing what you can get from the hop at different intervals of production. This is the key to getting aroma that you know to be possible. Some could squander that piece if they don't embrace the correct timing and handling. Symbiosis is about understanding the relationship between hops and the variable elements of your beer. Water minerality must sync up with the hop profile, and of course, your yeast must be amenable to working with your hop interaction. The interaction between hops and yeast is well-discussed, but it can go in either direction— and those directions are dramatically different from beer to beer. We subscribe to the notion that yeast should do its thing, and then hops get its shot. We do not tend to believe that the two should be on the job together.

BITTERNESS
50–75 IBU

COLOR
2–5 SRM

ALCOHOL
6.4–7.9% ABV

MOUTHFEEL
Medium-low to low body

CARBONATION
High

SERVING TEMP
35°–40°F

SENSORY
Crisp, refreshing,
clean bitterness

GLASSWARE
Pint, stein,
Willi Becher (pictured)

COLD IPA

A more recent development in the hop-forward IPA evolution is the Cold IPA. First concocted in 2018 by brewmaster Kevin Davey from Wayfinder Beer in Portland, Oregon, this "wester than West Coast" style is essentially a crispy, dank, anti-hazy IPA that's brewed with a lot of hops, a simple malt bill, Lager yeast, and adjuncts like corn or rice to increase the alcohol content, lighten the body, and amplify hop character.

"Brewing with adjuncts may be the most American way of brewing so I wanted to incorporate adjunct brewing in IPAs," says Kevin Davey. "Using rice and corn is what gives Cold IPA its bright appearance and allows it to be dry without being overly bitter—it's an assertive clean bitterness that's crisp and bold."

Neutral malts and clean fermenting yeast are also paramount to creating a canvas for hops to shine. Kevin instructs, "Cold IPAs need to start with a soft water profile and use a clean fermenting yeast to allow huge assertive hop character to shine without any interference from the esters associated with ale yeast strains. I used my own house Lager strain of yeast but ferment it warm [65°F] to avoid excess sulfur dioxide. Dry-hopping is also key to my process. I use a technique commonly used for making Italian Pilsners [called the dry-hop spund] where I add fresh fermenting beer to a finished tank with the dry hops. This helps fully carbonate the beer and the active yeast biotransforms the hops and scrubs out any oxygen we might add during dry-hopping."

The result is a style categorically different from IPL and an IPA like no other—a unique ale with tremendous hop aroma, clean bitterness, bold hop flavor, and crisp finish that balances the hops with its higher ABV. Aside from Wayfinder's many Cold IPAs and their original Relapse IPA that uses bucket loads of Old and New World hop varieties, other new-school brewers are jumping on the Cold IPA beer wagon to create hoppy masterpieces that showcase a wide variety of the newest New World hops from the United States, New Zealand, and Australia. Breweries like Hop Butcher, pFriem, New Realm, and 21st Amendment are just some of the places bringing bright, clear, and highly drinkable hoppiness to us all.

WAI-ITI

Another tasty modern hop variety developed by the New Zealand Institute for Plant and Food Research, Wai-iti is named after an area of the North Island where it is believed some of the first hop gardens were grown in the mid-1800s. Released in 2011, Wai-iti is a triploid hop with, most notably, one-third of its lineage coming from the German landrace Hallertauer Mittelfrüh. In the field, Wai-iti stands out in the intensity of the aromas, attributable for the most part to the high weight of oil and the oils-to-alpha ratio. Freshly squeezed limes with top notes of mixed citrus are all part of a heady blend of essential oils.

Brewers take advantage of this lush aroma hop in early additions where the citrus characters take a small step back to make way for low cohumulone levels and high levels of farnesene terpene to create a rounded clean bitterness. Wai-iti is best known for its high oil content that delivers fruity, aroma-driven results. Fresh peaches and apricot dominate in late additions and dry-hopping, especially when used in single-hopped beers, from Lagers to ales, where sessionable bitterness and fruity aromas and flavors fill the glass and the senses.

TYPE
New World New Zealand
(proprietary)

SENSORY
Stone fruit, lime, citrus

ACIDS
Alpha 2.5–3.5%
Beta 4.5–5.5%
Cohumulone 22–24%

OILS (ML/100G)
1.6

USE
Aroma

TASTE IT IN
Collective Arts Brewing
Audio/Visual Lager, Hoof
Hearted Reptilian Beauty
Secrets Pilsner

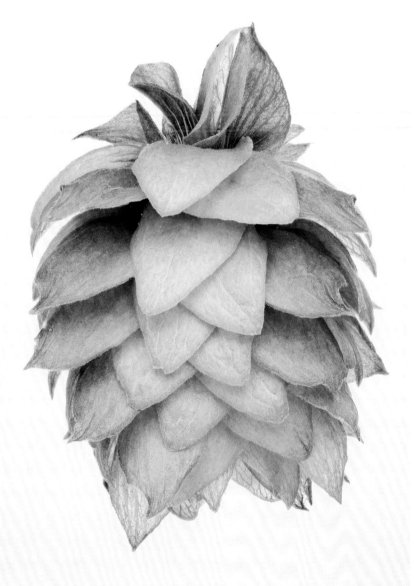

WAIMEA

Waimea translates to "river gardens" in the indigenous Maori language of New Zealand and is the perfect name to describe the terroir of the rich, fertile soil of the Waimea Plains that lie a short distance from the Tasman Bay in Nelson. This area is also one of the country's sunniest spots and makes the perfect home for this beast of a hop.

Waimea is a triploid cultivar that links its lineage back to Late Cluster, Saaz, and Fuggle. With amazing parents, outstanding oils, alphas, and excellent performance in the fields, it should be no surprise Waimea became an instant success after its release in 2012 by the New Zealand Institute for Plant and Food Research.

A hefty alpha hop that carries an even greater weight of oils, Waimea was born to be a multitalented, dual-use superstar. It can be used across an array of beer styles in a variety of brewing applications—from early kettle additions right through to dry-hopping. Quality bitterness and aroma abound with fruity tangerine, grapefruit citrus, and pine needle characteristics that contribute to the reputation Waimea has as a great finisher.

TYPE
New World New Zealand
(proprietary)

SENSORY
Pine, citrus

ACIDS
Alpha 16–19%
Beta 7–9%
Cohumulone 22–24%

OILS (ML/100G)
2.1

USE
Dual-use

TASTE IT IN
Maui Brewing Waimea
Red Ale, Upland Brewing
Tropical Vortex IPA

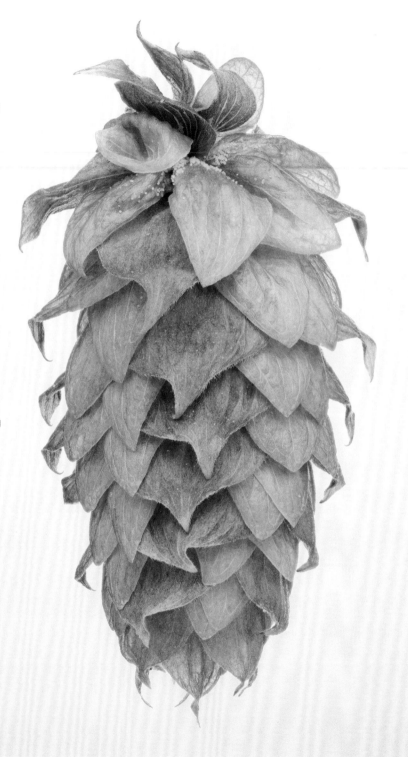

WILLAMETTE

As scientific and technological progress in the hop industry allows for the breeding of super strains, it's important to remember early pioneering varieties such as Willamette that were hopping our favorite barley pops long before anyone knew what a IIPA was. Still grown in all three major hop-growing regions of the United States, Willamette was released in 1976 by usual suspects Al Haunold and Chuck Zimmerman as part of an effort to find an American replacement for the British Fuggle variety. Although acreage in Willamette has declined with the ascendance of more statistically impressive varieties, it once accounted for more than 75 percent of the total hop acerage in Oregon.

Born in and named after the great state of Oregon, Willamette has complex spice, accented by floral earthiness with notes of herbs and fruit, which predictably comes from its Fuggle pedigree. Low levels of alpha acids make Willamette a good late-boil or whirlpool addition for a variety of styles—from Lager and Golden Ales to the entire catalog of English Ales.

The long history of Willamette with American breweries includes both macro- and microbreweries alike. The industry-wide large brewery shift toward hop extract combined with the high-alpha movement are leading catalysts for the decrease in acreage of this legacy hop.

TYPE
New World American

SENSORY
Spicy, herbal, earthy,
floral, fruity

ACIDS
Alpha 4–6.5%
Beta 3–4.5%
Cohumulone 28–35%

OILS (ML/100G)
0.6–1.6

USE
Aroma

TASTE IT IN
New Belgium Fat Tire,
Harpoon Boston Irish Stout

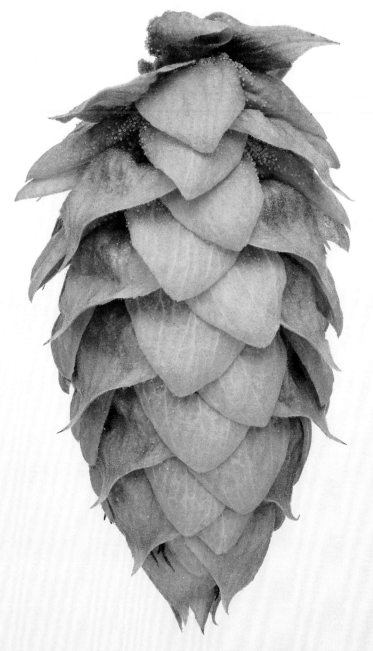

ZAPPA

Like its counterculture icon namesake, this 100 percent *Neomexicanus* variety is an indefinable enigma, born free in the wild American landscape. Found growing wild in the mountains of New Mexico, Zappa is a unique aroma hop that balances a blend of spices, fruit, and pine. Singled out by Tom Nielsen of Sierra Nevada and brought to us in 2018 by Eric Desmarais of CLS Farms, Zappa is proof of Mother Nature's pure and wild spirit.

Named after Frank Zappa, this hop seems to speak to everyone differently. Loads of fresh passion fruit and mango characteristics are coupled with spearmint and pine. Some brewers have resorted to using descriptors like "impulsive" to describe this riddle of a hop. First and foremost an aroma hop, Zappa is best suited for whirlpooling and dry-hopping in hop-forward and fruited beers such as IPAs and fruited Sours, where the unparalleled, wild fruit profile of Zappa can find synergy with the other ingredients in the brew.

"The aromas are very unique and not ones that most craft brewers have been exposed to, so they open a whole new aroma spectrum for brewers. We have had some brewers come through the farm and describe Zappa hops as 'purple,' which is an uncommon descriptor for hop aromas, though we've found many people resonate with it."

—ERIC DESMARAIS, OWNER, CLS FARMS

TYPE
New World American
(proprietary)

SENSORY
Passion fruit, mint, spice,
marmalade

ACIDS
Alpha 6–8%
Beta 8–9%
Cohumulone 40–45%

OILS (ML/100G)
1.8–2.5

USE
Aroma

TASTE IT IN
Duck Foot Brewing Company
Why Does It Hurt When IPA?,
Tattered Flag Brewery Zappa
Cold IPA

PART 3:
RESOURCES

Craft Beer Lingo

The continued progress of craft beer culture is driven by a diverse community of industry professionals and craft beer drinkers who are often as eccentric as the special language they sometimes use. Here's a rundown of "juicy" terms to consider while crafting a "balanced" vocabulary on your path to becoming a true "zythophile."

ABV: Alcohol by volume, a measure of strength; the percentage of alcohol present in a given volume of water.

ACETIC: Sensory descriptor implying vinegary acidity and generally considered undesirable.

ADJUNCT: Any nonmalted source of fermentable sugars. This includes fruits, vegetables, and sugars such as honey and maple syrup, as well as unmalted grains, such as barley, wheat, oats, and rice.

AFTERTASTE: Any lingering tastes noticeable after swallowing a sip of beer.

ALCOHOL OR ETHYL-ALCOHOL: The intoxicating liquid byproduct of the fermentation of sugars by yeast.

ALE: A category of beer made with top-fermenting yeast at temperatures relatively warmer than its counterpart. See also Lager.

ALPHAS: Common term used for alpha acids contained in the resin glands of hops. These are the main source of hop bitterness in finished beer.

AROMA HOPS: A broad category of hops that contain a high level of essential oils that impart a multitude of diverse aromas and flavors to the finished beer. See also oils.

ASTRINGENT: A drying, puckering mouthfeel sensation that's generally unpleasant. See also hop burn.

ATTENUATION: The degree to which sugars are converted to alcohol and CO_2 during fermentation. Highly attenuated beer generally has a clean, crisp mouthfeel, whereas low attenuation contributes to more body and sweetness.

BALANCE: A harmony between contrasting elements typically used when speaking of hops and malt.

BARLEY: By far the most common cereal grain used in beer production. See also malt.

BARREL: A wooden vessel; or a measurement of liquid thirty-one gallons. A typical keg of beer is equal to half a barrel.

BARREL-AGING: Conditioning of beer in a wooden barrel often over a long period of time in order to mellow and absorb the characteristics of the barrel itself or of the liquid that previously was held in the barrel.

BINE: A climbing plant, such as hops, that wraps itself around a support. Unlike a vine, a bine doesn't use tendrils or suckers, but instead twists itself in a helix around a rope as it grows.

BITTERING HOP: A broad category of hops that contain high amounts of alpha acids, which are generally boiled in order to activate bitterness. See also isomerize.

BITTERNESS: Generally refers to the hop characteristic that is sharp, astringent, and lacking any sweetness.

BODY: Used to describe the liquid viscosity of beer and the sensation of its fullness, thickness, or lack thereof on the palate.

BOTTLE- OR CAN-CONDITIONED: Beer that is carbonated naturally by live yeast inside the bottle or can itself.

BRETTANOMYCES OR BRETT: A genus of wild yeast, generally considered a spoilage organism, but it is intentionally featured in Sour and wild beer styles.

CARBONATION: The amount of bubbles that occur when carbon dioxide (CO_2) dissolves in beer. This can vary widely depending on the beer style and/or a brewer's preference when they "carb-up" their beer.

CHILL HAZE: A hazy appearance that results after a beer is made cold.

CLEAN BEER: Broad term for the many beer styles made in sterile environments with *saccharomyces* yeast strains.

COLLAB: A collaboration between two different breweries or brewers on the creation of a single beer often promoted and released collectively.

CONTINENTAL HOPS: See Old World.

COOLSHIP: A shallow, open-top vessel that exposes freshly brewed wort to the open air, both to cool this hot liquid down and to inoculate it with yeast and/or other microorganisms.

CRISPY: A mouthfeel associated with a high attenuation and/or high carbonation. Also, a slang term for a craft Lager beer.

CRUSHABLE: Beer that is easy to drink and refreshing, usually referring to a lower ABV. See also sessionable.

DDH: Double dry-hopped.

DECOCTION: An old-school mashing technique where a portion of the mash liquid is removed, boiled, and then returned. See also mash.

DIACETYL: A buttery, undesirable off-flavor caused by incomplete fermentation/conditioning or bacterial contamination.

DISTRO: Short for distribution; used to describe beer that is delivered and made available in bars and stores, not just the brewery. See also release.

DRAFT (DRAUGHT): Beer poured from a faucet or tap.

DRAIN POUR: A beer that is undrinkable for various reasons and discarded immediately.

DRY-HOPPING: Adding hops during or after fermentation with the goal of infusing only the aromas and flavors associated with the essential oils, not the bittering alpha acids.

ESSENTIAL OILS: See oils.

ESTERS: These are flavor compounds created primarily by yeast during fermentation, where an organic acid and alcohol combine to form what are generally considered sweet, fruity flavors.

FERMENTATION: The conversion of sugar to ethyl alcohol and carbon dioxide by yeast.

FERMENTER OR FERMENTATION TANK: A vessel used in the brewing process to ferment beer.

FG: Short for final gravity; this is the measurement of the relative density of a beer at the end of fermentation.

FILTRATION: The process by which particulate matter is removed from liquid via various methods and mediums to stabilize or otherwise clarify the liquid.

FINISHING HOPS: Hops that are added toward the last several minutes of the boil in the brewing process; generally aroma or dual-use varieties.

FLIGHT: A tasting sampler of a brewery's offerings, typically poured in smaller serving glasses.

FLOCCULATION: The propensity of yeast cells to aggregate after fermentation and drop out of suspension, characterized as high, low, or medium. For example, high-flocculating yeast will drop out almost completely and is less likely to be left in solution.

FRESH-HOP: See wet-hop.

GRAINS: During the brewing process, grains provide the sugars that will drive the production of alcohol by yeast during fermentation. The list of grains that can be used is vast, although most beer is made from cereal grains like barley. See also malt.

GREEN: Term generally used to describe beer that has finished primary fermentation but has yet to finish conditioning. Can also refer to a freshly packaged beer that if drunk too soon presents more vegetal and/or harsh hop flavors rather than a smoother flavor, if allowed to rest for a period.

GRIST: All the grains for a beer recipe that are milled and mixed together.

GRUIT: Popular prior to the adoption of hops, this alcoholic beverage utilized a mixture of bittering and flavoring herbs and other botanicals instead of hops to balance the sweetness of malt.

HAZE/HAZY: The cloudy appearance of unfiltered beer. See also turbidity. Also, a slang term for New England IPA.

HEAD: The frothy foam at the top of a poured beer.

HEAT: A warming mouthfeel associated with higher ABV beers.

HEAVY: A bold beer with higher alcohol content. Also often called "high-gravity" or "big" beer.

HOP: The female cone flower of the plant species *Humulus lupulus*.

HOP BIOTRANSFORMATION: The symbiotic interaction between the actively fermenting yeast and the hop oils where new and otherwise unattainable flavor and aromatic compounds are achieved.

HOP BURN: An excessively astringent mouthfeel or unpleasant dry-mouth sensation associated with overly dry-hopped beers exhibiting flavors most often described as green or vegetal.

HOP CREEP: An unwanted secondary fermentation phenomenon that can be harmful to beer and attributed to the excess release of certain hop enzymes during dry-hopping.

HOP-FORWARD: Any beer whose first impression (smell and taste) is dominated by hop alpha acids and/or oils and nothing else.

HOPHEAD: A lover of all things hops.

HOPPY: Having aroma and flavor qualities attributed to hops.

HYPE BEER: A beer whose extreme popularity and/or exclusivity creates a viral demand that artificially inflates its reputation.

IBU: International Bittering Units, an ascending numeric scale of bitterness in a beer.

INOCULATE: To introduce a microorganism into a medium suitable for growth, such as sweet wort. All beer is inoculated with yeast. Some styles may also inoculate their wort with lactic acid–producing bacteria. See also Lacto.

IPA: Short for India Pale Ale, a popular hop-forward beer style that has led to DIPA (Double IPA), IIPA (Imperial IPA), NEIPA (New England IPA), IPL (India Pale Lager), and countless other spin-offs.

ISOMERIZE: A chemical reaction initiated by high or boiling temperatures that activate and unlock the bitterness in the alpha acids of hops.

JUICY: Used to describe hoppy characteristics absent of any noticeable perceived bitterness. Often associated with hop varieties or beers known for more fruit-forward flavors and aromas.

KETTLE, OR BREW KETTLE: A vessel used in the brewing process to boil wort with hops.

KILNED: Describes an ingredient that has been dried (hops) or roasted (grains) at high heat through temperature-controlled equipment called a kiln.

LACING: The residue left on the inside of a beer glass from the head after the beer is consumed.

LACTO (LACTOBACILLUS): An acid-producing microorganism generally associated with accidental beer spoilage, this bacteria consumes sugars and converts them to lactic acid and is intentionally used in many Sour beer styles to acidify the beer. See also Pedio.

LACTOSE: Sugars derived from milk that provide beer with added sweetness and increased body. Yeast is lactose intolerant; it cannot ferment this sugar so it remains in the finished beer.

LAGER: A category of beer made with bottom-fermenting yeast at temperatures relatively cooler than its counterpart. See also ale.

LAGERING: The act of cold-conditioning Lager beer, from the German word "storage."

LAUTERING: The process of separating and extracting liquid wort from residual grain solids.

LAUTER TUN: A vessel used in the brewing process for lautering. See also lautering.

LUPULIN: Glands found exclusively in hops that contain all the resins, essential oils, and other flavor and aroma compounds.

MAILLARD REACTION: A heat-induced chemical reaction that occurs between amino acids and sugars, resulting in the browning of foods, like bread to toast. This reaction is determined by the degree to which the grain is kilned and is responsible for most of the color and malt flavors.

MALT: Grains that have been malted. See also malting.

MALT BILL: A list of all the malted grains (and sometimes adjuncts) used in a recipe to brew a beer.

MALTING: The process of germinating grains that are then kilned for a specific length of time and at a specific temperature to determine the color and flavors of the malt.

MASH, MASHING: The process of creating wort by combining the grist with warm water. See also grist; wort.

MASH TUN: A vessel used in the brewing process to boil the mash.

MIXED CULTURE: Refers to the combination of multiple microorganisms in fermentation. See also Brett; Lacto; Pedio; Sacc.

MOUTHFEEL: A term used to describe the sensory attributes that effect how a beer feels inside your mouth. See also body; carbonation.

NEW WORLD: A category used to describe the origins of certain hops and also to describe the more robust, bright, fruity, and citrusy flavors and aromas they are renowned for.

NOBLE HOPS: A term used to classify traditional Old World hop varieties whose roots trace back to specific growing regions in Europe where they first grew naturally in the wild.

OG (IN BREWING): Short for original gravity, this is the measurement of the relative density of wort before fermentation. See also specific gravity.

OG (IN HOPS): Short for onion-garlic, used to describe hop aroma or flavor that resembles onions and garlic.

OILS: A broad term used to encompass all the essential oils found in the lupulin glands of hops that are responsible for imparting all the hoppy aromas and flavors of beer.

OLD WORLD: A category used to describe the origins of certain hops and also used to describe the reserved, subtle, and traditionally floral, earthy, spicy qualities and clean bitterness these hops are renowned for.

OXIDATION: Exposure to oxygen. Often used to imply overexposure, which results in stale beer.

PASTEURIZATION: The process of boiling to sterilize the wort to kill unwanted microorganisms.

PASTRY: A beer that incorporates confectionary ingredients to mimic the flavors and mouthfeel of the dessert they base their theme upon.

PEDIO (PEDIOCOCCUS): An acid-producing microorganism than can cause spoilage, this bacteria consumes sugars and converts them to lactic acid and is intentionally used in many Sour beer styles to acidify the beer. See also Lacto.

PH: Short for "potential of hydrogen" and measured on a scale of 1 to 14 to express the level of acidity (low pH) or alkalinity (high pH) in beer.

PHENOLIC: Used to express the presence and degree of spicy, smoky, and/or medical flavors from polyphenols in beer. See also polyphenols.

PITCHING: The addition of yeast to the fermenter.

POLYPHENOLS: Organic compounds found in hops and the husk of grains that generally promote the precipitation of proteins, meaning they contribute to a hazy appearance or chill haze. They can also contribute to hop burn.

PORCH BOMB: A canned beer that has the potential to explode due to additional sugars from fruit purees often added post-fermentation that activate a second fermentation after packaging, resulting in dangerous pressure from the CO_2 created.

POST-FERM: Short for post-fermentation and used to express something performed in the brewing process after fermentation is complete.

RACK, RACKING: The transfer of wort or beer from one vessel to another.

RELEASE: The day a beer is made available to the public for consumption. Available at the brewery as a "brewery-only" release, one time as "limited" release, or wide distribution.

SACCHAROMYCES OR SACC: Proper name for the primary strains of yeast used in brewing. *Saccharomyces cerevisiae* ferments at the top of the liquid and is used in making ales. *Saccharomyces pastorianus* ferments at the bottom of a liquid and is used in making Lagers.

SENSORY ANALYSIS: The use of your human senses (sight, smell, taste) to examine and evaluate any aspect of beer and/or its ingredients.

SESSION: A beer with a lower alcohol level, typically less than 4 to 5 percent ABV.

SESSIONABLE: Term used to describe any beer that's easy to drink regardless of ABV.

SKUNKY, SKUNKED: A beer that has been overexposed to UV light and presents a sulfur off-flavor that resembles the odor of an actual skunk.

SMASH: Acronym for a beer produced with a single malt and single hop.

SINGLE-HOP: A brewer's use of only one hop variety in the brewing process.

SOUR BEER: A broad term for the many beer styles made using wild yeasts and bacterias.

SPARGE: The process of rinsing hot water through the exposed grist bed while lautering to maximize sugar extraction.

SPECIFIC GRAVITY: The measurement of a liquid's density compared to water and used in brewing to track the sugar content of wort during fermentation. The difference in specific gravity between original gravity, or OG, and final gravity, or FG, is often used to calculate the final alcohol percentage, or ABV, in beer.

SPONTANEOUS FERMENTATION: The use of naturally occurring airborne yeasts and other naturally occurring fauna and flora to inoculate and spontaneously cause fermentation using an open-air vessel (coolship).

SRM: Standard Reference Method, a numeric color scale used to specify the color intensity of a beer.

TABLE BEER: An easy-drinking, highly sessionable beer that's shared with a group of friends and family, historically sitting around a table.

TALLBOY: Slang term for a 16-ounce can of beer. A 19.2-ounce can may be called a stovepipe; a 22-ounce a silo.

TANNIN: One of the polyphenols found in hops that, when present in beer in higher concentrations, can lead to an astringent, dry-mouth sensation. See also polyphenols.

TERPENES: Volatile unsaturated hydrocarbon compounds found in the essential oils of the hops that offer an array of flavors and aroma to beer.

THIOLS: A specific group of organic compounds found in the essential oils of hops that are responsible for providing a wide range of the more exotic and tropical fruit flavors and aromas.

TRUB: A shallow, cone-shaped pile of collected residual matter and hop debris that remains in the center of a kettle after whirlpooling.

TURBIDITY: The level of opaqueness (high-turbidity) or clarity (low-turbidity) in the appearance of a beer.

VERTICAL: A tasting series comprised of different examples of the same beer style. See also flight.

WET-HOP: The addition of freshly picked, undried, and unprocessed hop flower cones during brewing, usually within twenty-four hours of harvesting.

WHALE: A very rare, exclusive, or hard to acquire beer.

WHIRLPOOL: To circulate the wort after boiling to collect, separate, and remove any solid matter from the liquid.

WILD FERMENTATION: Similar to spontaneous fermentation except that wild yeasts or bacterias are intentionally pitched rather than airborne.

WORT: The sweet liquid that results when grist is steeped in warm water for a period of time to trigger enzymes that convert the grain's complex carbohydrates (starch) into simple, fermentable sugars.

YEAST: A single-celled fungi that is responsible for fermentation.

ZYMURGY: The science of fermentation.

ZYTHOPHILE: A lover of all things beer. You.

Contributor Resources

VINNIE CILURZO is a cofounder and brewer at Russian River Brewing Company with headquarters in Santa Rosa, Califonia. Learn more at: russianriverbrewing.com

BLAKE CROSBY is president and CEO of Crosby Hops in Woodburn, Oregon. Learn more at: crosbyhops.com

DR. PETER DARBY is a retired hop researcher and breeder at Wye Hops Ltd. in the United Kingdom. Learn more at: britishhops.org.uk

KEVIN DAVEY is brewmaster at Wayfinder Beer in Portland, Oregon. Learn more at: wayfinder.beer

CLAIRE and **ERIC DESMARAIS** are fifth- and fourth-generation family farmers at CLS Farms in Moxee, Washington. Learn more at: clsfarms.com

DAVE DUNBAR is the managing director at Freestyle Hops in New Zealand. Learn more at: freestylehops.com

ANDREW GODLEY is the founder and owner of Parish Brewing Company in Broussard, Louisiana. Learn more at: parishbeer.com

KEN GROSSMAN is the founder and owner of Sierra Nevada Brewing Company with headquarters in Chico, California. Learn more at: sierranevada.com

SHAUN HILL is the founder and brewer at Hill Farmstead Brewery in Greensboro Bend, Vermont. Learn more at: hillfarmstead.com

ADAM LAWRENCE is head brewer at Left Hand Brewing Company in Longmont, Colorado. Learn more at: lefthandbrewing.com

JASON PERKINS is brewmaster and VP of brewing operations at Allagash Brewing Company in Portland, Maine. Learn more at: Allagash.com

JASON PERRAULT is a fourth-generation hop farmer at Perrault Family Farms, lead hop breeder at the Hop Breeding Company, and CEO of Yakima Chief Ranches in Toppenish, Washington. Learn more at: perraultfarms.com; hopbreeding.com; and yakimachiefranches.com

DOUG REISER is a cofounder of Burial Beer Company in Asheville, North Carolina. Learn more at: burialbeer.com

SAM RICHARDSON is a cofounder and brewer at Other Half Brewing Company in Brooklyn, New York. Learn more at: otherhalfbrewing.com

JIM SOLBERG is a cofounder of Indie Hops in Portland, Oregon. Learn more at: indiehops.com

ELISABETH STIGLMAIER is a sixth-generation hop farmer and designated hop ambassador in Hallertau, Germany. Learn more at: hopfenfuehrung.de

JEFFREY STUFFINGS is a cofounder and owner of Jester King Brewery in Austin, Texas. Learn more at: jesterkingbrewery.com

DR. SUSAN WHEELER is a plant scientist and cofounder of Hop Revolution Limited in New Zealand. Learn more at: hoprevolution.co.nz

SIMON WHITTOCK is manager of agronomic services and head of the hop-breeding program at Hop Products Australia. Learn more at: hops.com.au

Additional Contributions

Michael Carbrey, Joe Catron, Grace Irwin, Owen Johnston, Marlize Mitchell, Zak Schroerlucke, and Dr. Shaun Townsend.

Special thanks to Coleman Alluvial Farm, Blake Garcia at Bend Brewing Co., Adam Rogers, Virgil Gamache Farms, Tim Sattler at Yakima Quality Hops, Scott Shumski, Smokedown Farm, Sodbuster Farms, Amy Treadwell, and Adam Wood at Market of Choice.

Additional Photography Credits

The author and publisher would like to thank all the contributors who provided additional photography for use in this book:

page 23 photos courtesy of Indie Hops

page 27 photos (top left, top right, bottom right) courtesy of Elisabeth Stiglmaier / XYZ Photography

page 30 photos courtesy of Peter Darby

page 33 photos (top left, bottom left, bottom right) courtesy of Hop Revolution

page 33 photos (top right, middle right) and page 52 photo courtesy of Freestyle Hops

pages 36, 111, 119, 123, 129, 213, 219, 221 photos courtesy of Hop Products Australia

page 39 (top left, bottom left) photos courtesy of Crosby Hops

pages 74–76 photos courtesy of Sierra Nevada Brewing Company

pages 90–93 photos courtesy of Parish Beer Company

pages 134–136 photos courtesy of Jester King Brewery / Granger Coats

pages 162–164 photos courtesy of Other Half Brewing Company

pages 190–193 photos courtesy of Hill Farmstead Brewery / Bob M. Montgomery Images

pages 204–207 photos courtesy of Russian River Brewing Company

pages 222–224 photos courtesy of Burial Beer Company

Hop Variety Index

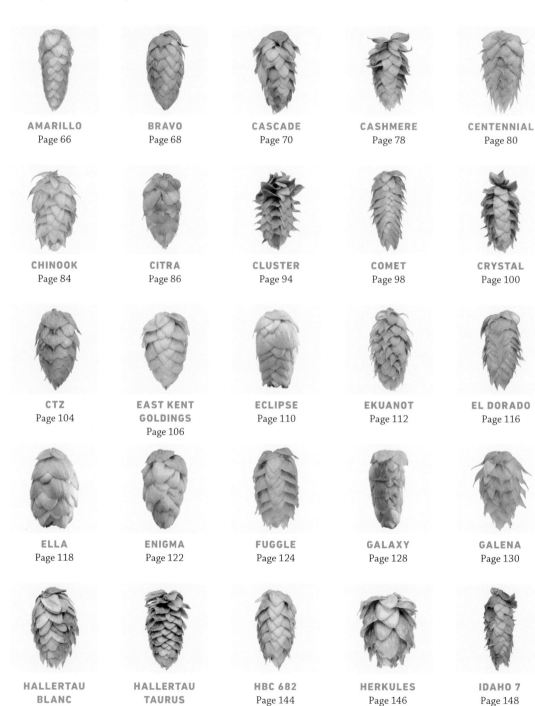

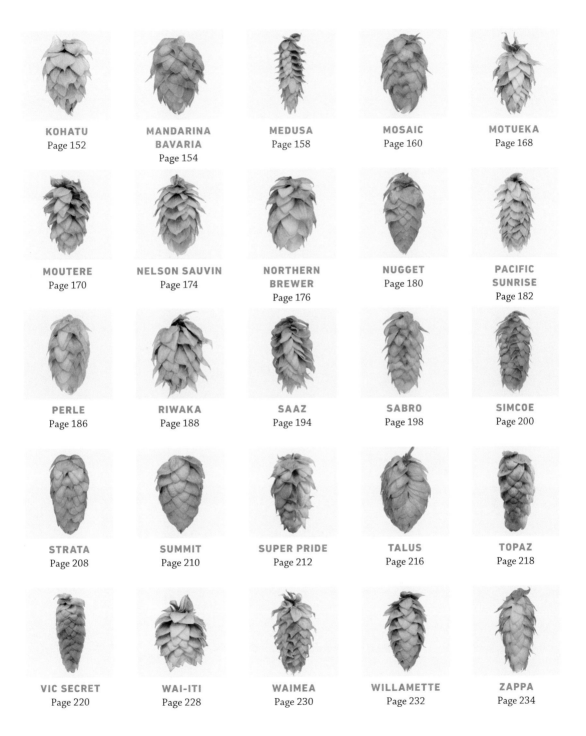

KOHATU
Page 152

MANDARINA BAVARIA
Page 154

MEDUSA
Page 158

MOSAIC
Page 160

MOTUEKA
Page 168

MOUTERE
Page 170

NELSON SAUVIN
Page 174

NORTHERN BREWER
Page 176

NUGGET
Page 180

PACIFIC SUNRISE
Page 182

PERLE
Page 186

RIWAKA
Page 188

SAAZ
Page 194

SABRO
Page 198

SIMCOE
Page 200

STRATA
Page 208

SUMMIT
Page 210

SUPER PRIDE
Page 212

TALUS
Page 216

TOPAZ
Page 218

VIC SECRET
Page 220

WAI-ITI
Page 228

WAIMEA
Page 230

WILLAMETTE
Page 232

ZAPPA
Page 234

Beer Style Index

AMERICAN IPA
Page 83

AMERICAN LAGER
Page 97

AMERICAN PALE ALE
Page 73

BARLEYWINE
Page 151

BELGIAN TRIPEL
Page 173

COLD IPA
Page 227

DOUBLE IPA
Page 203

ENGLISH BITTERS
Page 109

ENGLISH IPA
Page 215

HELLES
Page 179

IPL
Page 185

KÖLSCH
Page 143

LAMBIC
Page 133

MILKSHAKE IPA
Page 115

NEW ENGLAND IPA
Page 89

PILSNER
Page 197

PORTER
Page 127

SAISON
Page 121

SCHWARZBIER
Page 157

STOUT
Page 167

WITBIER
Page 103

Published in the United States by Ten Speed
Press, an imprint of Random House, a division
of Penguin Random House LLC, New York.
www.tenspeed.com

Ten Speed Press and the Ten Speed Press colophon are
registered trademarks of Penguin Random House LLC.

Amarillo® is a trademark owned by Virgil Gamache
Farms, Inc.

Bravo™ and Hopsteiner® are trademarks owned
by S. S. Steiner, Inc.

Citra®, Ekuanot®, Mosaic®, Sabro®, and Talus™ are
trademarks owned by Hop Breeding Company, LLC.

Eclipse®, Ella™, Enigma®, Galaxy®, Topaz™,
and Vic Secret™ are trademarks owned by
Hop Products Australia.

El Dorado®, Medusa™, and Zappa™ are trademarks
owned by CLS Farms, LLC.

Idaho 7® is a trademark owned by Jackson Hop, LLC.

Kohatu®, Motueka™, Moutere™, Nelson Sauvin™,
Pacific Sunrise™, Riwaka™, Wai-iti™, and Waimea™
are trademarks owned by NZ Hops, Ltd.

Cryo Hops® and Simcoe® are trademarks owned by
Yakima Chief Ranches, Inc.

Strata® is a trademark owned by Indie Hops, LLC.

Summit™ is a trademark owned by the Association
for the Development of Hop Agronomy, LLC.

Library of Congress Cataloging-in-Publication Data
Names: DiSorbo, Dan, author. | Christiansen, Erik
 (Photographer) photographer.
Title: The book of hops : a craft beer lover's guide
 to hoppiness / by Dan DiSorbo ; photographs by
 Erik Christiansen.
Description: First edition. | New York : Ten Speed
 Press, an imprint of Random House, a division of
 Penguin Random House, LLC, 2022. | Includes
 index.
Identifiers: LCCN 2021031483 (print) | LCCN
 2021031484 (ebook) | ISBN 9781984860040
 (hardcover) | ISBN 9781984860057 (ebook)
Subjects: LCSH: Beer. | Brewing—Amateurs'
 manuals.
Classification: LCC TP577 .D57 2022 (print) |
 LCC TP577 (ebook) | DDC 663/.42—dc23
LC record available at https://lccn.loc.gov/
 2021031483
LC ebook record available at https://lccn.loc.gov/
 2021031484

Hardcover ISBN: 978-1-9848-6004-0
eBook ISBN: 978-1-9848-6005-7

Printed in China

Editor: Sarah Malarkey
Production editors: Ashley Pierce and Ann Spradlin
Designer: Chloe Rawlins
Production designer: Faith Hague
Typefaces: Linotype's DIN Next by Akira Kobayashi,
and Sandra Winter, and Adobe's Chaparral Pro by
Carol Twombly
Production manager: Dan Myers
Copyeditor: Andrea Chesman
Proofreader: Jeff Campbell
Publicist: Natalie Yera
Marketer: Daniel Wikey

10 9 8 7 6 5 4 3 2 1

First Edition